CONTEMPORARY BRITISH WOMEN ARTISTS

In their own words

REBECCA FORTNUM

I.B. TAURIS

LONDON · NEW YORK

Published in 2007 by I.B.Tauris & Co Ltd
6 Salem Road, London W2 4BU
175 Fifth Avenue, New York NY 10010
www.ibtauris.com

In the United States of America and Canada distributed by Palgrave Macmillan
a division of St. Martin's Press, 175 Fifth Avenue, New York NY 10010

ISBN: 978 1 84511 224 0

A full CIP record for this book is available from the British Library
A full CIP record is available from the Library of Congress

Library of Congress Catalog Card Number: available

Printed and bound in Great Britain by TJ International Ltd, Padstow, Cornwall
Layout by FiSH Books, Enfield, Middx.

CONTENTS

ACKNOWLEDGMENTS

I would like to thank the Arts and Humanities Research Council, the Arts Council of England and the Research Committees of Wimbledon School of Art and Camberwell College of Art for their financial assistance in the making of this publication. I'd also like to thank Eve Fortnum, Beth Harland and Richard Elliott for all their help in so many ways, as well as Martyn Evans and Jacqueline Griffin for their professional expertise. Thanks also to Nicola Denny and Susan Lawson from I.B.Tauris. Finally, I would like to pay tribute to the dedication, integrity and insight of the artists whose words you will find in this book.

Photo credits
Photographs of Tacita Dean and Gillian Ayres by Richard Elliott
Photograph of Tracey Emin by Johnnie Shand Kydd
All other photographs of artists by Rebecca Fortnum

Typographical design
Gary Pearson, lomi-lomi.co.uk

Arts & Humanities Research Council

University of the Arts London Camberwell

WIMBLEDON | SCHOOL OF ART

ARTS COUNCIL ENGLAND

INTRODUCTION
Something of the moment

Rebecca Fortnum

I think there are artistic truths that hit something of the moment of
when they are made.

GILLIAN AYRES

This collection of interviews with British women artists captures a moment in
time, to record how and why contemporary art gets made (1). In doing so it
reveals the artists as individuals, articulating their experience of the world,
contemplating their particular set of concerns. Often their integrity in doing so
is overwhelming; a far cry from the charlatanism popularly associated with
contemporary artists. Indeed, I feel these interviews confirm the existence of
genuinely reflective art practice in the early twenty-first century.

One aspect of this book that becomes rapidly apparent is that the artist is
audience as well as maker. When Anya Gallaccio marvels over the 'economy of
gesture' in such different artists as Pina Bausch, Giotto and Vermeer, we quickly
become aware of her finely honed ability to analyse an artwork's qualities and
how that clarity of thought is then directed unflinchingly at her own practice.
Like many of the artists represented in this book, this evidence of creative
intelligence is all the more exciting for being so seldom a topic of discussion. For
the abstract painter Maria Lalić, Beethoven's *Diabolli Variations* provides an
epiphany as she realises the potential of her own work's form and structure. As
a young artist, Hayley Newman hears John Cage for the first time and a whole
world of possibilities for the future present themselves. Maria Chevska's deep
involvement with modernist literature generates new visual form, conversations
with the texts she excavates. In reading these artists' ruminations, one becomes
aware of them engaging with other practices, present and past, in a very real
way. Listening, looking and thinking; they sift art's canons, finding works that will
sustain them in their creative journeys.

Another sense that emerges from these interviews is that of the material prac-
tice of art. These artists *live in* their work. Painter Vanessa Jackson, eloquently
borrowing from Heidegger, describes it as 'set[ting] up a space that I can dwell in'.
What I understand by this is that the potential for thought and contemplation
offered by making a work of art is hard to find in other spheres of existence and

requires total engagement. It exists in the complete technical and intellectual immersion in the materials and mechanics of making and can occur in any medium. This experience often eludes formal description, yet continually surfaces in these conversations. When Tacita Dean describes editing her film she confides, 'you see, I edit alone and I edit on film'. With this we form a sense of the intense, and perhaps necessarily solitary, decision making process. Runa Islam discusses how she felt making three film-based works from 1998 and says, 'naming the processes seemed impossible'. This to-ing and fro-ing between bewilderment and certainty, knowing and not knowing, is crucial to the creative process and is characteristic of this sense of *living in* a work. When Emma Kay gave up professional singing, she realised that it was the 'rigorous discipline' of daily exercising in the pursuit of perfection she would take with her into her text based 'memory' works. More traditionally, perhaps, painter Jane Harris marries the self sufficient and absorbing structures of geometry with her acute visual observations stemming from her art school training. Harris describes this balance of 'external' and 'internal' references, saying, 'it is to do with perception but there is a structure underlying it that has rules'. Her practice absorbs visual phenomena, relying on the integrity of its internal structures. This evidence must go some way to allay Clare Barclay's concern about the 'fracture between making and thinking' in current contemporary art practice. In these practices, thinking and making happen concurrently and inform each other. Barclay goes on to assert:

'I believe we mustn't lose touch with the world through making and understanding how things come about'.

The evidence, amongst these artists at least, is that this is far from the case.

Barclay's comment clearly reveals her belief that this sense of *living in* the work includes an ethical dimension. These art practices do not require an ivory tower, but rather a window to look out on the world. The work may contain ethical judgements yet hold back from didacticism. Often a note of urgency permeates these artists' words. When Jemima Stehli talks about reaching a crossroads in her practice ('I wanted to deal with the things which are really at stake'), it is clear that her ambition for her work is bound up with exploring issues important to her. Indeed, in different ways, for all these artists, the collision between ethics and experience is evident. For some, such as Christine Borland, this dimension forms the actual subject of the work. For others, like Lucy Gunning, it leaks out of the work's structure. Some tackle ethical issues explicitly. Both Paula Rego and Tracey Emin have made work about abortion that draws attention to women's real experience in contrast to the philosophical or legal perspectives of other public platforms. Tania Kovats's *Virgin in a Condom* has direct political implications yet emerged from a sustained dialogue around the notion of the Madonna 'as a

site' and an awareness of the way the work's meaning can shift in relation to its context. Indeed, it is only through this personal engagement with the material that the deep politics emerge. As Paula Rego says of her work:

'The painting is a thing on its own, apart from you.When I've finished it's telling *me* something.'

And of course it also tells others; the work mediates between its individual maker and the world, finding ways for both artist and audience to comprehend their surroundings. And there is something else. I believe that this desire to speak from experience about the world through an engaged material practice has the influence of feminism at its root.

Griselda Pollock and Roszika Parker's seminal *Old Mistresses; Women, Art and Ideology* and other important works of feminist art history produced in the eighties, informed generations of female visual artists, including most of the artists in this book. Issues to do with the personal, the body, the domestic, as well as the use of low status techniques or materials, became validated as a consequence of these feminist explorations. In these interviews I believe we witness the impact of this feminist consciousness on art practice, both directly and indirectly. For example, the important 'feminist' artist Mary Kelly, who practised in the UK in the eighties, is cited by several of these artists as a key point of reference. The fact that none of the artists in this book define themselves as 'feminist artists' does not signal feminism's failure; this would be to misunderstand its strength. Indeed, the triumph of feminism (within the visual arts at least) has been its ability to integrate the real issues affecting women into the language of contemporary art. Feminism is a fundamental tool in our understanding of the world. For these artists, feminist issues take the form of the debates around ethics, power, representation, knowledge, memory and narrative, which are integral to their work. For example, artists as different as Jananne Al-Ani, Jemima Stehli and Christine Borland all record the way their practices have responded to the established feminist dialogue around the (female) body as object. Today we can detect feminist scholarship in the UK in the writings and exhibitions of a broad range of women theorists, artists and curators (2). Much of this work looks carefully at the artworks produced by women artists in order to analyse how it can contribute to feminist debate. This is important; for too long we have policed ourselves as good and bad feminists, feminists in life but not in art, in a cul-de-sac of recriminations. Now it seems possible that we might engage seriously with feminist issues in relation to the exciting work being made and shown today by successful women artists, without requiring it to be a straightforward celebration or a direct critique. Sonia Boyce embraces her political positioning as an artist but has developed a speculative approach to her practice. She says:

'Now I don't need to adhere to a declaration of intent; a right and a wrong. Instead I say, let's just see what this is and how it unfolds'.

With this statement Boyce is not shunning her responsibilities, rather she is aware that the complexities of the ethical (and emotional) issues her artwork explores need particular and discursive forms to articulate them.

However, we are also in debt to feminist art history for spelling out another crucial fact. Artists, even those with contemporary success, cannot expect an assured place in the history books. Indeed, the lives and thoughts of women artists through the ages have often been painstakingly reassembled by feminist scholars to whom we owe the knowledge of their practice. This leaves us with an understanding of the importance of writing women 'in' to the story for future generations. This book aims to mark an investment in the account of women artists in the early twenty-first century for posterity. The impact of feminism has been far reaching, but not quite enough to sweep away the status quo of centuries. Let's look briefly at the situation for British women artists in 2006. *Beck's Futures*, the excellent talent spotting competition held annually since 2000 at the Institute of Contemporary Art in London, is a handy barometer of the contemporary art scene in this country. Just over a third (3) of the artists nominated for the award have been female. This is not to say that the competition discriminates against women; rather I think this figure represents the state of play for professional women artists. Of Turner Prize nominations, another very visible marker in the careers of young British artists, 27 per cent have been female (and less than 10 per cent of the winners). However, if we compare the early years (1984–1996) with more recent times (1997–2005), the figures show a leap from 19 per cent to 41 per cent of women artists nominated. So it is into this arena that this book goes. We have vast progress in the status of women artists but not equality, yet. Perhaps it should also be noted that we hardly start from a level playing field. In this country the vast majority of professional artists have been to art school and these art schools, for the last ten years at least, are made up of disproportionately more female students.

Lastly, a question remains in a book of this nature about the interviews themselves. What can artists contribute to the debate around their work? Recently, in my role as an academic researcher, I have initiated a project to document artists' processes (4). A more detailed knowledge of creative processes allows us to establish models for practice as research and this is proving useful in our current academic climate. But this is more than merely responding to contemporary academic demands. I believe that once we have acknowledged the fact that works of art can never be fully translated into words, a range of multivalent narratives quite happily attach themselves to visual production. And, whilst the artists are here, and willing to answer questions, we have the

opportunity to add their voices to any discussion about their work. If it is clear that they do not hold the 'meaning' of their work as a privileged author, then their accounts can often extend our thoughts about their own artworks, often creating additional levels of understanding. This chance only exists during the artist's lifespan, after that we cannot predict with complete certainty how these words, or indeed the work, will be valued. Personally, I am grateful to the interviewers of the painter Alice Neel whose witty observations seemed to strike a chord at an early stage of my own practice. Indeed, my artist self is always interested in hearing other artists talk of their work. Rarely, if ever, have I been disappointed. Articulate or otherwise, the mysterious relationship of an artist to their work can never be exhausted and is compulsive listening, particularly for those that also try to make.

I am all too aware that the current field of women artists practicing in the UK is vast and that I have selected only 20 artists from it. The artists were chosen to represent a cross section of practices from the UK's art scene. You may detect bias, for which I can't offer a defence – this is surely inevitable in such an endeavour. Bearing in mind that many of the readers of this volume will be artists themselves, often at an early stage in their career, I have often chosen to spend time tracing the paths of the artists' development. Indeed, these artists provide a range of models for how creative practice can evolve. I admire all the artists in this book enormously and have found their reflections fascinating. I hope you will too.

NOTES

1 Tacita Dean, Jane Harris and Tania Kovats interviews took place in 2001, Gillian Ayres, Maria Lalic, Maria Chevska, Vanessa Jackson in 2004 and all others in 2005.

2 I'm thinking, for example, of writing by Maria Walsh, Paula Smithard, Marsha Meskimmon or Rosemary Betterton or exhibitions such as *Warped* (Angel Row Gallery, 2002), *And the One Doesn't Stir Without the Other* (Ormeau Baths Gallery, 2003), *Unframed*, (Standpoint Gallery, 2004), *Her Noise* (South London Gallery, 2005) or symposiums such as *Mediated Pleasures in (post) Feminist Contexts*, convened by Sue Tate and Clare Johnson at the University of West of England in 2005.

3 27 out of 73 nominated artists in Beck's Futures (2000 – 2006) have been female. Interestingly, there has been an equal split between male and female winners. Since 2001 there have been 32 judges, 12 of them female.

4 The *Visual Intelligences Research Project*, at the Lancaster Institute for the Contemporary Arts, Lancaster University where I am currently Research Fellow.

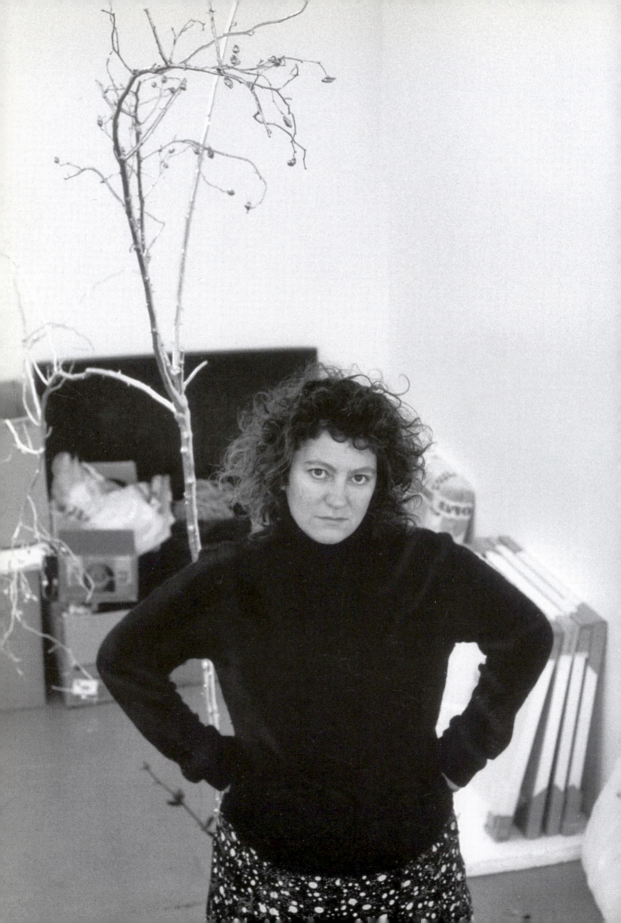

ANYA GALLACCIO

Anya Gallaccio is known for large-scale sculptural installations that employ organic materials. Her early work used vast quantities of flowers and she continues to juxtapose stable and unstable materials. The work often creates a visual spectacle, for example a piece from 1996, *Intensities and Surfaces*, centred on a 32-ton block of ice.

RF What drew you towards making art?

AG I resisted going to college straight from school – at 18 I wasn't interested in staying in education. But I drew a lot and travelled for a bit and ended up in the wardrobe department at the Royal Court Theatre. Then I met Michael Morris who was then running the theatre at the ICA. I went to Paris to see Pina Bausch and to a festival in Holland to see Anna Teresa De Keersmaeker and other performers. A whole new world opened up to me. I became aware of working practices where there seemed to be no hierarchy between performer, director and designer – a true collaboration that I found both exciting and inspiring.

While I was at Kingston University in London doing an Art Foundation course, it became apparent to me that most theatre isn't like that and that the visual aspect of it is secondary to the text or the director's vision. The tutors at Kingston said I was too idiosyncratic to be a designer. At that point I was determined to do something that was vocational because I wanted to be able to support myself, so I really resisted going to art school. There weren't many women artists visible then; it wasn't very long ago but it feels like a different world. I didn't fit neatly into sculpture or painting and so Goldsmiths College at London University, that offered fine art as opposed to subject areas, was the only place I felt that I could go. I really struggled whilst I was there. The artist Richard Wentworth, who was a tutor, persuaded me to stay, citing this list of people who were successful in their fields – entrepreneurs, restaurateurs, designers, record producers, musicians – who had gone to art school.

RF But when you wanted to leave, what were your reasons?

AG	I felt that I was being self-indulgent and it was too abstract just making stuff. I work better to a deadline and within a structure, so being able to do anything felt a bit wanky to me. It was a real struggle. I was always fighting with myself.
RF	You have said that your degree show was a disaster.
AG	Yes, it was. I bodged it up, I included too much stuff and it didn't make any sense. The main thing that I wanted to show got thrown away. I was working with found and organic objects and I was growing weeds in this rusty frame of a toy pram that was outside in the alleyway because it needed sunlight. Everyone saw it in the skip and thought it odd, but no one mentioned it to me until it had gone. Because I'd got it into my head that the whole show was based around it, I just panicked and put everything in.
RF	You joined a grand tradition of artists getting their work chucked away like Joseph Beuys!
AG	It was a really brutal lesson. So I learned to be a bit more flexible. I was feeling pretty despondent, but then I started work on *Freeze* with Damien [Hirst] and all of a sudden I had a space and a set of parameters, so I had another opportunity.
RF	And this time you were clear about what it was for?
AG	Yes. I was showing with Gary [Hume]'s paintings. He was making door paintings and they hung very low, virtually on the floor. I knew that I couldn't make anything high that would interfere visually with what he'd done. The more restrictions Damien imposed, the clearer my choices became; I poured a ton of lead on the floor. Pouring the lead and working directly in the space opened up a whole new set of possibilities for me and then I was invited to do another show. Something clicked into place in my brain and I'd found a way I could allow myself to make things. I continued working in the theatre doing costumes, props and stage-managing. Later I remember having an argument with one of my contemporaries who felt that I wasn't an artist because I had a job.
RF	Perhaps if the money hadn't been coming from a different source, you would have been forced to make different kinds of works.
AG	Yes, absolutely. I was pretty resourceful and my outgoings were low. This way I managed to retain my independence and continue to work in interesting

places. I feel that if I've achieved anything, I've done it on my own terms, which is important to me. Obviously, loads of people have helped me and I would never diminish the importance of that support, but I feel that I earned it.

RF If you start delving into most successful artists' financial backgrounds you find that a lot of them had a head start.

AG Yes, but I also find that not having much money forces you to be more creative. Sometimes when I've had too much money to throw at a problem, I haven't looked at it from all angles. On the other hand, being really stressed, with no money, totally cripples you. If you've got a bit of money, it just switches one button off at the back of your brain and allows you to spend your energy on problems that are more interesting.

RF If you're out of the studio because you're working, how does that affect the pacing of the work and the development?

AG I've stopped teaching because I found it too disruptive. I'd wake up in the middle of the night with the solution to someone else's problem! My problem now is that I take on too many projects and the thinking time gets eaten into. I always underestimate how much time you need to sit and read or be still with an object in a space. That's an important part of the process, it can give you the answer to what to do next. Mostly the requirements of the space come first. Sometimes I respond formally or architecturally, which will get me started. Over the years I've built up a large vocabulary or palette of materials. I think that working with ephemeral materials has a lot of limitations, so I've changed the way that I've been using materials.

RF Maybe to begin with you knew less about how your materials reacted and now you can predict things?

AG Yes, I like not knowing what is going to happen. I don't want to illustrate a process. The process is what I'm interested in, so I have to extend that vocabulary. It's a collaboration between the material and me.

RF But how do you bridge that gap between your initial concept and what it is? How do you experiment?

AG There's an organic balance between the mental process and planning and the physical/material process that doesn't come into play until you're in the space.

I'm excited by the gap between the idea and the action. It's tricky working in institutions because you have to plan so far ahead, and they want to be confident about what they will get. When you're working in a studio this aspect is generally worked out in private. When you're working with fabricators or technicians there's more slippage because there's another layer of communication and translation.

RF Is there any leeway to change things?

AG Often there's not really much you can do. The ice piece at Wapping [*Intensities and Surfaces*, 1996] was made in one day. One of the slabs cracked when we were installing it and I left it broken. I try to accept the inconsistencies of the processes and materials that I use. We took the scaffolding down the day of the opening, so that was the first time I saw the object in the space. I had three hours to get my head round the idea that this was my piece of work.

RF You have said that you don't want the 'workings out' to show and you want it to look easy. Why's that?

AG I think a lot of the time work that shows technical expertise and effort is applauded. I always compare it to cooking; Italian food is pared down to one or two ingredients. I'm much more in awe of the purity and discipline of this approach than the skill involved in High French cuisine. For me, when my work is successful, I'm surprised by it. There's an emotional resonance, something that I can't put into words, that happens between you and the object or in the space. That is what excites me and keeps me going. I went to the Donald Judd ranch in Marfa, Texas and saw the work with a hundred or so aluminium boxes. It was a truly sublime experience and I cannot articulate how those objects produce such an emotional response. It was incredible.

RF I think there are contrary impulses working together in your work. One seems to be about something that's slight and the other is about spectacle, almost bodily shock.

AG When I think of the works of Pina Bausch, Giotto and Vermeer, there's an economy of gesture underlying a strong emotional resonance; it punches you. An invisible tension, undeniable and inexplicable. I'm fascinated by how something so restrained can be so charged.

RF It was quite brave of you to go from those flower pieces under glass, which were overwhelming, to the lighter daisy chains.

AG The flower and glass works were very straightforward; taking an apparently 'serious' structure like the minimal grid and using an emotionally loaded material but in a matter of fact way. Like the painting with the chocolate, [e.g. *Couverture*, 1994] it's about taking out the gesture and seeing if the material itself has the capacity to resonate emotionally. I always found it disingenuous that you should look at a Judd or Richard Serra work as a purely objective entity. I have a physical reaction to some of those works; I feel intimidated by them or frightened. With the flower works I made a conscious choice to make them appear easy, to hide the effort involved…the daisy chains are a pain to do! The chains offered me an opportunity to respond more spontaneously and occupy the space. It felt like drawing in space. Again, the experience of them in actuality is very different to them flattened out in photographs.

RF There has been some discussion of the feminisation of minimalism. I remember seeing a show subtitled *Women Artists and Minimalism in the 90s* at the MOMA in New York. Did you see your work in relation to that?

AG Yes, at the time. I initially took the structures from that language and filled them with a different agenda to see what would happen. Most of the artists who were visible here when I started, Mary Kelly, Susan Hiller, Victor Burgin were making theory-driven works. Often I felt that you had to have read something before you could look. I thought this was exclusive and sometimes intimidating. It wasn't sensual or physical at all. A lot of women artists' work was being marginalised as being too subjective or emotional. There seemed to be an alternative system where this work existed. The work that I was drawn to – Judd, Serra, Carl Andre – seemed to be admired for its objectivity and purity. This seemed like an interesting problem to tackle. I felt there was a gap, a place to occupy. Mapplethorpe could work with flowers, could I work with flowers and have them taken seriously?

RF In an interview in 1996 you said you were a Romantic but in 2002 you said you weren't. I wondered whether that reflected a change in you or the use of the word?

AG I would say that I'm a Romantic in terms of being idealistic; I have an unrealistic expectation of life. I'm also very pragmatic, very down to earth and straightforward, there's a contradiction in the way I work.

RF I saw it in terms of a relationship to Romanticism, that there's a spiritual remit for the work, that it's meditative or has some capability to replicate the sublime associated with landscape.

AG Possibly. I think I'm old-fashioned in what I want from art; I don't want it to be an entertainment, I like to be still with things. For a painting or sculpture to be rewarding you have to give it time. I like being in a museum when there's not very many people, and when you're allowed to make your own connections. It's all about those experiences that are unexplainable and if you try to articulate them, it becomes really clunky. I'm fascinated when you see someone moved to tears in front of a painting. I understand how the movies or music trigger your emotions but an inanimate object, paint, or stone or clay? I'm really in awe of that.

RF Your work is often seen as ephemeral but it is also durable because it can be remade. I went to a talk by Howard Caygill about destruction in art and he was asking why we think about destruction of art as being a terrible thing. He pointed out that everything made is destroyed, quite often by the makers themselves. He said the strange thing isn't that things die but that we try to preserve them.

AG Yes, I always felt that that the flower works were a practical solution; you had the instructions and the permission to remake them. They didn't need to be maintained and preserved. They exist for a moment in time. It's really hard to perceive work as it was seen when it was first produced. You see something that you know was radical but it looks dusty and faded like those Fontana paintings. It's hard to feel the exhilaration and the edginess they must have had. I can't decide whether it's important to feel shocked or whether admiring them as beautiful objects diminishes them? I've been really amazed by the amount of energy and effort that goes into preserving and protecting things. Often there are huge battles going on within museums between the people who look after the objects and the people who want to show the objects.

I remember going to see the Sistine Chapel when it had just been cleaned and people were appalled because it was so bright and garish. We feel we know the work in its more muted state. The Eva Hesse exhibition [Tate Modern, 2002] was like an archaeological excavation! She knew those materials were going to perish when she was working with them. Would she have just shown things until they fell to bits or would she have remade them? It seems that once people have invested money in a work it becomes sanctified, it's a relic. I wish they had made an exhibition copy of some of the work so you could have seen how different the work looked when the material was fresh and if it changed how you responded to the work. She didn't seem to be that precious; it seemed to me to be much more about the process and trying things out.

RF I was at this seminar the other day where the sculptor Alison Wilding was talking about Rachel Whiteread's *House*. She said that by it not existing it lives in people's minds and is extremely powerful.

AG Like the artists who died young and have become canonised, they had the luxury of not fucking up. Then you get Mario Merz or Warhol, who lived a full life, who had plenty of opportunities to make some dud work.

RF And they've taken them, on occasion.

AG Personally, I find that exciting. You should be allowed to make mistakes.

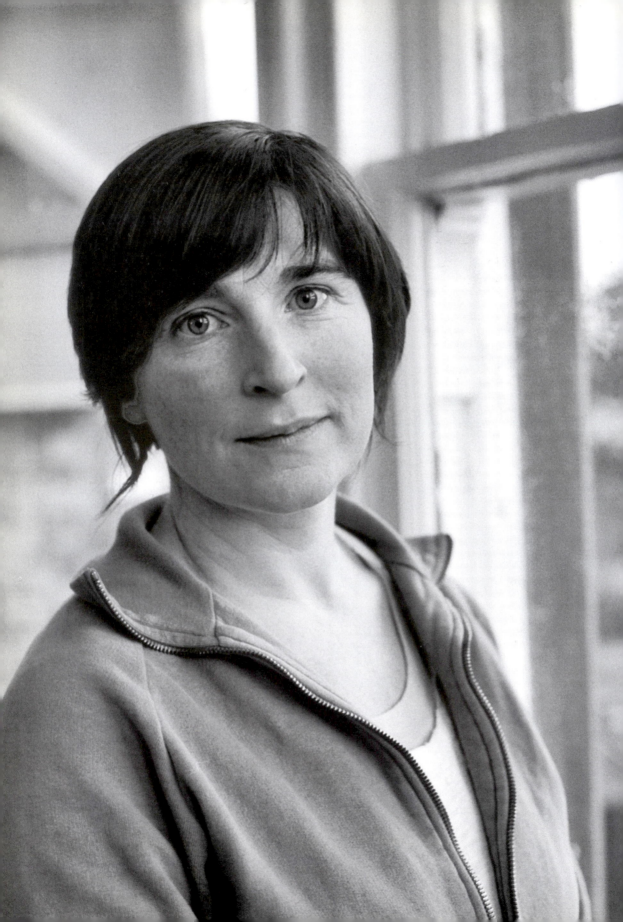

CHRISTINE BORLAND

Christine Borland makes installed artworks that are concerned with the way the body becomes socialised. Her work often meditates on ethics and employs forensic technologies. She has used drawings, films, found objects, sculptures, and even dust, to explore these issues.

RF What kind of things were you doing at college?

CB I can't get away from the fact that amongst other things I was looking at Judy Chicago, the *Womanhouse* project [1972] and making sculpture that looked like 3-D versions of Georgia O'Keeffe.

RF That was in the mid eighties when the 'New Glasgow Boys' [Stephen Campbell, Peter Howson, Ken Currie] were very dominant in the UK.

CB Yes. My tutor Sam Ainsley was the only woman who was in any position of authority within Fine Art at Glasgow School of Art. I was in the Environmental Art Department because the Sculpture and Painting Departments were very medium specific and it was hard to step outside the boundaries of their traditional materials. Environmental Art was called 'Murals' when I started, the name was a kind of hangover from the seventies. It was a place where people who didn't fit in ended up, so there was lots of discussion, film projects and installation. It was a really live, fantastic place! Then I went to Belfast [University of Ulster] which, looking back, was a very important move. I knew that I didn't want to go to London for my MA. I'd visited it enough to feel that the kind of emphasis there was not really what I needed. Belfast had Alistair McClennan, a performance artist, who was an amazing, charismatic guy and an inspirational teacher. Because of the situation it didn't feel like a place to make monuments; everyone was doing temporary work, ephemeral stuff, installation, performance…..

RF So what kind of stuff were you doing there?

CB I was always sniffing around markets and sales of bomb damaged goods. I surrounded myself with a lot of stuff that I then began to use in the work.

The pieces previously had been sculptural but these were exploring space using installation. They still had a feminist aesthetic, if that's the correct term. They were trying to come to terms with the situation there, which was extremely complex. Whenever you thought something appeared to be one thing, it turned out to be something else. The sculptures had a façade and then a reverse side showing the true picture – they were literal in that respect. I suppose it was only when I moved away that I was able to make work dealing with the influences, situations and ideas that I'd had when I was there. For example, relatively often I'd pass cars whose windows had bullet holes. Shattered glass was something that stayed with me, it was so powerfully attractive and repellent, but there was no way I could use that image while I was there.

RF There was a feminist taboo about using the body in the UK then.

CB Yes, *The Subversive Stitch* [Roszika Parker, 1984] was my bible when I was in Belfast! I was trying to deal with how to represent the body without it actually being present, so that was very much an issue. The process of doing it was also very important. I had to make contacts within the anatomy department of the University, speak to people, go into dissection theatres and try to borrow a skeleton. I was given the name of a company where I could buy or borrow a skeleton, so I called up and they asked if I wanted 'natural' bone or plastic and that was the start of the reconstruction project, *From Life*. But from 1990 to 1994 I went through a period of being obsessed with forensic methodologies. The work that I feel was my first mature piece was called *Supported* and was shown in 1990 at what was the Third Eye Centre, now the Centre for Contemporary Arts, in Glasgow. It was in a group show with Douglas Gordon, Roddy Buchanan, Craig Richardson and Kevin Henderson, that we curated ourselves, titled *Self Conscious State*. I was interested in the history of the representation of the body in medicine, and went regularly to the anatomy museum in Glasgow University. This was the first piece where I used elements of the body and the skeleton but there was actually nothing present, just dust. That was a pleasing way of representing the body.

RF That led to work with researchers and professionals from other disciplines. What is that like?

CB I don't always have an exact idea in my mind and so often work develops from things shown me or anecdotes told me. It's always an interesting series of dialogues within institutions, finding the right person to work with. It's often someone who's considered slightly eccentric or a maverick within the institution.

RF Did you also become aware of different ways of thinking?

CB Oh yes, very much. I suppose my work tries to tease out both the connections
 and divides between the scientific mode of exploration and the artistic one.
 I'm in the middle, somehow bringing the two together. Generally the people
 that surround me are people who have an interest in the implications of what
 they're doing and how it affects society, whereas not everyone in the laboratory
 would. I always get to a point where I'm grateful not to have to follow their
 rules. It takes time for an idea to generate something that may become a piece
 of work. So this process of long-term investigation has become a good way
 for me to progress. Gathering and documenting is a way of keeping going.
 The work itself is often two years behind my research.

RF Your work seems to look out to the world, rather than examine art history
 or sign systems. When you first started showing, that kind of conceptual
 investigation was rare in this country. What kind of reception did you
 encounter?

CB I'd say that most of my friends or artists I hung around with were also working
 like this. I suppose earlier on we used the language of conceptual art and
 minimalism more self consciously. Often I was dealing with complex issues
 with different ethical dimensions but I wanted the presentation to be simple,
 so I also borrowed from the formal language of minimalism or conceptual art,
 although the basis of the work was more politicised. People just went out and
 did things, either in public situations or site specifically. On the Environmental
 Art course, we had a project every year where you had to realise an ephemeral
 piece outside the art school. You had to negotiate how to do that and it became
 a modus operandi. You can't do that without getting engaged with people.
 We were all supporting each other and I suppose in that aspect it related to
 Damien Hirst's year at Goldsmiths and the shows they put on. It was self-
 generating, there was a real feeling that if someone was doing a show
 somewhere they'd ask if they could bring their friends and that generated the
 buzz around the Transmission Gallery where we were working. People became
 aware there were artists working in Glasgow and there was something worth
 making a trip for.

RF Reviewers tend to pigeon-hole your work as art versus science and this seems
 simplistic because you don't set up an either/or situation.

CB When doing a piece I usually try to make the processes obvious,
 demonstrations or talks will be part of the exhibition. I try to build in a sense

of the layers of complexity that I'm dealing with. It goes back to Belfast where, on this side of the water, I was used to the situation being presented as a rather crude divide but once you think about the actual people involved in day-to-day situations, the complexities get interesting.

RF But maybe that goes back to that early interest in feminism, about the personal being political?

CB Yes. It's just something that's always there. It's not that I'm gathering information or data and then I go back to the studio and make the two things are much more interconnected and overlapping. It's always important to me to be working with materials and often some surprising things will happen that might throw me. I can't bear to use the word 'intuitive', but the discoveries naturally feed back in and, somehow, always relate to the idea.

RF It must happen that objects don't function in the way that you think they might?

CB I've been using a room in my house, working on quite a small-scale investigation and then large-scale things come together in the exhibition space and surprise me. I can feel frustrated that I don't see the things until it's too late, so I'm building a studio at the moment. It's difficult to bring all the elements together and I often have to get things fabricated for me. But it's a regular problem; it's just something that you have to deal with.

RF Does the object need to be transformed?

CB There's a pragmatic aspect of working with private galleries. They like it if you make a piece of work that doesn't change into something else and can be for sale. One thing that's always been important to me is installing work myself and being at liberty to change the work. How it'll be described in terms of being an object that's part of a market is for somebody else to worry about. There are things that are impossible to realise completely within one piece of work, so I take either the material or the undeveloped aspects of the idea on with me to the next work.

RF *From Life*, where you traced the provenance of a skeleton sold for medical purposes, must have provided some ethical dilemmas?

CB Yes, that was really hard, but it's good to put yourself in these situations. It would be too easy to make critiques of science or medicine without implicating oneself.

RF Did you get criticism?

CB I don't know whether there's anything in print but certainly, when I did talks some people would be quite hostile. Within the work I reached a point where I didn't want to progress further with the reconstruction or the tracing to reach any definitive 'conclusion'. I knew that the circumstances were going to be tragic and that was enough. There was always a place to stop, creating my own ethical parameters; I made these decisions for myself. I think it was important to actually go ahead and purchase that skeleton because it put me right at the middle of those ethical questions.

RF As did *L'Homme Double* [1997], the piece where you commissioned six sculptors to make busts of the Nazi doctor Josef Mengele from very little information. What ideas were you exploring then?

CB I was researching the Münster sculpture project and 'found' these heads in the University's anatomy museum, within a teaching context. It didn't take much questioning to find out that the department had a dark history in eugenics and that during the war it had been one of the leading universities promoting 'racial hygiene'. Mengele's teacher had taught here, and there was lots of study material from the camps. I wanted to deal with the heads' provenance but, although they'd survived the bombing during the war, any records of where they'd come from, or why, had been lost. So I made the work, *The dead teach the living* [1997] where I recreated these heads in different materials.

RF So how did they feel about a Scottish artist investigating it?

CB Fine. It's typical of the situation in Germany now; they had someone at the University from the Philosophy Department whose fulltime job was to find ways to deal with the history of this university in relation to the war. They just hadn't got round to this. So when I said I was interested in trying to trace the identities of these nameless faces, it was seen as a positive way to deal with the situation. They were able to make facilities and researchers available to me who accumulated a mass of things, like medical records, to look through. But within this German situation I couldn't be as specific as I was with the Mengele piece. In Britain we've looked at years of war films and personalities like him are at the forefront of our consciousness yet occupying a territory between fact and fiction. Here it felt more relevant to deal with the idea. What interested me was to do with the façade presented. Mengele was constantly described as handsome, even by his victims. That desire to conjure the face of evil was something that fitted in with my ongoing concerns. I started off speaking to a

group of portrait sculptors and it grew from there. All I gave them was descriptions and a copy of a bad photograph of someone who might have been Mengele.

RF Can you just tell me a bit more about what you're working on at the moment?

CB I've moved away from thinking about the historical aspects of eugenics but a more contemporary interest in genetics has continued. The human genome project was happening and coincidentally I was pregnant myself and more forms of genetic testing have become possible. Now I've started getting involved with ideas in medical humanities, working with groups of medical students. My last show at the Lisson Gallery in London [*Simulated Patient*, 2004] looked at medical students involved in role-play with actors. It's part of their training, seeing how they deal with certain situations, and has a real performative element. Communication Studies is a huge issue within medical training and I feel as if there's an artist's point of view in there. Things that they're talking about, like the use of silence or of body language or eye contact, have been written about and discussed within critiques of contemporary performance art. I try to be the artist's eye within that discipline and explore it from an artist's perspective.

CHRISTINE BORLAND

***Bullet Proof Breath*, 2001**
Glass, spider's silk, steel
34 × 22 × 22cm

Image courtesy of the artist and Lisson Gallery, London

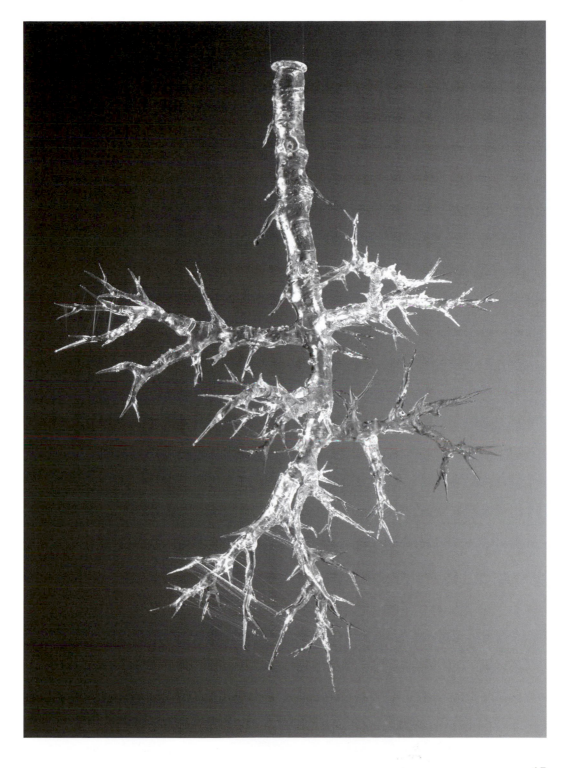

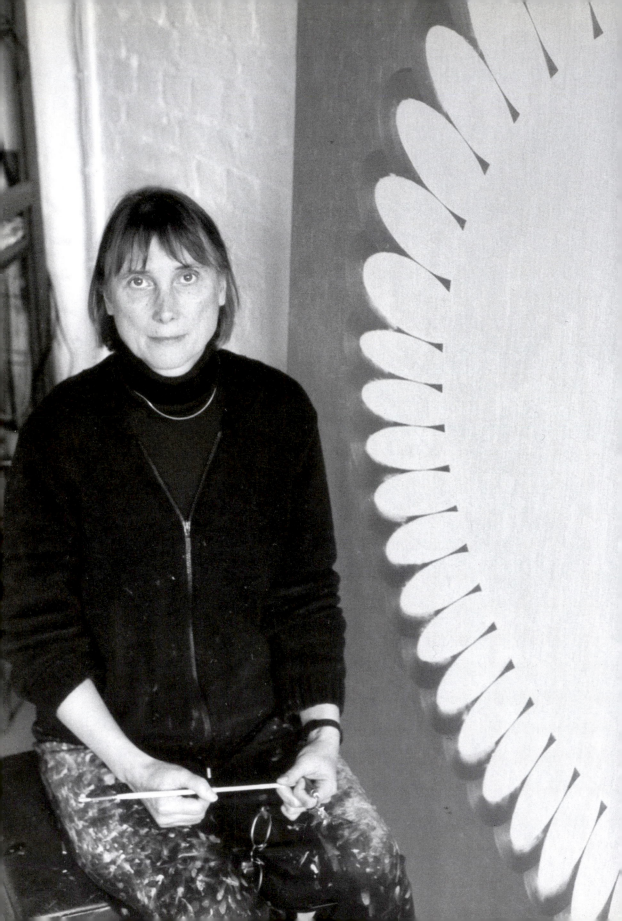

JANE HARRIS

For some years Jane Harris has made paintings and drawings that depict the shape of an ellipse with fluted edges. These works are constructed from many uniform brush marks in a way that disturbs the spatial reading of the painting. Sometimes the ellipse appears to be hovering on the surface of the canvas, but as the light changes it can also be experienced as an aperture.

RF You currently have a very precise, considered area of enquiry. How did that come about?

JH I started my BA at Camberwell College of Art (now part of University of the Arts, London), did a year there and didn't get on very well. You were slotted into areas of interest and I was in a very traditional, academic area; still life, life drawing/painting, based on the 'Euston Road' school of observational painting associated with the artist and art educator William Coldstream. Looking back it was useful because it was very rigorous and disciplined but at the time I felt it wasn't really where I wanted to be. I transferred to Brighton and finished my BA there and then I went to the Slade for my postgraduate. Going to the Slade School of Art [London University] was a little bit like going to Camberwell, and I came across Coldstream again. At that time I was making large-scale, abstract, formal works, using a combination of geometry and more painterly aspects. I was working within a tradition of painting and I wanted to be part of that. After the Slade I got a scholarship to travel to Japan to look at formal gardens. From that point the work became very specifically about the relationship between structure and ornamentation. The work that I made after my visit to Japan was to do with particular aspects of the containment of nature. I visited royal gardens and private gardens that had been made public from the sixteenth, seventeenth and eighteenth centuries and some more modern ones. They all work within certain rules. I learnt that there are two main types of gardens, which fascinated me; the walking around type and the sitting down type. In one you sit statically and contemplate and in the other you are guided around in a specific way, coming across viewing points. That's something that really connected to my work; you can sit in front of it and you can walk around it. I wanted those two things to combine, to gel.

RF Did the visit have an immediate impact on your work?

JH Yes. I took loads of photographs and made work whilst I was there, drawings and watercolour for information. I then got interested in formal gardens in the West, looking at differences and similarities, and spent a year in Paris where I had another scholarship to look at French classical gardens. A couple of years after that I went to Goldsmiths College [London University].

RF Did you come up against thinking there that you hadn't encountered at the Slade? A questioning of authority?

JH Absolutely, all the time. In fact, I wrote my essay on the 'anxiety of influence'.

RF But you kept painting. Did you feel you had to make an argument for it?

JH No, that wasn't an issue. I think there is a misapprehension that Goldsmiths doesn't support painting. Nobody questioned whether one should paint or not, the questions were within painting; 'What are you trying to define?' 'How does it relate to the other things that are around it?'

RF In the seventies and eighties some feminist critics suggested painting, because of its history, wasn't a suitable medium for women artists. Did you ever feel you had to respond to that attitude?

JH No, I never have. I do think that my work is very female but I've never tried to incorporate feminist issues in the work. The issue about whether as a woman one can paint has never bothered me. I suppose it's because I have a deep-rooted passion for painting. Another area I'm interested in is architecture. The fact that most architects are men wouldn't stop me wanting to make a building or design a garden.

RF There are certain rules in your work. When did they come about?

JH They came about during my time at Goldsmiths and they have been re-defined slightly, ever refined. I got the place at Goldsmiths because of some drawing of real objects. I covered paper with black charcoal and then rubbed them out so one got a white absence with a detailed edge of whatever I'd chosen to draw. You couldn't really tell what it was, apart from the intricacies of the edge. I then started making paintings that did a similar thing, getting involved in the detail of edging; what that did or didn't tell us. I had questions about whether decoration is an embellishment, something you add on or whether it's intrinsic

to the character of something. I made a painting that I needed to make an ellipse for. I wanted it to be like a mirror shape, very baroque, so I had to find out how to make an ellipse. I read about what to do and the equation I had to make. I read that it had two focal points and that struck me as being very interesting, because it has the possibility of being both two dimensional and three dimensional at the same time.

RF Did you like entering into that geometric world?

JH Yes – it's something that goes back to my childhood. I have always liked geometry, making patterns and filling them in. I liked the idea that the work is about something external and something internal. It's to do with perception but there is a structure underlying it that has rules.

RF Your work seems to go straight to the abstract/representational divide. How do you describe it?

JH That has always been a problem. I'm usually slotted into the abstract category and I've railed against that for quite some time. The problem is that there isn't really a term for it.

RF One of the things I admire is the way the paintings are so concise. They have so few elements, yet when you start thinking about them they raise all types of problems – the abstract/representation dilemma being one of them. Two dimensional/three dimensional, object/material, object/surface, it all starts unpacking.

JH That's what I hope to achieve. The rules are always the same, the limitations I give myself but within that the potential seems endless, the possibilities for variation.

RF I imagine you allowing yourself certain freedoms and then retracting from others. How do you judge the leeway you give yourself?

JH I'm quite a strict person but I also think the paintings are witty. I'll set myself these limitations and I could say for years, 'well I can't do that, that's not within my rules'. Then something unexpected happens and I think, 'I can do that now, why have I said no to it for three years?'.

RF Geoffrey Worsdale, writing about your drawing, pointed to the inability of the two ellipses to 'function as a plausible, singular and unified composition'. I feel you almost want to look at one with one eye and one with the other!

JH I had a painting in the John Moores [juried painting biennial in Liverpool] called *Coming on big* that had four ellipses, that is the most I have done. I do lots of drawings to work out which ones I want to make into a painting. The four ellipses were receding in size but the decoration around them was increasing in size so, overall, the size was exactly the same. It was a complex thing to do, but it was a very successful painting. I knew immediately I'd done it that it was good, which doesn't happen all the time. Afterwards I did a painting with three and then one with two. The two ellipse paintings seemed to me to be really interesting because of what you just said. They are ostensibly the same, one is repeated, but they occupy different spaces on the canvas, so however one much one tries to look at them as the same, they never are.

RF It was interesting that you described the paintings as referencing ornate mirrors. I see them as blank mirrors; referring you back to your (absent) self – quite a terrifying experience. It seems as though you are implicating the viewer, making them reflect on looking in a physical way.

JH Yes, that's exactly what I want to do. The viewer has to negotiate the responses you've talked about as well as the shifting around the work. It happens whether there's one form or two, but with two, if you are looking obliquely at the work, one form is going to appear slightly bigger than the other. There's a certain sort of discomfort with what you are looking at because you can't quite bring them back together to occupy the same plane. There is an optical and physical relationship that for some people is quite disturbing.

RF You must feel very ambivalent about having your work reproduced, it looks so different in different lights and spaces.

JH It's always a problem. At least when people see the real thing they get a lot more rather than less. It means your audience has to be quite persistent.

RF I remember listening to two successful artists in New York talking about how some artists make work for reproduction, work that looks sexy and shiny when scaled down in reproduction. Of course, others don't. Sigmar Polke's 'metaphysical' paintings are different in different climates, they're hard to reproduce faithfully.

JH Yes, he's a good example. I remember seeing works by him painted on both sides of perspex or glass so you got a completely different image from either side; they were moving all the time.

RF This seems to go against the notion of commodity, yet your paintings are beautiful objects.

JH Yes, that's another thing I've had to come to terms with – that it's all right to make beautiful work. Just the other day I came across a Gillian Ayres quote – Howard Hodgkin had said 'you mustn't make work that is just about beauty' and she had said 'why not?'

RF Pleasure is important?

JH Yes, certainly – they do need to be seductive.

RF You've talked in interviews about your work's relationship to the visual world. Why does your work need to have a relationship to what you see?

JH I think it goes back to these opposing forces that are within me and therefore within the work and that goes right back to the early student work. I've always had these two desires. One is the abstract, formal or geometric and the other is work from observation. I like work that's keenly observed and I wanted to marry those two interests for myself. I like looking at things. Often, if I'm stuck, I'll go out for a walk and whether I'm out locally or in the centre of London, something might strike me that's a key moment. The observation is often about colour, which generally comes from just seeing two colours.

RF So you hold that as a memory and use them with your next painting?

JH Yes, but it might not be the next one; it's like a memory bank of colours or I might write it down to remind myself. It's a moment of being outside oneself. My work is all about the relationship between one thing and another and the edge between them. I need to have some 'stuff' coming in, because one's imagination can be limited, it can become very circular. It could be something big like the sun against the sky or it could be minute, like the corner of a room. I like the fact you don't know where it's going to come from.

RF Going back to that word decoration – at a symposium recently the artist Vanessa Jackson said that she didn't see decoration as an 'add on' but rather as something 'intrinsic' as in a Corinthian column. The term 'decorative' is often used pejoratively. Although in some ways your paintings are quite austere, there is this decorative aspect to them; the fluted edges, the brushmark patterns.

JH There are many paradoxes in the work. The decoration is not just any old decoration, everything that goes round the ellipse is another ellipse. There is a sense of rules coming into play. For me the edging is more to do with giving a personality or character to the form to set them apart. On the one hand it is an embellishment of the edge (I prefer the term ornamentation to decoration) but it's there for an intrinsic purpose, it's not an afterthought. Everything in the painting is there simultaneously. From a purely pragmatic point of view I had to find a way of giving myself more edge to play with as I wanted to work with a certain amount of detail. These areas of positive and negative or presence and absence start to create strange discrepancies of scale. For example, in this painting [*Pine*, 1999] the blue looks as if it's in front but at the top it looks as if it's behind, so it gives it an extra dimension. I do lots of drawings and then I scale up versions of the drawings before going to canvas.

RF The same size as the painting?

JH Yes, it's like a cartoon. I've got familiar enough with that whole process to know that once it has gone to canvas, it's starting to do the things I like it to do. But sometimes the colours go very badly wrong.

RF You have different layers of colours underneath?

JH Yes, very rarely totally different because I start with the general idea and then I have to tune it up over the layers.

RF Is it tempting to leave a little edge as a trace of these layers?

JH There's a lot of temptation on the way but for me that would be decorative if I left those little edges that look lovely. I can't do that, however tempting that may be.

RF The last thing I want to ask you about is the titling of your work. It seems to me that reading the title will start all kinds of associations. The titles seem provocative, they're a challenge to the viewer's interpretation and they can make you laugh.

JH Rather like the colours being taken from the real world, I do a similar thing with titles, so I'm always writing down words that come to mind or come up on the radio. Titling is something I like to play with, even when there isn't a painting around. The titles, such as *Buff, Flip, Deuce* or *Come Come, Sky Dive, Holy Smoke*, might come from something I've heard or read or they might come from

particular paintings, the manufacturer's name for the paint often seems appropriate. I like using onomatopoeia in the titles – language is not only about sense. There are some titles that I'm really pleased with and others are more forgettable.

RF But the playfulness in them is important?

JH Yes, the titles are really important to the work. I haven't ever not titled.
It's really interesting to me how words operate in relation to the visual.
It's another pleasure.

HAYLEY NEWMAN

Hayley Newman works across the media of performance, video, text, photography and sound. Her events are characterised by their humour and, often, absurdity; for example *Smoke, Smoke, Smoke (a silent choral work for a smoking choir)* [1999]. Her work explores performativity and issues surrounding mediated experience.

RF How did you start making performances, how did you know you wanted to do it and how did you know you could do it?

HN At school I had a Saturday scholarship at the Guildhall School of Music in London where I studied singing – I always enjoyed the very practical aspects of learning to sing but I hated the theory side, until I discovered John Cage when I was 16. We had a tutor who sang a piece by John Cage and I remember sitting in the class weeping at the discovery of something that I really enjoyed and engaged with.

RF I would have thought that most 16-year-olds would be a bit baffled by Cage.

HN I think I was somewhat embarrassed by it because this woman, standing in front of four students, was going 'Ooehr, waahhe zyee ee …' but something deep inside me related to it enough to get over the embarrassment. From that point my interest in singing and classical music started to wane and my interest in making art and experimental music started to grow. I wanted to have a more autonomous relationship with being creative. Within the musical structure I couldn't do that, because I wasn't proficient enough to write music. I was probably a better interpreter and performer than a technician, so it was obvious I'd go into something where I could make decisions rather than following someone else's lead. I started making performance work derived from John Cage's chance theories. I'd paint a grid on the floor and then throw a dice and cut off items of clothing that related to numbers or something ridiculous like that, it was good fun.

RF How did that go down at art school? Performance tends to get marginalised, I think.

HN Yes, I marginalised myself because I didn't like the idea of being the school entertainer, so I'd also engage with performance through photography, video or writing, much the same as I would do now in fact. Occasionally, when I really needed to, or when I felt really driven, I would make a performance. You asked 'How did you know that you could do it?' That's quite an interesting question for performance because I don't know if 'can' or 'cannot' are terms that you should apply to performance. Performance isn't necessarily about developing a skills base.

RF I suppose I meant 'could' psychologically.

HN Imagining yourself into a position of doing it? In many ways what I've done has been limited by my imagination of it and my fear of it. Part of making work is trying not to have any fear, or to overcome fear; not just physical fear or putting your body through extremes. Maybe it's more about doing – the point at which you allow yourself to do something is very important. This, I think is the crux of a psychological approach.

RF What was it like to study with Marina Abramovic?

HN Well, before that I'd done a postgraduate at the Slade School of Fine Art (London University) with performance artist Stuart Brisley in the Media Department and he was great. I'd always wanted to go and live in Germany, since I was a child. I knew about the DAAD Scholarship and so I applied and got one. My choice to study with Marina was quite arbitrary at that time. I knew I wanted to go and study with a female performance artist, and really I chose by the city. It was at the beginning of Marina's teaching career, before she started to identify herself quite as solidly as a teacher and founded a class that was really, truly international. The class in Hamburg was a mix, it wasn't all acolytes, not everyone was in agreement with Marina. It was a very liberating structure for me, having been through education here, to go into a situation where I could use the class as a forum for trying things out. Marina was very open and incredibly practical about how to make and do performance. There would be lots of class discussions and Marina would show us really odd video works that had often only tangential relationships to performance, or we might all choose favourite segments from films and talk about them through performance. I think that Marina's made a successful transition between performance, as it was in the sixties and seventies, into something that might now be called post-performance or performativity. In Hamburg I came across Marina's piece *Biography* [first performed 1992] in a book. It's a performance in which she stages her life through a series of

photographs, and was a very important work for me. Then there was a piece by Paul McCarthy and Mike Kelly called *Fresh Acconci* [1995] where they got porn actors and actresses to restage Vito Acconci's work for video in this big mansion in Hollywood. The actors don't know the context of the Acconci work, so they're just delivering these texts as if they're scripts. Those were very formative pieces for me in that year. I was looking for something where performance wasn't, or couldn't be, as straightforward as an action. These were the first works I came across which began to discuss how the performance was framed.

RF You seem to be coming from a different place to Abramovic; the sense of the transcendent that seems so important in her work appears to be undermined in yours.

HN It's not entirely undermined by me. I'm still weird enough to believe that the world is mysterious. Most people that have engaged with performance in any way have had to deal with their egos and an underside of failure, of misunderstanding, of misrepresentation, and so are often generous to other people that are making it, understanding the slippages within the practice. When I was in Marina's class I already had a sense of independence. I've never had a problem saying no to people, because my drive to do things has always been stronger than my need to please people. I'm still in contact with her and I saw her in Italy this summer; we orbit each other.

RF Could you talk about the relationship between the 'real event' performance and 'fictional' performance? Your piece *Connotations – Performance Images 1994–8*, where you documented fictional performances, is presumably a filter through which people see your work now?

HN Yes, every time I do anything everyone goes 'Well, did you really do it?' I say 'Well, *Connotations* gives you the information that it's fictional'. I've always felt that work gets fictionalised – it rids itself of the stuff that isn't important after the event. I just inverted it and made the fiction the first thing, rather than being something that you orchestrate in post-production. It came from observing the relationship between the experience of making performance and what is then seen. When you give your friend the camera and they take a photograph, there's a big gap between the experience of seeing yourself in an image doing a performance and the experience of being the performer.

RF Yes, the document becomes the audience's experience of the work. How has *Connotations* affected work that you've done since, are you re-thinking those ideas of fiction?

HN It was never about a binary relationship between fiction and reality; it was more complicated. It was made as a critical analysis of performance, by including stuff that was expressive; through fictional writing and aesthetic images.

RF What about the notion of documentation?

HN I might use the term 'mediated imagery' rather than document and I'm still working around ideas of representation. I'm interested in it as a living event rather than something that's about an archive. I think about mediation in terms of a temporal experience and the ways in which we collect and consume information.

RF One of the things that also came out of *Connotations* was the relationship between text and image. The text felt quite dominant and seemed to override what you were looking at.

HN Yes, I'm interested in that. I'm doing this project at the moment which has got the working title *Rubbernecking*. The basic premise for it is that I'm doing a series of trips to places that are reported in the news. I'm interested in the problem of representation and how you, as a person, relate to that information, how it affects you. For example, my publication, *The Shanghai Week*, shows the news article and a photograph, and then there's a text explaining how I went to these places in Shanghai, but there's no information about the experiences that I had on that trip. I'm trying to look at how experience gets represented and I've been looking at travel journalism a lot. I'm interested in a way of looking that's actually very blunt and unsophisticated, so I'm using a term like 'rubbernecking' to moot an idea about how one might intentionally engage with an event in a one-dimensional way.

RF Is it also musing on ideas of authenticity?

HN It's about an embodiment of space between the point at which you're reading about something and the event itself. It's almost like you're reading at home and then you get up and embody that distance between yourself and what you are reading about. It's not only about notions authenticity, but obviously that's part of it .

RF I just wondered whether it was about 'seeing for yourself', trying to make a mental engagement physical?

HN Yes, people do that – I've booked in to go on a literary tour of Oxford next week! It's this idea that fiction has some sort of physical manifestation and it often does, as it's written over real places and experiences. They're ways in which cities present themselves; aspects of an identity of a place that you use as a way in which to envisage that place.

RF What does it feel like when you perform? You have talked about your discomfort as a performer.

HN What does it actually feel like? Fucking horrible! Embarrassing, alienating, abject! There are different structures through which you perform. I've done a lot of very singular body-based sound works that are short, maybe four minutes long, so that's different to the experience of one of these journeys from my home to a site in the *Rubbernecking* project. In the more conventional sense of an experience of performing, where the relationship between you and the audience is relatively fixed, the experience can be anything from complete elation to absolute devastation. You can completely lose a sense of yourself or you can become incredibly aware of yourself. There isn't a single thing that you could talk about in terms of experience, just as you couldn't talk about a single kind of performance. I'm very interested in how experience informs judgement within a performance. That idea of experience then goes back to the idea of craft and becomes the way in which you shape things. I think the idea of craft acknowledges that whatever you do is seen within an historical context. You acquire a physical memory of a performance, a mental picture of it, an emotional relationship with it, all of which have quite a complicated set of relations. It should be acknowledged that you learn through doing. When a student makes a performance for the first time and it's absolutely fantastic, they often then make another one and it's absolutely shite. The not knowing is what's so fascinating, them not knowing what they're dealing with, what they're handling, how they're doing it. It pushes them forward and makes a fantastic open-ended moment. But how do you sustain that? It's very complicated.

RF 'Not knowing' can create audience discomfort and embarrassment.

HN Embarrassment isn't something I'd set out to create but it's not something I'm afraid of. Sometimes you watch people and there's a level of awareness that's incredibly embarrassing.

RF Have you set things up with different types of audience?

HN A few years ago I'd have been more interested in the relationship between performer and audience of the kind that you're talking about. Most performers have experience of different types of audience: live audience, audience as witness, as performer, as reader etc.

RF What about other strategies, such as the relationship between improvised and planned aspects. How has that developed?

HN Again your language takes it back to a more conventional sense of performance but I'm trying to open that up to a wider way of making work. I think that improvisation is quite a difficult term but it acknowledges how the audience might be able to change the performance, not by making a direct physical intervention but just by the feeling of them as a group of people. When you work with other people it changes the direction of the work and the kind of thing you might produce and I'm interested in that.

RF Lastly, can I ask you about your PhD?

HN When I started doing my practice-based PhD at The University of Leeds, I was told: 'It's great a PhD, you don't have to do any writing at all', so that's the reason I went. I saw it as a scholarship to make work. Then halfway through we were informed that we had to write fifteen thousand words, so I had to learn how to write! I set about trying to generate text and started to do things like write for the length of time that it took to smoke a cigarette or write postcards from different locations. There were all these different ways of writing; one is called *Translation of the Sensation of the Left Hand into the Right*, where I've got my left hand in this pat of butter and my right hand's writing about the left hand in the butter and then there's another one called *Kiss Exam* where I'm kissing this boy, up against a wall, and I'm writing a report at the same time. My PhD talked about textuality and performativity and the ways in which I'd approached writing. It was in the form of a self-interview which, like the photo series *Connotations*, referred back to an idea of a 'live' moment.

RF There seems a range of opinion regarding creative and theoretical writing for practice-based PhDs.

HN I wouldn't say I wrote a theoretical PhD but I would say that theoretical ideas were embodied within it. My question would be, 'Can't creative practice be theoretical?'.

Crying Glasses (An Aid to Melancholia), 1995
On public transport in Hamburg, Berlin, Rostock, London and Guildford
Photo: Christina Lamb

Over a year I wore the crying glasses while travelling on public transport in all the cities I visited. The glasses functioned using a pump system which, hidden inside my jacket, allowed me to pump water up out of the glasses and produce a trickle of tears down my cheeks. The glasses were conceived as a tool to enable the representation of feelings in public spaces. Over the months of wearing the glasses they became an external mechanism which enabled the manifestation of internal and unidentifiable emotions.

HAYLEY NEWMAN

Crying Glasses (An aid to Melancholia) **from the photographic series "Connotations – Performance Images, 1994–1998", 1998**

Black & white photographic print,
40.2 × 50.2cm

Photo: Casey Orr
Image courtesy the artist and Matt's Gallery, London

MARIA LALIĆ

Maria Lalić makes paintings that explore colour and paint.
She works in systematic series over a number of years, examining a
particular aspect of her materials. For example, her *History* paintings
[1995–2004] layer semi-transparent colour, using the pigments
available in different eras to produce a series of 53 monochromes.

RF What it is about colour that fascinates and sustains you?

ML The first paintings I ever made were white. I was terrified of colour and at the
same time deeply fascinated by it. It seemed such a huge subject. I was most
familiar with it used aesthetically and I felt very uncomfortable with that. I was
trying to think about what its function was, how to use it and what it meant to
me. At the time I used white in a process way, so colour didn't really have a
function. Then I started making paintings where I just used colour straight
from the tube – I knew of Josef Albers' paintings and I was fascinated by
Homage to the Square. He was absolutely factual about colour, but then would
allow some of its resonant qualities to affect him; a poetic capturing of the
space that he revealed in the supplementary title, for example, *Homage to the
Square – Silent Hall.*

RF And you couldn't have the poetic without the structure, the material?

ML I knew I wanted to find something that had an underlying rigour that
would allow me room to play. That particular summer I'd been listening to
Beethoven, to the *Diabelli Variations* and I thought 'oh, this is wonderful!'.
He took a given, Diabellis 16-part waltz, and composed 33 variations around
it. In each the basic structure is retrievable but they are all stunningly different.
I thought I could set one kind of palette to work, a parameter within which
there's all this room for invention. I started 'playing' with colour that summer.

RF At that time you were thinking about it as paint rather than as colour?

ML Yes, as material with colour being one of its properties. It became obvious that
I should start using metals and colours that were derived from metal. I was

influenced by Eva Hesse, Robert Ryman, Carl Andre, Brice Marden – as a student I'd seen a succession of wonderful solo exhibitions of them all at the Whitechapel Gallery (London). I was trying to look at colour as a reality, as a material fact. Initially I made a number of three-part paintings that used a central panel of metal: lead, iron, copper, zinc, chrome and aluminium. Each metal was flanked by two of the colours derived from it. I felt I'd just tapped this seam that was very rich. I started those in about 1989 and I'm still working through all the permutations.

RF Some people wouldn't want to anatomise the thing that they were drawn towards.

ML It is a huge subject – I mean that's why I was frightened of it, because I could be lost in it. I needed to find my own way in. I realised I looked at material in a particular way, which might be to do with growing up in a heavily industrial area of South Yorkshire; mining, steel and glassworks. The processes fascinated me. When I realised that was my way in, it gave me a tremendous amount of freedom. I began to see that if I put the lead colours with lead, you can't help but feel there's something about those colours that belong with lead – there's a weight to them. Lead has seductive qualities as a material and is quite different to looking at colours that derive from copper. If I put zinc white next to a white that comes from lead, they're very subtly different. Then if you start to do it with things like greens and yellows, they stretch the possibility of what green can be. There are so few words to describe a very particular colour and it seemed to me you have to see it, feel it, to know it. That's what I liked about it.

RF I think it's very interesting that the work is a visual enquiry through conceptual means. You've made a decision to put two colours together for reasons that are inaccessible visually, but perhaps they are not if you really look. Do you think that some people look harder or better than others?

ML If you look at the colours that were available to someone in the cave era, say, I wondered how they saw, because they had so few colours available. There are four coloured pigments from that period and they're so resonant with what that life was situated around – fire and earth, carbon black from fire, and from the earth, yellow, red and chalk. It says so much about a particular culture and civilisation, then you think of the Egyptians adding to it, expanding this palette with colour derived from precious and semi-precious minerals. And so on through Greek and Italian inventions to the eighteenth, nineteenth and twentieth centuries. I think I'm simply excited by recognising a time and place through colour.

RF My four year old said to me, 'Why are there so many colours in the world?'.
 He'd begun to realise that he doesn't have words for all the colours he's seeing.

ML Yes. I'd also think of a kind of colour which I didn't grow up with; the colour
 through television and computers, the colour of light, virtual colour, a whole
 other palette.

RF Is research an important part of your work?

ML When I started the *History Paintings* in 1996 I was aware that it was going to be
 an extensive project. It needed conceptual honing, technical resolution and a
 lot of historical research. Initially I made two complete ways of starting it
 before I got to the one that was successful. Initially, say I was making a
 'twentieth century painting', I started by painting all 18 colours that belong to
 that era in incredibly thin lines, almost like cotton, from the top to the bottom
 of a canvas. I kept repeating them so eventually the colours disappeared into a
 blue grey, or pink grey or whatever. Although intellectually it answered
 everything I was looking for, viscerally it did nothing, it felt very light. For me
 painting has to have a visceral pull, because I think unless you are engaged
 with it in this way, you're not going to go beyond that. The next thing I did was
 to layer all 18 colours but in a very thick, slab like way, but what that meant
 was that at the end, all that was left was the final colour. It was too heavy and
 didn't have enough of that sense of its making or of one colour affecting
 another. I didn't want them to just be an illustration of an idea, so eventually
 I came round to working with glazes. If you look at the edge of the *History
 Paintings* or through the surface, you can track a little bit of how the painting
 was made, but essentially you are looking at a monochrome. That really
 seemed to me to get the balance right; it's first and foremost a visual experience
 of a single colour and then the other things are there, if you want to
 interrogate it further.

RF Do you think there's a tension between the structure, the concept and what it
 materially is?

ML I think there can be. I can get the balance wrong to begin with because my
 mind is absorbed with the research I've been doing and when I start painting
 it's too dominant. The *History Paintings* were an eight year project, though I had
 no idea of this at the start, and the first thing I did was to get original pigments
 to work with. I wasn't sure about their stability. I spoke to a lot of people, the
 chemists at Winsor & Newton, read my Max Doerner again and again and
 many other textbooks on pigments. In the *Egyptian Paintings*, had I used real

Orpiment, a sulphide of arsenic, it might have turned successive glazes black. I thought then, this is not an academic study, it's an idea, and so I used contemporary equivalents for those that were less than stable.

When I started the *History Paintings* I also started the *Landscape Paintings*. Since I first started painting I'd been fascinated by eponymous names of oil paints Naples Yellow, Raw Sienna, Burnt Umber. They work on me like the name *Nineveh* in Masefield's poem *Cargoes* did as a child, they take me off to wonderful places. I knew some Umbrian paints were from Tuscany but also that a lot don't necessarily relate to the place. I made a number of attempts to 'find' the paintings I wanted to make then, but it's only in the last couple of years that I've really made sense of this particular ambition, conceptually, technically and viscerally.

RF Why is it so crucial that the paint is stable for you?

ML I have made, and continue to make, oxidised copper and steel paintings where I deliberately set off the oxidisation process. They're changing over years and it's an intrinsic part of what I'm doing. But if I'm making a painting about colour, where I've made the raw material into paint, I don't want it to change significantly.

RF You didn't want the painting to look like you'd used earth to make it?

ML I didn't want it to be untransformed; I want it to be both a material and a colour. I was thinking about the development of landscape as a genre in art and how quickly it moved away from painting – of Michelle Stuart and Walter de Maria bringing earth into a gallery space – and I really wanted to connect with the line through painting. In particular, non-figurative landscape painting in the twentieth century; from Agnes Martin and what she called her 'anti-nature' paintings and Brice Marden's *Grove Group* series. I wanted to make reference to the longer history of landscape painting as well. One of the paintings uses the colour Delft blue. I was thinking of Vermeer's *View of Delft* in The Hague. My painting is the same size as the Vermeer. It's horizontally divided in two; the top half is painted with the manufactured paint Delft blue and the bottom half with paint that I've made from earth I collected in Delft. It's titled *Delft Blue Landscape Painting, 2004* and in brackets underneath, *A View of Delft, Vermeer, 1660*.

RF You're referring to painting but you had to go to the site as well.

ML I did. So far all the sites have been within the EU but import restrictions outside the EU will mean my finding a different way to access some earths. I think, in the back of my mind, this idea has been going on for a long time. How do I experience landscape? It's not a clinical study but I'm trying to think about my relationship to landscape now. I'm off to Suffolk in a couple of weeks to get some earth from near Flatford Mill and that will be the *English Green* painting.

RF In a series that's going to last a long time, is there a difficulty in keeping it alive for you, or with subtle differences coming into play?

ML There isn't at all. I would only start such a project it if I felt completely committed to it and felt I'd resolved any logistical or technical questions. The artist Roman Opalka built in subtle changes by the addition of 1per cent white to each successive work in his *Detail…* series but, as in those paintings, I think it would be very hard for anyone to detect any significant differences in the series over time. I remember a gallery saying a painting I was sending wasn't new but to me the date of its making is incidental. The *History Paintings* could all be dated 1996 because that's when the idea was generated. Or they could be dated at the point at which they are actually shown publicly because that's when they become another kind of reality.

RF You've mentioned Agnes Martin, Eva Hesse, Ryman and Andre and about taking up the baton in terms of landscape. Do you feel that your work is part of a larger enquiry, that you have a conversation going with other artists?

ML Definitely. I think it would be very difficult to work without that reference. A lot of the work I respond to, and have always responded to, is of a particular kind so it's not surprising that I'm trying to make things that develop within that. If I look at some of the ways in which other people group my work I'm sometimes surprised, and then there's the pleasure in sensing someone else's way of looking at it. Once it's left the studio though, the work has to fend for itself wherever it is. All my concern and attention has happened in the studio during its making.

JANANNE AL-ANI

Jananne Al-Ani uses photography and film to reflect upon the politics of representation and issues around 'the gaze'. Her films are installed to physically engage the audience, using multiple monitors, large-scale projections and sound. Much of her work includes her family speaking poetical narratives that operate on both personal and global levels.

RF I wondered if you could tell me a bit about coming to film and video via painting and photography?

JA As an undergraduate I remember being interested in the idea of a complex narrative within a single painted image. Often it was moralistic, making reference to human, communal relations and political narratives. I wasn't making aesthetic choices, it was more about drama. When I was younger we would visit from Iraq every three or four years and mum took us to places like the Tate and the National Gallery. There is a painting of Lady Jane Grey about to be executed [Paul Delaroche, 1833] and she's on her knees, with the executioner standing behind her. There was just something about the drama of it that appealed. I guess it was like a photographic, decisive moment, just before she has her head chopped off. Of course, I look at it now and realise it's not a great painting.

RF I know, but there is something about it.

JA It was about the detail in the folds of the fabric. For me there was a fascination with the way that paint can create an illusion of texture or space – as well as all the drama. Here were female characters who on one hand were victims but who also had strange powers over the male characters in these narratives. So I thought great, I'm going to be a painter! In my first term at the Byam Shaw School of Art in London, I worked in the life drawing studio. I also started modelling at the Royal Academy because I thought everybody who worked from the nude should also experience modelling naked. At Byam Shaw, although there were more women students in the Life Room than men, the models were always female. It felt so archaic, it really put me off. Gradually

I stopped painting and by the time I graduated I was making photographic installations. I was against the idea of art being consumed as a commodity and that was one of the reasons why I started making big, complex installations. I thought that if you removed the desire in the audience to possess the art work, then maybe the viewer could have a more intimate and 'pure' relationship with the work. In retrospect, my thinking was naïve but you have to remember that this was a time when museums and collections would have considered it a ridiculous proposition to buy an installation.

RF Yes, a time when there were some leftover ideals about anti-commodity art, before we realised that everything could be bought and sold!

JA I was working with the human body, creating life-size photographic images. I did a piece that looked at archetypes of feminine beauty in the history of painting, working with images like Botticelli's *Venus* and *The Three Graces* and sandwiching these images with pictures that I'd taken of shop fronts. I used a Boucher painting, with nice fleshy buttocks, superimposed with a gory butcher's shop window.

RF Did you see it as feminist work?

JA Yes, in an instinctive way. We set up a women's group at college and employed a feminist art historian, Roxanne Permar, to do a lecture series on women artists. I suppose it came out of Griselda Pollock and Roszika Parker's *Old Mistresses*, [1981]; we were looking for information and going out and finding it for ourselves. It's interesting, because in my recent teaching experience I've been surprised to notice young women beginning to talk about the body and the representation of the female body in advertising and art again. I think the new fashion for cosmetic surgery has made young women look again at the way their bodies are represented. In the eighties there was still a lot of discussion amongst women artists about whether it was acceptable to use the image of the female body. The same debate is happening now with the work I've done on the veil. Actually, I don't think that it's now possible to use the veil as an object in a photograph. It has become loaded in such a narrow and specific way by its association with Fundamentalist Islam.

RF But you have made work about the veil.

JA Throughout my MA this interest in the way women's bodies are represented continued. When the first Gulf War broke out I was taken aback. I realised that the only way the West understands the rest of the world is through

documentary and TV. Here was a situation that had been outrageously misrepresented and I knew this because I understood the complexity of politics in the Middle East. It made me look much more critically at photography and documentary and I started working with appropriated images from the press. That got me looking more specifically at the orientalist tradition in Western photography. So that's when I started looking at the veil, because I was looking at the history of European photography and the development of photography in the Middle East in parallel with European colonialism.

RF You have talked about how the photographer's gaze and the gaze of the veiled woman collide.

JA Yes, that was a revelation. Malek Alloula's book [*The Colonial Harem*, 1985] looks at photographs produced in Algeria in the early twentieth century. He drew a parallel between the gaze of the veiled woman and the gaze of the photographer as a privileged gaze. He compared the eye of the veiled woman to the lens of the camera, able to scrutinise everything before it. And this in a period when the photographer would literally cloak himself in order to focus the lens. I thought it was an interesting analogy for the challenge that a veiled woman presents and why for many it's such an unnerving and often infuriating encounter. I don't think it's because they're thinking 'You poor, oppressed woman, I want to liberate you'; they're thinking 'You can see me and I can't see you' and that power imbalance is extraordinary.

RF When you're used to being able to see, you notice when you can't.

JA Yes, it's the colonial privilege to see everything. I made a film of a woman who's brushing her hair over her face [*Untitled*, 2002]. For me it's also about the veil but we don't see it literally represented. It's more about that encounter, when you're seeing the subject of a work of art who is resisting our gaze and preserving her identity – you never get to see who she is. It's a more oblique way of thinking about it.

RF Your work mixes the formal and the everyday and I wondered what role you felt aesthetics had in your work?

JA It is important, there needs to be seduction on a formal level. It's a way to tempt your viewer in. If anything, I think the work may sometimes be too severe formally, too pared down.

RF But it seems to be more than merely seducing the viewer into looking; aesthetic pleasure and emotional longing seem intertwined.

JA I hadn't really thought of it like that, although that's often my experience in looking at artworks. I know that whenever I go and visit my mum, I always get out the family photographs and it doesn't matter how many times I've seen them, each time they have the same charge for me, it doesn't diminish. What I'm interested in is how you can share that preoccupation with someone who doesn't have any connection to the people represented. I remember going to the conference around the show Val Williams curated at the Barbican [Art Gallery, London 1994], *Who's looking at the family?* Joachim Schmidt was talking about his collection of other people's photographs. He would advertise for people to send him photographs and then arrange them into groups or archives and re-present them. It's what archaeologists do – they find the evidence and then try to piece it together and tell you something about the lives these people led. For him it's nothing to do with the individuals in the photographs. I try to find some route by which people can enter the work, so cutting out specifics is actually quite important. I could sit down and tell you the exact narrative of my parents' meeting, it's a great story, but it's not the content of my work.

RF One of the things that makes much of the work so visually compelling is that the portraiture is strong, the faces are so interesting to look at.

JA That is something I'm interested in playing on. In all families characteristics come and go as you look across the generations. It's also about the individual in relation to the collective and the idea of tribalism. I've just come back from Switzerland where they speak French, German, Italian or Romansh. How can you have such a tiny country of only six million people, where if you go an hour on a train from here to there people can't understand each other? Apparently Switzerland used to be made up of little groups and tribes, that were completely autonomous. I'm not sure why Europeans don't seem to understand the tribal Middle East. People talk about tribalism in Iraq as if it's mediaeval. Coming from a large extended family, I think the natural intimacy in the family group is also part of the seduction of the work. It certainly is for me. If I travel halfway across the world for an exhibition of my work it can be very comforting to find my mum and sisters there, chatting away.

RF One of your strategies is that sequences and fragments have to be made sense of by the viewer.

JA It's about trying to make the viewer more active in relation to the work. In *The Visit* [Tate, 2005] you have to negotiate the space to get anything out of the two works. You have to keep moving backwards and forwards. If you want to hear what's going on in *Muse* you have to move away from the *Echo* because the sound is bleeding across. There are two sets of life-size portraits I did of five women in various stages of veiling/unveiling [*Untitled I & II*, 1996]. The works are hung so that they are facing each other; the audience passes in between the two photographs. So the women are not looking out at you the viewer, it's as if they are looking at their own reflection in a mirror and the viewer interrupts this. And it's not possible to see both images at once without turning back and forth. It's an obvious strategy in a way but its effect can be quite subtle.

RF And you've got to find some way of dealing with those different experiences?

JA Yes, so for example *A Loving Man*, [1999] and *She Said*, [2000] both have monitors built into a relatively small, circular structure. I've watched people interact with the work; some watch the work from the periphery, preferring to stand at the entrance to the work Others stand right in the middle and keep moving round and round. When there are more than two or three people in the space, they have to negotiate each other as well as the work and that can become quite uncomfortable. So the relationships people have towards each other in the space forms part of the experience of viewing the work.

RF Maria Walsh discussed the film-maker Antonioni in relation to your work and I wondered whether you were consciously influenced by cinema?

JA No, I didn't make *The Visit* with any reference to film; it's more about the photographic moment, though I must admit I do like films where not much happens and it's very slow, which is kind of working against film. One of the things I'm very interested in is the idea of compressing time and space. We all understand the conventions of cinema; you cut from this to that and we know that ten years have passed. In a way I'm more interested in the audience's experience of watching film rather than what's going on in the film itself. You know, this idea of total abandonment and absorption and this absolute passivity. The contrast between that and watching live theatrical performance is really interesting. For me, when I go to see live performance I'm totally on the edge of my seat; I'm worried for the actors, I'm worried for the people who've designed the set or the sound that something will go wrong, somebody's going to forget their lines, somebody's going to trip over. There's always that potential for disaster in live performance. When I'm filming there's no rehearsal, even when I filmed those shots of the man pacing in the desert [*Muse*, 2005]. I used each take we shot, even when things went wrong.

RF You have said your performers are amateurs, does that bring an everyday quality to the work?

JA Well, I want to lull the audience into a false sense of security so you are floating along with the fantasy of it for a bit and suddenly it collapses. It's almost like pulling the rug from underneath you. Watching the news drives me crazy because of the way it's so carefully edited. Each narrative is perfect, with a beginning, a middle and an end, when what you're talking about, say, the war in Iraq, is complex, never-ending and chaotic. I want to disrupt the comfort that the viewer has in watching anything that's been stitched together by an artist or film-maker.

RF So, when you set a process in motion, you want to have some kind of spontaneity?

JA Yes, and sometimes it doesn't work. Sometimes I'll set something up and we film and it's just not interesting. For example, where it works in *A Loving Man* is where the seriousness of what's being discussed is disrupted. One person will say something with such emotion and strength of feeling, then the next person says exactly the same thing and it's as if they're reading a recipe, there's no emotion at all, so it undermines the first performance. So, did the first woman really mean it or was she just a brilliant actress?

RF In that work I thought about the notion of being spoken 'for' that you can have in families, where you anticipate someone else's needs. Within a global perspective it's the idea of the West speaking for others. Maybe there's always an element, even if you're caring for your sister, that if you speak for her perhaps you're dominating her in some way. There's a reference to the different and shifting power relationships and struggles within families.

JA Yes, in some ways the works are more like documentary than they are like film. The idea that you make a space for everyone to have their say can always be patronising because it depends on who's chosen to speak, what questions they've been presented with and what happens in the edit; none of us knows how these things have been put together.

RF Why did you start putting yourself in your work?

JA In the photographic work, it took a while for me to include myself in the early portraits. I was originally just photographing the other members of the family as a personal document and it wasn't until later that I decided to include the

portraits in a piece of work. I then started looking at photography more critically and it was at that point that it felt more important to include myself, partly because I didn't feel comfortable being behind the camera directing other people. It felt more democratic or honest to put myself in that position too. Then, when the work started to become more about the relationships and narratives between the family, it was even more important to be included.

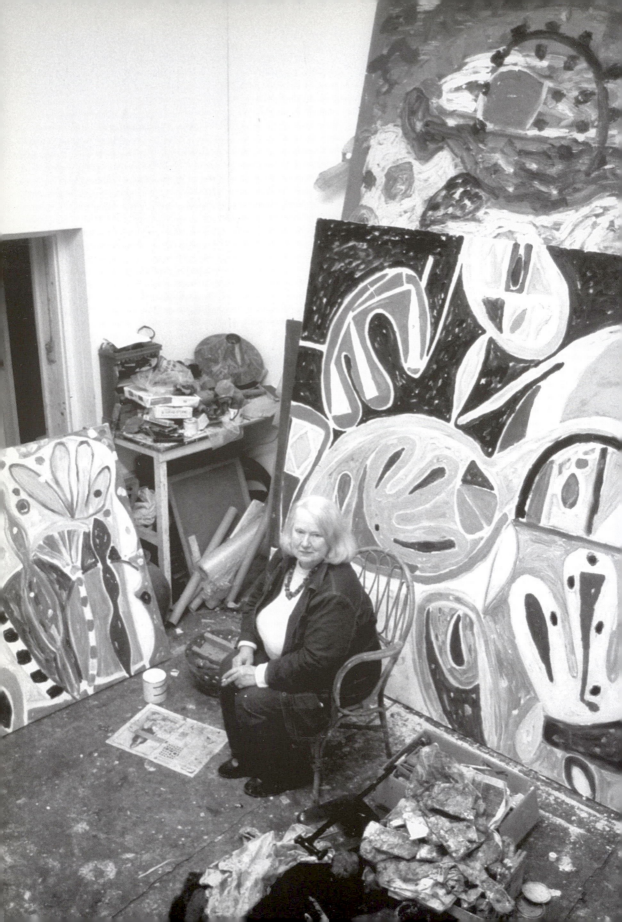

GILLIAN AYRES

Gillian Ayres makes large-scale paintings, using vigorous, expressionist mark making. She became known for works that used poured paint techniques and her work has taken various forms since, always remaining essentially abstract. Bright and multiple colours characterise her later work that includes energetically inscribed symbols and shapes.

RF One of the things you've said about painting is that it's a marvellously silent medium.

GA Well it is! I think there's a visual language. God knows how you describe red, or green or blue. We see it. In the seventies they used to scream against formalism, and it probably led to conceptual art. I think there's a language of visual form that is of its time. You can always date it. We experience it as a minor poetry. I think there are artistic truths that hit something of the moment when they are made. In the thirties, with someone like Mondrian, you would see his influence in a tube poster. I think it feeds down and we recognise it. I believe in it so much, I probably don't really accept anti-modernism, but maybe you can say it's a generational thing, like the formalist attacks in the seventies. Whatever it is, it must still be out there for me, the experience of vision.

RF And it has something universal in it?

GA Well, one thing about modernism past or present is that it has made us understand a lot of cultures. If you were born in the Renaissance you'd probably only look at your own culture. There might be a culture we don't respond to, but I think we can probably take anything now, and that is something it opened up. Picasso looked at African art before anthropologists and think of Van Gogh and Japanese art. We can see other cultures, so we can respond visually to them now. You might get more out of somebody else's culture than your own. I think we've got this enormous inheritance, it's fantastic really. It's not a burden. It's completely marvellous.

RF Roger Hilton, when writing about visual artists, separated intelligence from theory. Do you think that's a useful distinction?

GA Roger Hilton said something like 'the buggers are born, not made!', I rather like that. The trouble is there can be judgements on other intelligences. Again, rather like literature, people can feel happy with 'university' intelligence. Turner was an intelligent man who picked up on Goethe's colour theory, but whether people would have trusted him in a donnish, university sense, I don't know.

RF You have said you don't like looking back – is painting always in the present?

GA No, I don't know why I said that, because you can use anything creatively. You can look back if you find it useful. But when you are painting it has to be in the present.

RF You're occupied with the problem in front of you?

GA You are trying to get somewhere and do something. You can call that a problem but it's many things. You can call it a struggle or unpleasant. You could say that it's wonderful that you can do what you want to. Whatever angle one sees it from, you certainly don't want to keep doing the same thing, you're always pushing something somewhere.

RF Has your attitude to painting changed over the years?

GA There are a few people that I've always liked. I find very early loves remain. There is constancy in what one responds to. I think I respond to what is considered painterly painting and colour.

RF What about in your own work? Do you feel you're involved in a different enterprise than when you started out?

GA Yes of course! And you can't repeat five years ago, you're just not the same person. I feel very unconfident about my work, always. I don't know whether one should admit this. I can even have a day and feel it's rather good, then I go back the next morning and think 'Oh shit!'.

RF Is there work that you've done in the past that you feel closer to now?

GA Funnily enough, the dealers came a fortnight ago and I got out those late fifties paintings, about five of them, and they are big paintings. There weren't many people working like that in this country then. I quite like them when I look back at them. With that MOMART fire I thought that one had been burnt and I was very glad that it hadn't. I seem to care about them but it may be because I've kept them around for so long. I feel they're all right but no, I wouldn't do them tomorrow.

RF You've talked about there being certain threads that follow through the work.

GA Yes, rather sloppy rhythms, it's probably like handwriting.

RF But the work you made in the sixties was quite different.

GA I got myself in an uptight state with those, because they had rules. They were tonally equal, although they had space in them. Actually, I hate perspective. It's an enemy to painting, mostly, but these painting had perspective. They had a terrible discipline, they had to be flat and they could have different marks within the acrylic. They were quite laborious. At the Tate sixties show [*Art and the 60s*, Tate Britain, 2004], I noticed they were a bit like the work of those New Generation sculptors. They're very of that time.

RF I think they're of now too. What is the surface like on them?

GA They're acrylic and they had to be perfect areas and took about five coats of paint. The forms came from different things, like strange jelly moulds. They have this perspective but at the same time I still wanted them to read across. And then they got very dark, some of them are almost black. They've got a 'humming' thing about them, they are bloody odd things. They came out of the teaching I was doing at Corsham at Bath Academy of Art (now Bath Spa University). I was put in charge of the Foundation and I thought , 'Oh Christ, they'd better draw!'. I set up still lives at the end of the room and started drawing these ribbons down these still lives. Then I suddenly broke into a dotted line and they got looser.

RF Did you think you wanted to change your process?

GA I began to feel that I'd got myself into a corner; they were very disciplined.

RF Is there a relationship to landscape in your work, as your titles suggest?

GA No. People think that, but it's not true. The titling is always done afterwards and the paintings are never anything to do with the titles, really. I know it's terribly misleading. When you don't paint an object, people really can't believe this and so they relate it to the history of painting and influences. I suppose for a very long time, probably since I was about 25, I've been asking 'what is painting?'. One of the answers is 'filling up an area with marks'. I realised that an Old Master was like this; made up of the relation of marks within an area. When I came to my house called 'Tall Trees', somebody said they could see the trees in the work. When I lived in Wales, then everybody saw this bloody slope that was outside the house. At the same time you can certainly be affected by whether it's a sunny day or a January day. But I never have a desire to do it literally, it's not the way I start a painting. I did a print that looked like a sunset and the flipping thing sold out. I used to walk up a lot of Welsh mountains and when you walk up a mountain clouds come in below you. I used to rather love this – to see the world like painting. On a foggy morning it's almost like a Chinese landscape. What happened with a vast landscape when you stood on top of a mountain was almost like pouring paint.

RF What does abstract mean to you? Does it mean abstracted from something?

GA I think even the St. Ives group tended to abstract, probably from nature. There's a painting by Peter Lanyon in the Tate [*Porthleven*, 1951] with a little church on the top, that one notices. In the sixties Bernard Cohen, Robin Denny and people like that said 'We're abstract, we're not like St. Ives'. I was the same age as them and felt that somewhere that was happening. Recently I was interviewed for the *Independent* and the journalist started off, 'Why don't you paint the figure?' I said, ' Well actually, I've never been interested in people'. You were made to draw from life four days a week for four years at Camberwell Art School [in London]. You were meant to draw like Raphael, to have that at your fingertips. Deep down I didn't want to do it, it just wasn't there for me.

RF But there is some recognisable imagery?

GA The stars and moons, yes. You can see that shape as a bloody great hill and what happens at a sunset. But it wasn't – I simply poured paint.

RF So you weren't making a conscious move to introduce images?

GA Not at all, quite the opposite. When I painted in India they really didn't understand the word abstract. They were very happy if you talked about symbolism. Funnily enough, a lot of Americans step fairly easily into an abstraction, but most people can't. I think it's a problem in people's minds, maybe culture, I don't know. But not only do I believe in abstraction, I hope it will happen tomorrow. If I don't do it, I hope somebody else does it because I want to see it. I believe that painting can go on in this way and hope for a new experience all the time.

RF Your work has been called optimistic, maybe because of the palette you use. Do you see it like that?

GA I can't work unless I've got tremendous energy. After the heart attack I couldn't work for six months, that's very rare in my life. I summon up this energy that I chuck into the bloody thing. It might be based on a sort of optimism because I believe in the possibility of things. I might be disillusioned. I can't work on more than one at the same time, it sort of splits my brain. I can think that one is all right, leave it and then completely repaint it a month later.

RF In the early days you worked very quickly. Is that the way that you work still?

GA They were on the floor and I literally chucked buckets of paint. I used to go and have a cup of coffee, come back and the whole puddle had moved, I liked that. I would see what the painting did and then change it, hacking back into it with handfuls of paint and I still do that. But with those big ones there was an enormous energy. I used to use a ladder just like an arm. I never thought about it, I just flew up and down it.

RF I was going to ask you about colour.

GA I think it's everything. Colour is light and light is colour. You can't have non-colour by the way, that I'm sure of. At Camberwell they taught tone and I've never forgotten it. They used to make you close your eyes and see a tone, but I think it is intensity that is important. You see intensity of colour when one colour comes up to another, for example, yellow comes up to black, whereas tonally it's the opposite. So I think about intensity because that's the way you read a shape. I like the accessibility of tons of colour. I even buy paint just for colour, I love it quite childishly! I think you can open a tin and feel utterly delighted. You can muck it up and it looks horrible and it's so exciting! You can open a blue and it's lovely.

RF You've painted with your hands – what other implements have you used?

GA Well, in the studio there's a big selection of brushes. I take a handful of paint and put it on. It seems too lengthy a process to fill in with a hog-hair brush. I decide what to use when I'm doing it, like tearing a corner off a box to use as a big palette knife simply because that's what you want at that moment. It's the same with which brush you pick up, there's no planning. The planning is in the accessibility to a lot of colours and the size of canvas you stretch up.

RF What is the relationship between the work on paper and the canvases?

GA I use acrylics on paper. There's a speed to paper, they dry quickly. When I was ill I did tons of things on paper on the kitchen table. There can be a sort of similarity between works on paper and the canvases, but never blowing up. There can be reasons for making work on paper, like on a holiday. I used to do these ones in the seventies with my children. I'd get up at six in the morning and do them in the kitchen. This still goes on, if I go and stay somewhere. I'll very likely just do things on paper, it's just practical. I call them drawings by the way, but I know it's not what other people call drawings. I've argued for years that it's all mark making. But it's not what people mean by drawing. They mean a Holbein or Raphael drawing.

RF Do you feel you have more in common with European or American art?

GA I don't care where it happens as long as it happens. One always looks outside for what one wanted. Of course there is Bonnard and Matisse and, after the war when Britain felt cut off, the Americans kept painting alive. Tim [Hilton] once wrote that I was like a Russian artist and I rather liked that. Although I'm not in the least bit Russian, I've always thought the world of those early Russian women abstractionists. In fact, I called a painting, *In Goncharova's Garden* recently, as a sort of homage. Frank Stella bought one of my paintings and I asked him what was going on with younger artists. He said, 'Well you know, if I can't be totally uplifted, I enjoy little bits quite a lot'. Maybe one can sift through a lot of things on that level.

RF Do you feel successful?

GA There is an ambition to do something wonderful but I don't know that you ever feel that you've done something wonderful. Success is not a thing measured with shows. I suppose what we want money for is to be able paint and get the right balance of what we want in life. I wouldn't know what to do

with tons of money. The older one gets, the less one can be bothered with things that are beside the point. There's one of my paintings in Birmingham City Art Gallery and when they made a video about it they said they had to put a barrier round it because children ran towards it to touch it. I felt terribly pleased at that. Is that success?

TRACEY EMIN

Tracey Emin makes work using autobiographical subject matter.
Textiles, performances, installations, happenings, sculptures,
drawings, monoprints, videos, paintings and neon light pieces
are all used to explore her confessional material. Much of her work
contains text and she has written her autobiography, as well as a
newspaper column.

RF Does your work ever surprise you?

TE My writing surprises me. Sometimes when I'm writing I write a sentence that
makes me laugh and I didn't know that I was going to write it, it's kind of an
automatic stream of consciousness. I have a real belly laugh because I just
wasn't expecting it. My work is quite a slow process and there are no surprises,
but sometimes there will be some alchemy or some magic working and that's
always a surprise, whoever you are or whatever you're doing. I did a drawing a
couple of weeks ago which really shocked me and I loved it – it was almost as
if I hadn't made it.

RF How did that happen?

TE I did the drawing, it was a monoprint, and when I turned it over it was really
scary to look at. It was really frightening. It looked quite malevolent and
strange. I was doing drawings for my show in New York but I kept this one,
I liked it too much. I want to own it; I want to frame it and put it up in my
house and I haven't got any of my work up in my house. So it's kind of weird
that I want it but it was like someone else had made it.

RF So do you usually map out where a work is going?

TE No, not really because even with the large blankets, they can be quite organic.
You know when you're doing an oil painting, you put the paint on and scrape
it off. Doing a blanket is similar to that. You can put loads of patches down
and think that's it and then you suddenly change your mind and change them
all over again. You sew them all down and then pick them all off and put them

back on again; it's really like doing a painting. Sometimes I write a poem and then want to make a blanket of that poem and other times the blanket is leading what the words are, because I've only got this amount of room for fixing it in.

RF Which do you like the best?

TE The poem one is more of a graphic process and the other one is an organic process.

RF You can't get any change into the neon works, presumably?

TE Yes, it has to be right. And I've got favourite neons, mainly because of what they say. Not everything warrants being made in neon. It has to be specific. Some things work on a blanket and they'd never work in neon. Some things work as a title for a drawing but they'd never work in neon. There is the odd thing that works brilliantly all the way across the board but that's quite rare. So, for example, you might have a thing like 'Super Drunk Bitch' or 'Stupid Drunk Bitch', it wouldn't work in neon but in a blanket it works good because it goes across the top. 'Kiss me, kiss me, cover my body in love' works really brilliantly in neon because of the Ks. On a blanket it wouldn't work so well because it would look like it was dropping off the blanket. And also neon is light, so, can you live with this thing glowing and the chemicals moving all the time?

RF So it's partly a visual thing and partly to do with meaning? You have said you would like to have some work back that you'd sold.

TE No. The stuff the Tate bought last year, some of that I've had for twelve years and I wouldn't sell it. I let the Tate buy it because I still feel that it's mine, it belongs to the nation and that means it belongs partly to me. But there are some things which collectors have that I would really like to get back because a) I wish I hadn't sold them but I was broke and needed money or b) there's a couple of things which I know I could make much better.

RF And does that mean you will make them again?

TE No – when the tent [*Everyone I have ever slept with, 1963–95*] burnt, everyone asked me if I was going to make another one; how could I? The thing about the tent in 1995, it was just a woman who nobody knew or cared about, making a record of part of her life which a lot of people do, consciously or

subconsciously, except that I was the first person to do it in that way and that's what made a difference. Had I been able to make my tent again after the fire, I'd have got about a million quid for it. But I couldn't make the tent again. I did it for the time when it interested me. At the time it was like carving out gravestones. It nearly killed me doing it and it was so sweet, the tent, it was about the way I made it in my flat, the moment, the history of it all and now it wouldn't interest me like that.

RF I was going to ask you about that labour of making; it's always seemed like an act of devotion.

TE Well, I don't make it all myself; I have people helping me sew. But I've always had friends who help me sew. I had friends who would come round to my little council flat and we'd sit there sewing in the afternoon and I'd make dinner for everyone, or tea.

RF And was it important that you were in there doing it?

TE Well, yes. There's nothing that's sewn without me saying it's got to be sewn like this. I do the cutting, I do all the laying out. The things that I've sewn feel different for me. But my sewing's got really bad, it's gone really mad. So sometimes I need things to be sewn really neatly, like some of my sewing is really tiny, tiny stitches and I just can't do that any more. I think it's because I had an eye operation, I used to be able to sew really close. But if you sewed one blanket on your own, it would take between six and eight months.

RF You've called yourself a bad painter.

TE I don't think I'm that bad a painter. I think I lost confidence after the Royal College. After the Royal College I just hated painting. I had an abortion and I think when I was pregnant the smell of oil paint made me feel really ill. If you're pregnant, oil paint – cadmium yellow – whoa, get away from it! It's quite a good reaction to have. But it was after I was pregnant that I stopped, got rid of all my paintings and got rid of everything. I would actually like to do painting again but in London it's too difficult. Oil paint's a really slow process and trying to find the head space and the time is difficult but I've got a painting studio round the corner, just for painting and drawing, nothing else. I paint there but it might take me two years to finish a painting.

RF But you've still got something that you want to paint?

TE I enjoy painting. After the Royal College, I remember my drawings had some longevity; whereas the paintings would be my student work, the drawings could still hold up now. A drawing is like handwriting. It's what I've always done. A lot of artists don't draw. They might draw for a working drawing but they never draw for drawing's sake. And they might have done drawing to learn to draw, to do life-drawing, but they don't draw. People still can't understand that the drawing is the finished work of art.

RF It's been hard for commentators to explore your work without equating it with your person, but in that Rudi Fuchs's essay for your recent show [*When I think about sex*, White Cube, 2005] he seems to go some way towards separating the two when he says, 'It cannot be just the content that makes Emin's art so intriguing, it must be the form and physical pointers'.

TE Yes, he put me into some historic context which other people haven't bothered doing. He's an art historian, he's like the balls behind art history in Europe so he's got quite a strong say on things and it's wound a lot of people up, his essay, as well. Rudi actually has got quite a good overview of things.

RF One criticism that's been levelled at you is that to be critical of your work would to be critical of you.

TE I don't mind people talking about what I'm wearing in the fashion pages or in a gossip column but in an art review it winds me up because they wouldn't do it with a bloke and that's for sure. My work works on lots of different levels and what I give, initially, is the most simplistic view possible to everybody. My work is a pyramid, a hierarchy. I'm talking right from the bottom, from the base going up to the top. People who are in prison, who've had no education, can understand it, to Nick Serota [Director of Tate] who's right at the top. You haven't got to be some intellectual, highbrow art genius to understand what a fucked-up bed is and what it represents and what it looks like. These people who don't get it, that's all that they see it as.

RF In the Carl Freedman interview [1995], you said you used to think it was important how things look but realised it was more important how a thing's made.

TE No, how things *are*. It's like the essence of where they're coming from. If I want to make a million pounds today I can. I can set up a factory with felt stamps, stamping out letters and everything, and I can get 20 women in here, paying them two quid an hour, and I can knock up ten blankets by the end of

this month for £150 grand each, no trouble! Dead, dead soul. They'd all look good, they'd all look nice. I've got countless people waiting around the world for them but I just don't feel like making them. I can make loads of things that look good but that's not what it's about. It's about how I feel about it and where it's coming from; the reason for me to make it in the first place. Like for my show in New York [*I can feel your smile*, Lehmann Maupin, 2005] I had white blankets half done, and I just said 'Fuck this!' and then did these really ethereal drawings, five of them. I just didn't want to make blankets, I didn't want to make heavy things.

RF Your recent London show used white and felt light.

TE Yes, but it was heavier than most of my shows, in content. But that's what's good about not using colour – I can put much more content inside it and get away with it. I can make it more sentimental; I can make it more corny; I can make it more violent; I can make it more tragic; I can make it more aggressive, more emotional. But if it was in colour, it would be so in your face!

RF How do you feel your work has changed?

TE This goes back to the 'me' in my work thing again. I've changed; I've changed a lot. I nearly didn't do my show at White Cube, because I felt that I'd really changed but my work hadn't changed as much as I had. I was in a really bad mood about it. When I left the Royal College of Art, I felt that my work hadn't caught up with me and I kept saying 'I want to make grown-up work!'. I feel I've just made a massive leap with my work and I think people will talk about 'before' and 'after' this year.

RF What are the differences?

TE Well, I live in a Huguenot house that was built in 1729 and it's very difficult for me to have my own art in my house, but a lot of the recent work I could have in my house. It's like coming to terms with what you can live with; we all fuck up; we all do things wrong, we've all made big mistakes but we have to live with them and come to terms with ourselves, so I see it a bit like that. It's like being able to get up in the day and live with myself instead of wishing I was dead or wishing I was somewhere else.

RF So do you think there's calmness now?

TE No, not really. I think it's still raging but it's not in bright pink or turquoise blue. It's easier to deal with, for other people especially. It's not like I think that what I've done is bad.

RF But you go through different stages and you have to commit to each stage?

TE Yes.

RF Is there a difference for you between work you make (like drawings and blankets) and work you re-create such as *My Bed,* [1998-99]?

TE When I first saw the bed for what it was and framed it in my mind, I mentally took it out of the bedroom and put it into a white space. I showed it in Japan, New York and the Tate Gallery and the Tate I enjoyed. I didn't enjoy doing it in New York, I loved doing it in Japan. At the Tate, after those Chinese guys had jumped all over it and that stupid woman had sprayed air freshener all over it, I was really upset because I had to do it all again and that wasn't part of the deal. The deal was that I had to install it once. The first time I'd enjoyed doing it, the second time I was crying because I didn't **want** to have to do my bed again. It was quite emotionally horrendous for me because that is my bed, the stuff on it is real and I was having to go through it all again, live through it all again.

RF So installing it is like making it?

TE I had to go back to where I came from, to get it right. At the Saatchi Gallery when the condoms disintegrated, I saw Charles Saatchi and we had this discussion about what I should do about it. He said, 'Couldn't you get any more?' and I said 'Certainly not, where the fuck am I going to get them from?' They were real condoms, from the time, full of spunk, covered in blood or whatever. They can't be remade. He was pretty good about the bed. He knew there would be disintegration and we said we'd cross that bridge when we came to it. Because there might come a time with the bed, when it gets shown again in ten years' time when I say well actually, you know, I think we should recreate the condoms or I wouldn't use real condoms. When he had it at his and Nigella's house it was fucking brilliant; it was in the living room surrounded by great big Persian rugs and all this silver and it just looked so baroque, it looked crazy, it looked amazing actually! I was totally surprised because I always saw it in a white space. He'd done it pretty accurately, it was quite good but I won't let any art installers or people do it. But when you think about it, it's real blood, it's real shit, it's real dirty knickers and that's what

made it so incredible, to bring this bit of terrible life into theirs yes, it's interesting.

RF Early on your work seemed subversive in a museum context, this slice of real life, real pain, real experience.

TE Yes, but that's wrong. I didn't say here is a slice of my life; I said this is an artwork that I've made that is now going into the gallery.

RF No, I meant that that kind of experience wasn't represented.

TE Listen, you had Van Gogh, Edward Munch, Egon Schiele, you had lots of people, and you had Magritte.

RF Blokes.

TE But they were using quite female emotions and that's why it was expressionism. They were expressing emotion. That hadn't been done before because it would have been seen as being too namby-pamby but they stepped over that line and used emotion, which is a female trait. That's why I like those male artists because they didn't care if they looked like cissies by saying, 'I was jealous' or whatever; they were open to those kind of things and there are lots of women as well, it's not a new thing.

RF But for a lot of young women today, when they see your work for the first time, it's the first time they see themselves represented in that context.

TE Yes, but that is because I didn't have a discourse behind it that was about Marxist theory in the twenty-first century. I said this is me. When I went on *Question Time*, I went on not representing some political party or a trade union or whatever, but representing the person who has an opinion about the world which we are all entitled to, whether it's wrong or right. So that's what makes a difference I suppose. It's like abortion, for example; there are so many opinions about abortion but not that many by people who have had them.

RF Do you see your work in the media as part of your work as an artist?

TE Sort of. It's communication and for me being an artist is about communication, so it works quite well for me. It's really good when you get letters from people who have never actually seen your art but they've read something in the paper; they're in prison, or they're ill or they're old or they live in Cumbria or

Cornwall or something. I always say that for every one bad word about me I have a hundred people that decide they like my art or what I stand for really.

RF Matthew Collings has said, 'She is a performer, not a maker'.

TE That's the side of me that Matthew likes best. I've done performances with him and he is a performer, as well as an art historian, so that's what he relates to in what I do. I used to do performances and readings but I don't do stuff like that any more because it is too exhausting for me. Also, when no one knows who you are, you can give a lot more on a genuine level but now I can't. I used to always be mucking around, I had a hat with my name on, for example, that I used to wear. It said 'Emin'. Well, I can't wear a hat saying Emin now because everyone knows who I am; it would look weird. So that's a metaphor for it.

RF You're one of the few visual artists that has managed to negotiate the media on your own terms.

TE Yes, well people in PR know that I don't have a PR person; I don't need it. I don't have PR, I don't have marketing, I don't have anything. What I do just has a natural snowball effect.

RF What authors do you read?

TE At the moment I'm reading an American short story writer called Richard Ford because someone sent it to me because they said if you like Raymond Carver, you'll like this and they were smack on; they're right. My favourite book is *Madame Bovary*.

RF What do you like about *Madame Bovary?*

TE I think it's a really good book to read to work out how you shouldn't be in life and the pitfalls of ambition and also it's heartbreaking. *Wuthering Heights* I read, which I really love. Books I like are where you jump into the book and go 'NO, NO, YOU STUPID IDIOT, NO!' and you get hold of the character, grab them and give them a really hard going over. I'm reading Robbie Burns's poetry at the moment; he's so beautiful; really, really amazing.

RF What kinds of decisions do you make when you are writing?

TE I write a column for the *The Independent* so I'm going to give you an example. 'It's about time', I would never put 'It is about time'. 'It's about time' because that's how I speak and that's how it flows. And the worst thing that can happen to me is that an editor puts 'It is about time'. On one piece I did for the *Independent*, my usual editor was away and someone else did it and I just screamed. I said 'If you want some fucking debutante from the fucking home counties to write your fucking column, go and get a fucking debutante from the fucking home counties, don't ask me to do it'. Because the person who edited it got rid of a lot of the swearing and there was a paragraph where I put 'I think' about 20 times and it was a joke which you got later on and the idiot edited it to 'I suppose', 'Generally thinking', changed it all. I went mad; I went ballistic. To me it's much better that I'm grammatically wrong to get my voice across. The other thing is that I'm learning to spell, so for things that are going to be read by the public, I get the spellings corrected. Before, I would have said just leave them as they are, but when you've just written a 60 thousand word book you can't have 40 spelling mistakes on a page because it will do people's heads in.

RF Do you think your visual work will be able to stand after you are gone?

TE I used to say that my work won't be half as good when I'm dead. But now I sort of think it will be all right.

RF And your writing?

TE My writing is my art. Instead of having a show at some big museum I've written a book [*Strangeland*, 2005].

RF Are you pleased with it?

TE Yes.

RF How long did it take you to do it?

TE 25 years.

LUCY GUNNING

Lucy Gunning is an artist who works across media. Early video work such as *Climbing round My Room* [1993] where the artist navigated her room without touching the floor, established an interest in the negotiation between imagined and physical states. Her work is always installed site-specifically and most recently this has included several elements within a space.

RF You sometimes seem more interested in the process of making art than the final product. You have said, 'time creates an end point and then you rise to the challenge'. Does it always work like that?

LG Well, I work quite organically, starting off with a film or something else. It tends to be something that unfolds and often I don't know where I'm going to end up. For example, the show *Esc*, at Matt's Gallery in London [2004], I had a sense of what I wanted but I didn't know the specifics of it – I had to find them.

RF So where does the idea originate from?

LG It's hard to pin down. It might come from things I'm reading or I might pick up on things that were around in a previous piece of work. One of the things that helps me structure the work is working with the exhibition space. It's an intuitive way of working, a bringing together of the real things that are around me, the architecture of the space. I might start filming something and then take it back to the space and have a look at it there. In *Esc* one of the elements I wanted was people practising the ancient Chinese exercise system of *qi gong*. I wanted to film a particular exercise, the exercise of the deer. I guess that was picking up on a relationship with animals and mimicry in earlier work. I also had a sense that I wanted the work to be about a kind of elsewhere or escape, something to do with being physically somewhere and mentally somewhere else. I knew the exercise very well and I attempted to film it about three times and it just wasn't working. There were always too many people at the class and it was just inappropriate. In the end I went for an intensive weekend in Ireland, to be on the course myself but also to film it. I'd asked people in advance if I

could film them but they were so self-conscious it wasn't going to work. By which time I had become just as interested in an exercise where people shake for extended periods of time. I was really taken with it and wondered if it could fulfil that part of the work for me. One morning I asked the instructor if I could film but didn't ask the participants – I asked them afterwards if I could use it. They didn't know I was filming because I started off doing the exercise, went out of the room halfway through, got my camera, came back in and no one noticed.

RF Your films often depict something physical, where a person becomes aware of their body or moves through that awareness into a different relationship to their body. What is it about that that fascinates you?

LG I'm interested in performativity in lots of ways. The earlier work was staged and focussed upon certain tasks that I or other people were doing, whereas it has become more about behaviour, the everyday and the architectural space. The relationship between the physical and mental is important. For example, in the piece *Malcolm, Lloyd, Angela, Norman, Jane* [1997], the participants all had some kind of aberration in their speech. It was the relationship between the physical act of speaking, what the brain wanted the body to say, and the anarchic refusal on the part of the body to say it. But with *Intermediate II* [Tate Britain, 2001] it's the physicality of the dancers, the relationship between them and the building that they're in. I've filmed them from the street, looking up at a second floor set of windows. There's something about the ephemeral nature of their gestures in relation to the hard-edged, modernist architecture that they're in. There is something fleeting about them and a sense that they are occupying another space or world. They look within that space to a teacher who is out of view or to other people in that space that you, as the viewer, cannot see. It's an enclosed world that we are not party to.

RF And within each dancer there's also a sense of containment or concentration. With that piece the viewer is very aware that you are outside the experience, that you can't see in and there's a barrier in the way. The pleasure of being in control of your body is ruptured, or there's some kind of problem with it.

LG Yes, and the film is only part of that piece of work. You watch it while you're outside this big crate

RF And then you go inside and feel really uncomfortable because it's a ballet studio and you can see yourself from every angle! I wanted to imagine myself as a ballerina but was confronted with my real self in the mirrors. Often there's an allusion to a romantic sense of an imaginary in the work, an otherness.

LG Yes. I am interested in where the imaginary meets the real.

RF Paula Smithard has written about the social aspect of these activities, particularly in relation to the football piece [*The Footballers*, 1997]. Although the participants in a ballet class or *qi gong* session are inwardly centred, they come together to do it.

LG With *qi gong*, it's done together because it creates a stronger energy field. In that Matt's Gallery show I brought together three very different sub-cultures and I was interested in the relationships between them. There's also the aspect of the viewer's physicality while they are watching. In the film of the drunken city workers at Liverpool Street Station in London, the viewer goes under and up inside this box; they're looking up at a monitor at a film of people who are looking up at a notice board. There's a disorientation, they're in a box where the bottom half of them is exposed to the rest of the gallery and they are aware that it's cardboard so that they can't really lean on it. There's a mirroring of what is happening on the video. Some people found it very funny. Some people found it made them feel sick. People had quite a strong reaction to it. When there were a lot of people in the gallery, people gathered in front of the monitors or were scattered throughout the space in a way reminiscent of Liverpool Street Station, where you get people standing around in groups. I filmed the drunken businessmen in suits at a moment when they're coming from a very internalised state to realising that they've got to negotiate their way home. I juxtaposed that with the video of people living in tree huts. These people have attempted to find a different way of living, outside bureaucracy and power structures. I set that video centrally in the space, to act as the landscape that the drunks and the people practising *qi gong* are in. I've kept information about these people to a minimum. I edited the soundtrack so that you couldn't hear them talking or the eco-warrior drumming. I guess I've idealised it a bit. I wanted it to have an imaginary aspect, if an apocalyptic one; that people had to retreat to some alternative way of living because, maybe, the whole symbolic order had collapsed and everybody gravitated towards the trees. That was a potential reading.

RF It seems like the ethics of dealing with other people are not unconsidered in the work.

LG Yes, I'd say they are very important. I suppose I set myself certain rules that come out through a situation. For example, when I was filming the drunken men at Liverpool Street Station there were certain things that I knew were overstepping the mark. If somebody saw me filming I immediately took the

camera off them. I was filming a state where they were unaware of their surroundings and what was happening to them. I had a lot of questions for myself in relation to filming it. Obviously I was being voyeuristic but I had a huge amount of empathy with these people. Perhaps filming the *qi gong* practitioners was more voyeuristic in a way, because they were in a private space, whereas these businessmen were in a public space. In a sense the *qi gong* practitioners were more vulnerable. With the tree huts it was different again because these people were used to having media coverage about their protest but I knew people didn't want their faces filmed. I guess with every single thing that I film there are always limits and they're always different, so it's about finding out what they are and questioning my own moral standpoint or the ethics of the situation. I'm always asking myself why, or how does this look, or is this exploitative. I guess usually there's some reason why I want to film something and it's usually because of my own experience of that activity.

RF A lot of your work seems to be about negotiating the kinds of passions that one has as a child – horses, ballet – that attach physicality to the imaginary.

LG Probably most artists use their formative experiences and I think that the physicality of growing up is something that has informed the work. I think in the early work I was identifying something that was to do with my own personal experience and I think latterly the work has perhaps become more social, more anthropological, but that personal investigation is still there. In a way, the work's become more complex. I'm more interested in the relationships between things now. It might be the relationship between the space, the viewer, the videos, the view out the window. It will be so many things.

RF For me the particular sensibility that the work often evokes is that of a female child. The red dress in *Climbing Round My Room* [1993] was important, wasn't it?

LG Yes, when I first started working with video after maybe the first six or seven pieces, I remember people saying, 'Do you only film women?' I was dealing with my experience and I think that's still there in different ways. Now it's more to do with how something is done perhaps rather than what it depicts. I think I do take up a position, an implicit questioning, that's probably gendered.

RF I feel an intimacy in the work, as if you are letting your audience into your mind. Ruth Jones writes about the idea of 'becoming' in your work. This is not a notion of personal fulfilment but about how you might act within the world, and she relates it to animals.

LG I am interested in animals and the sort of possibilities that they give us. I think the whole idea of 'becoming' provides possibilities for the imagination or a different kind of intelligence. I think there's something profound about this kind of primal connection. The impetus for me filming the *qi gong* exercise with the deer was from finding out about shape shifting, where people wilfully try and take on the shape or form of another living thing. It's usually an animal, sometimes it might be a tree, and it involves a ritual or rite of passage to make the transformation. The deer, both in art and religious history, is symbolic of a relationship between this world and other worlds. My position in relation to these ideas is one of interest and questioning. I never jump wholeheartedly in, by nature I'm sceptical but at the same time I'm absolutely fascinated and curious.

RF It puts me in mind of *The Secret History* by Donna Tartt. Your work's poetic has been described as 'a dislocated moment' within an 'everydayness'. Audiences have described your work as hesitant, anxious and uncertain, and, for me, there's a real lightness of touch. Is it difficult to know when something is substantial enough?

LG It's hard for me to answer that because in many ways it's an intuitive thing about listening to something and finding its pitch. I spend hours editing. I do it till I'm sick of it. It's always a relief to get back into the space and have the moving image become a monitor, something that sits in the space. It earths it and allows it to be more ephemeral or more tentative.

RF You have described using the hand-held camera as being like drawing.

LG The hand-held camera is a way of being able to deal with the moment – the spontaneity of filming as a response to something.

RF But you've got to physically do it yourself? You're not going to direct?

LG I did get someone to do some filming for me but I didn't like it. For the show that I had at Spike Island, the exhibition and studio space in Bristol, I filmed *Quarry* [2003] in this man's bed-sit. It was sort of giddy because it was all hand-held and we were passing rocks and objects across his room. It's a small space and there's a lot of movement in it. I know that a number of people did have problems with that. I want things to be very raw. When things aren't finished, as in slick and polished, it does something psychologically important. It leaves room for potential, it's a space for the viewer. Filming is an extension of me. I think I would find it really hard to hand it over to someone else. I'm

fascinated by the film director Werner Herzog and his relationship with his cameraman. It must be fantastic if you do find someone that you can work with that closely, but I think, at the moment anyway, it's important that I do the filming. It comes back to physicality again, another form of choreography.

RF The difficulty of watching choreography is that you might have to see a performance two or three times before you can get a total sense of it.

LG Which, I think, is why I've gravitated towards using lots of different elements. There is something about defying a single reading of something, just pulling the rug out from underneath something by juxtaposing it with something else, or changing the height it's shown at or where it's shown in relation to the window or something painted on the wall. Nowadays I rarely make a single, terminal work, but if I do it still has specific installation requirements; the work doesn't stop with the monitor frame, the monitor is part of the work, as is where and how it's placed. The way I orchestrate something is a physical experience of being in a space and going from one thing to another or looking at the juxtapositions and bouncing things off one another. That has become a really important part of the work.

***Tail*, 2002, Photograph**
51 × 61cm

Image courtesy the artist and Matt's Gallery, London

JEMIMA STEHLI

Jemima Stehli makes photographic works that deliberate around theories of the gaze. Often using herself as her subject, she questions the notion that the female nude can only be viewed passively and explores the role of the artist in making such a depiction.

RF You've become known for making work that deals with the objectification of the female body, ostensibly drawing on your own narcissistic impulses whilst evoking gender power relations. How did you start making the work you've become known for?

JS I was trying to work out how to make experience my subject, in relation to already formed languages. I was using the domestic and thinking about all the things that I touch. I started by using the things around me, which was about taking charge and understanding my immediate circumstances. I made a piece called *Black Still Life* [1997] that I showed in a shop window. It was a group of objects and furniture on black carpet. I wanted to make something that was formal, (I was thinking about Ad Rheinhart's black paintings), but that also felt personal. All the pieces were cast and polished resin in different shades of black, so they were like paintings, and when they were behind glass you also saw the different layers of reflection. People responded well to it, but I felt they were just seeing it formally. I became frustrated by the fact that I was thinking so much about the labour and process of turning something ordinary into something that's aestheticised, but that my intentions for the meaning seemed to be invisible, and were only talked about in these formal terms. I had made a piece called *Pink Shoes* [1996] at a point of exhaustion of making and to emphasise my presence as the artist. I took a photograph of me lying face down on the studio floor, naked but wearing pink shoes. Initially I was planning to make a cast of my body in resin and polish it, but when I looked at the photograph I realised it was already doing all the things I was thinking about. I started to think about the problem of subjectivity and to use the body as a site for it.

RF Did that feel like a revolutionary moment?

JS Yes, it was really liberating. After that I made *Wearing shoes chosen by the curator* [1997]. It came out of a suggestion by the curator that he choose the shoes. It was meant as a joke but I decided to take him up on it and implicate him in the meaning of the work. I was also working on the show at *City Racing*, an artists-run space in London, and that's when I remade Allen Jones's furniture sculptures as photos using myself. These were a conscious remake of *Black Still Life*, but focusing on all the things that I felt were left out when people looked at that work, like the sexuality. I thought about the connection between the black patent leather shoes and the polished surface of the resin casts. In making myself into the furniture I was making the artist the art object.

RF Everything that I've read about your work describes it as rigorous or formal. I started to wonder whether that's a counter-balance for the self-expression or narcissism or …

JS Sexuality? Yes – I use the structuring to contain it. That's why the work is about the studio, even when it's site-specific.

RF Do you think that the investigation of what an artist is, and the relation of the artist in the studio, is more acute for a female artist? I was thinking about those photographs that Sam Taylor-Wood did of herself as Jackson Pollock. It's as if she's trying to work out what her relationship to that history is.

JS Yes, I started out wanting to be an artist as a child and as a teenager got more and more excited as I discovered more work. But then at art school there were these old professor types wandering around, spouting, 'This is fantastic!' and 'This is shit!'. It doesn't make any sense and you have to find a way to understand where it relates to you. I think it's less like that now, but in the eighties it was still like this.

RF I want to ask you about your relationship to feminist theory.

JS What I became most interested in is how problematic pleasure becomes. Having an immediate relationship to what you're making becomes so difficult and I guess that's what the romantic idea of the studio represents for me. It's having that freedom to isolate yourself from the world and engage with all the language that has been developed historically, regardless of where it comes from. I think if you deny yourself that then you're losing a rich language, but of course it isn't that straightforward. The problem becomes your own subjectivity. I think feminist theory can be destructive when it means the artist

always has to be reflexive of their own position. Obviously, women in the seventies highlighted the issue and it was important for women artists to recognise but I think it's also hard for male artists. The problem for every artist is how to cope with the weight of history when you have your own immediate experiences and desires.

RF But feminism as a theory allowed us to realise that.

JS Yes it did but I think there's a simplistic understanding now about how that's particular to women. At that time feminism had a positive impact in a very practical way on women artists' lives and on the work that they could make. I think by the eighties some of the ideas started to get fixed, and other strategies got ignored. Artists like Hannah Wilke, who made work about flirting and her own narcissism, got sidelined. Joan Jonas probably interests me the most from that era, because her work isn't reliant on sexual politics. I like some of the very kooky work and I love the roughness, the way the work was made. I think that the humour in many of those early works is fantastic. By the eighties we were mostly seeing works like Judy Chicago's *The Dinner Party* or Mary Kelly's *Interim*, where the dryness of it is so desperate.

RF The Lisson Gallery's press website says of you, 'She is not critical of patriarchal history or the objectification of women within it'. This feels like a disavowal of the political content. Surely your work is a critique?

JS It's important for me that the work doesn't exist only as a critique; I'm reinforcing a one-to-one relationship to making art, that's the struggle. The best situation would be the modernist ideal which has a less troubled relation to history and allows you to go into your studio and make your work, but work that is made in this way looks stupid. I want to reinforce the importance of making within a framework of understanding these complexities. I'm uncomfortable calling history patriarchal, I wouldn't use that term. Roland Barthes wrote about the way de Sade uses repetition to cancel things at the same time as he sets them up and I became interested in thinking around language.

RF Are you talking about using a repetition to break down the iconic image?

JS Yes. With *The 120 Days of Sodom* there's so much writing that it becomes inert, not just by repetition but the monotony of it. I think it's an interesting way to deal with history, treating it neutrally. I also read a book by Peter Brown, *The Body and Society*, where he describes male and female as being the division of

subjective and objective. He discusses how, in Greek civilisation, women represented unruliness and wildness as a way for men to place their fears outside of themselves. That's a description of misogyny that makes sense to me and it makes patriarchy a construct that's relevant to us all. Formalism, focus, isolation, make up the cliché of the male artist, but life messes it up. In fact, every artist struggles with getting that equation right.

RF But that's why I think your work really speaks about feminism. It's not tidying it up and presenting a positive image of women or a simplistic critical statement about the way things should be. We can say that an image by Helmut Newton is sexist because it's presenting an idealised woman: however there's a woman in the picture who has agreed to have her photo taken. It's something that we have agreed will happen in our society, that we've all invested in. By putting yourself in the position of both photographer and model you are engaging with women's fantasies of themselves as well as more obviously men's fantasies of them. It's not just about a powerful artist and the model as victim.

JS Exactly. But the most important thing about Helmut Newton's *Here they come!* is that it is a stunning photograph, so you're thinking why would you want to get rid of an image like that? I don't want women to be seen only as sexual objects but I do think that women objectifying themselves is more complicated. 'How are we different? How are we the same?' – these are the things that everybody struggles with and they are real concerns. What I think is a shame is when attitudes are static or rigid, so you don't see other forms of beauty. People have asked me if I would like to use a man and I wouldn't want to, because my concerns are to try to understand things as they are. I have wanted to make works with other types of women, but it's really hard to get anybody to do it and that's why, in the end, I made the narcissist photographs *Standing Nude and Studio Nude* [2001-02].

RF Was it that the women didn't want to see themselves as objects?

JS And that the subject is kind of taboo. I'm out on a limb here but I think it's to do with a fear of sexuality. That's one of the reasons I used the Allen Jones works because I think the kind of sexuality they represent is very exciting. Engaging in that language can be an expression of the dark side of your own experience. And narcissism is one of those things that's difficult to discuss, but actually it's absolutely essential to have a good sense of self, definitely in any art practice, and probably in life! When I made the Allen Jones work I felt that I was running out of time, I was 37 and I wanted to deal with the things which

are really at stake. I think when you're making work you have to take the risk that you're fucking everything up – you can't play safe. When I started to make the photographic work *Strip* [1999-2000], where I stripped in front of a series of male art critics, curators and dealers, I chose men that were in powerful relationships to me, that's what it was about. It could have made them feel very uncomfortable and it could have jeopardised my teaching job and career. But it felt right to do that for the work, it's exactly what the work's about; what happens if you test those hierarchies.

RF How did it change in the transition from idea to reality?

JS I was surprised. What I didn't expect was how much the male viewers who watched me strip revealed of themselves in the moment they chose to press the cable release that took the shot. I had very mixed feelings about exposing that. Some, like the art writer Matt Collings, were very funny, but it was interesting to see their anxieties. I think it's a shame that *Strip* doesn't get talked about more in terms of how those men show themselves as very human and how they are each so different.

RF That's part of the critique; it keeps unfolding and it's not a simple power relationship. You can see them deciding how they're going to perform themselves. Is referring to other artists (Francis Bacon, Helmut Newton, Jeff Wall) a starting point for you?

JS Yes, on a simple level, you can really engage in something you like. I like to make all the elements that make a work, explicit. The influences are just there like the equipment's there. The Bacon ones, for example *Red Turning* and *Headless Orange* [2000] started when I was making the strip photographs. I was working with coloured backdrops because I didn't want it to be like a seventies black and white sequential work. I wanted them to be more fun and more humane. When I saw Adrian Searle's photos, *Strip no.6 Critic* [2000] it was clear he really tried to get me off guard. I'm in the most awkward positions struggling with my pants and he looks all thin and wiry on the red background and I thought of those Bacon paintings. I saw it as a way of developing what I was doing with the colour. Then I realised that it was also a way to describe the studio as a set, so I took that further.

RF That kind of revelation about the means of making is important isn't it?

JS I was thinking about the photographic backdrop as a space where dramas can happen. The studio is what goes on inside the artist's head. It's a space which is

separate from everything else, but here it's used as the frame that shows the mechanics of how the image is made. The way the Bacons are composed, they frame and isolate the figure in this anxious moment. In *Standing Nude* [2000-02] the studio replaces the backdrop and becomes the set. I'm not wearing shoes so it's the first totally naked image that I did and I wanted it to be properly narcissistic. I have make-up all over my body, which I don't usually use, but I play around with how much the real body interrupts the consumption of the image. In one of the works you can see I'm covered in bruises and I look a bit older, I like that.

RF Has Laura Mulvey who wrote the seminal essay, 'You don't know what is happening do you Mr Jones?', made any comment about your Allen Jones's pieces?

JS I'd love to have had more contact with her. I have met her but she hasn't written on my work. I re-read her essay, once I'd made those pieces and I think it's still good. It has been over simplified by another generation.

RF It occurred to me that now you are operating at a high level in the commercial world, there may be people who want to purchase your work who are the same people who would want to purchase Allen Jones's work?

JS Actually I think that the work is sometimes better understood in a commercial situation. In my experience, the academic response has often been really simplistic. Perhaps when someone decides to buy a work for themselves they don't feel they have to justify it in the same way as is demanded in other situations. They'll buy what they like and can allow themselves to understand the work much better because they're not having to justify it within already existing ways of thinking. They can relate it to their own understanding and life experience. My work is trying to describe, as fully as I can, all the complexities of things as they are. I set up situations and place myself in the work as a way to do this. For me that's the performative aspect, experiencing it. What does it mean to objectify yourself and make yourself into an image of another artist's work? For *After Helmut Newton's 'Here They Come'* [1999] I had to stand in front of a mirror almost every day for six months. And what does that do? It wasn't always a positive experience. It was the first time I had ever had a hairdresser, I always had my nails done perfectly and I learnt to walk in heels. On a personal level, *Strip* [1999-2000] was also about the feeling of exposure you have with studio visits. It did have an impact on some of the relationships depicted and that's something I wasn't prepared for. I think there is a personal impact in making work in this way but there's also too much carefulness and

prudishness in the art world. You can play safe or you can do what you feel is right. Since my work has become known I have had to carve out space in my own head to work out how to get back to that point where you are pushing forward and breaking through things.

CLAIRE BARCLAY

Claire Barclay's sculptural installations include a variety of elements, often contained by three-dimensional frames. She uses both found and fabricated objects that are suggestive of utilitarian purpose. Traditional craft techniques, such as wood turning and pot throwing, are employed alongside 'taboo' materials such as snakeskin and fur.

RF You are on record as saying you feel more removed from conceptualism than some of your peers?

CB I suppose I find conceptualism a difficult thing to quantify – I see my practice as having a conceptual starting point that is at the mercy of the intuitive process that tends to take over during the making of objects. I've realised it's not satisfactory to describe the work I make solely in terms of the thematic framework which has inspired it, although to some extent those ideas tend to emerge subconsciously in the work.

RF Was your work at college very different to the work you're making now?

CB Like now, I was interested in utilising spaces and creating an atmosphere through the work. I made installations with found objects at first, until deciding to make all the elements within the work, in order to have more control over their meaning and associations. For example, I'd been making work with broken crockery that would conjure up domestic violence or an accident in the home. When I started making my own slip cast ceramic objects and using them in the installations, their strange forms were far more ambiguous and their meaning much more subtle than the broken cups and plates. I realised that the ambiguity felt right and I think I have pursued that in my work ever since.

RF So the domestic was the right reference?

CB Yes, I've always been interested in everyday objects, both contemporary and historical, and the meanings held within them. I started out making hybrid objects; merging something institutional and something domestic, like the slip cast ceramic objects I mentioned. They might be medical or for use in the

home. I didn't want the work to be representational, instead I wanted it to have a sense of the familiar yet difficult to place, hovering between real and fictional.

RF Was there a sexual aspect to it?

CB I think it's the seduction of the materials and forms. Hoops, holes and rods can't help having these anthropomorphic associations. I was quite concerned at first but now I'm used to sexual associations being read into the work, it's human nature to do so.

RF Who do you see as your artistic parents or peers?

CB Early on I was influenced by people like Eva Hesse, Louise Bourgois and Joseph Beuys but I think the range of influence over the years has been very diverse and as much from the fields of craft and design as fine art. Anonymous makers of the artifacts in museums have always been particularly interesting to me as a source of ideas and inspiration.

RF Do you have a conventional studio where you make?

CB Yes, I have a studio at the Glasgow Sculpture Studios where I can access workshops and equipment in order to make large-scale messy work if necessary. I also have a quiet space at home for drawing and thinking. I use a wide range of materials but due to time restrictions and other limitations I need to involve other people in the fabrication of some elements. I find it difficult to do this as I much prefer to adopt a hands-on approach when making work. So, I'm always on a quest to acquire new skills in crafting materials. I get a lot of enjoyment out of experimenting and learning more about the scope and limitations of a particular medium. When work is fabricated by someone else, I need to decide on a design at the start and the mistakes and evolution that usually occur along the way through making don't happen to the same degree.

RF Tell me about your time in Australia.

CB I was there initially doing a residency for a year and it was a big influence on me and my work. I was struck by the ways in which the landscape in Australia has become fetishised and how people's identities were informed by the commodified New Age culture that was so present there. I was able to relate to evidence of influences of my own culture that I found omnipresent and especially prominent within historical museum collections, which became

another source of inspiration for the work I made there. I also became interested in the use of animal derived products. The attitude to hunting and animal skins is quite different there because it's part of a pioneering, survivalist ethic. I started to use emus' eggs, fur and snakeskin to make sculptures. Using snakeskin doesn't have the same shock value there as it does here. For me, this raised a dilemma about using these types of materials.

RF Did you get criticised for doing that?

CB No, I was criticised once for using fur in this country. I made work using second-hand fur coats. The materials I use in my work are chosen very specifically and are central to the meaning of the work. To comment on specific associations of fox fur, for example, I need to use fox fur and not an imitation. For me it was about how this commodified New Age culture relates to the idea of the wild. That's where the idea for the photograph of me with the wolf came from. I tried to make an image of being at one with the wild – it was meant to be ironic. I suppose I was a bit cynical of the hypocrisy bound up with New Age issues about the environment, where conservation and exploitation go hand in hand. I adopted the motif of the dreamcatcher as it seemed to epitomize these hypocrisies; what happens when you take an authentic, cultural icon from someone else's culture and adapt it to suit your own. It loses its original meaning and becomes an aesthetic object or one that relates to a completely different set of principles and context.

RF Are you saying there is an authentic or that it's no longer possible?

CB Well, some might think that the only authentic dreamcatcher would be one made by indigenous people in North America but then the versions in the crystal paraphernalia shops in Melbourne have a different sort of authenticity because people still invest belief in them. I'm really fascinated by the transformation of the 'traditional' dreamcatcher into the bizarre mutations that you find.

RF Because it shows a human inventiveness?

CB Yes, exactly. They're transformed through a craft process as much as a commercial process , so expose the handmade eccentricities of personalised objects. We can find endless ways of reinterpreting and relating to everyday things. Artists can take something very familiar and transform it in a surprising way, allowing you to see it in a new light.

RF Your work with architects seems to run contrary to the ephemeral nature of your work.

CB I've worked on a couple of architectural projects and it's a real challenge for me. The ephemeral aspects of the work are often to do with upsetting the finite object, like things being half finished, soiled or disintegrated or like limpets attached to built environments. One of the exciting things about making work *in situ* within the gallery space is that it's like a studio environment but on a bigger scale. At some point it needs to be open to the public but ultimately many things are not resolved, it's more like a pause in an investigative process. Architecture on the other hand usually calls for details to be fixed and durable.

RF What about use and function in relation to the work? The pieces often have a residue of the possibility of function, like 'found' objects. I'm also thinking of the work's relation to craft.

CB Function is central to forming an understanding of the objects I make. They are suggestive of functions and scenarios but as they're invented objects, responses to them are drawn from people's imagination and experience of similar real-life objects. The way that different elements are grouped and positioned affects the way they're interpreted. Dysfunction is always an important part of the interpretation as the objects are never able to be completely understood and they often suggest absurd or eccentric uses. I'm only ever interested in making work that is absurd, ambiguous and contradictory. But, at the same time, I'm trying to make things that have a relationship to the environment in which I live, rather than only being able to relate to the world of art. My work never sits on plinths but instead is installed in a way that suggests that it's temporary or unfinished. Crafted elements, some of which have been completed in the space, add to the suggestion of work in progress.

RF Are you are interested in craft as an ethical relationship to the world?

CB I'm concerned about the fracture between making and thinking and how the two have become considered separate. I've always acknowledged how craft techniques, even if re-invented or unconventional, exist within fine art practice. Lately though, I've become very interested in ideologies which attempted to combine design, art, craft and architecture in an ethical quest to improve society and the environment. William Morris and the Arts & Crafts movement, the Wiener Werkstatt or the Bauhaus, shared a belief that through making, people would have an enhanced quality of life. I'm quite interested in where their ideas failed and where they succeeded. Maybe it relates also to the move towards utopian ideals in contemporary art. I've enjoyed and benefited from being able to cross over different fields like architecture and ceramics and screen-printing. I've started to throw ceramic pots and that process sparked off this interest in a

deeper understanding of the connection between thinking and making. On the wheel it's very difficult to articulate what is going on, when you're making a pot, why a form is aesthetically pleasing and why another is not. Or, why the pot that came into being easily is better than the other laboured one.

RF Are you drawn towards works of art that demonstrate skill?

CB Yes and no. I'm drawn to beautifully crafted objects but I'm just as interested in oddities and mistakes. There are a number of things that I work with, leather, ceramics and turned wood. I keep coming back to them because each time I make something it suggests another approach or idea; there's a sort of obsession. I enjoy seeing that obsession in other artists' work. I believe that we mustn't lose touch with understanding the world through making and knowing how things come about. We shouldn't take the production of objects for granted and we should be aware of how all these things around us come into being, whether handmade or manufactured.

RF And your objects draw attention to the way that they're made?

CB I would hope they do. I think the means of production informs the way they are read and the psychological feeling, the mood that they give off as well. My work is very tactile and its physical characteristics are intentional. The weight, the textures and the smell are all implicated in the meaning of the work. The contrast between different materials or between machined and hand-modelled surfaces highlights the way it's been made. There is always a conversation between more than one element. That's why I started making structures to contain objects, so that the connections between them became more apparent. The word 'craft' conjures up so many different definitions; from the kitsch Blue Peter, sticky-back plastic approach to highly skilled traditional pursuits. Then there are traditions that have evolved into new phenomena, like bird decoys that originally were purely functional, but are now carved by some people with exquisite but absurd realistic detail.

RF The 'hobbyist' approach can be quite compelling for the maker.

CB I think some of the work I've made has had an element of that sort of obsessiveness. I've spent days winding dozens of balls of wool around a timber structure, like threading a loom but for no apparent reason. I think that when somebody has laboured in the making of something, then that apparent toil is compelling whether it's absurd or logical. Part of the attraction to other people I'm sure is their desire to also be involved in the making process.

MARIA CHEVSKA

Maria Chevska makes paintings that incorporate texts into their surfaces. These are often made from poured paint and kaolin, a clay based medium, producing a glossy liquid that solidifies on drying, forming words out of the material of the painting. Recent work includes installations and sculptures that incorporate found objects and constructions.

RF I last interviewed you in 1990.

MC 1990 was a watershed for me. At the time I'd simplified my images, introduced new processes, and I had begun to exhibit my paintings together as a number of juxtaposed panels intended to be 'read' rather like a sentence. I wanted to find ways of relating the activity of painting to the world of everyday gestures, objects, environment, and ideas – it had become less necessary for me to work within the single pictorial frame. My method was to consider the viewer an interpreter; open-minded and inquisitive, rather than the passive recipient of a defined visual narrative.

RF So the audience works to make sense of the elements?

MC Yes. This seemed less complacent. Around 1990 I gave more emphasis to two elements in my work: the physical materiality of the painting, and the use of text – written, or sewn into the surface. Later in the 1990s I began making simple objects to accompany paintings.

RF Is this the *real*ness you've referred to?

MC Yes, 'realness' was important. I see a painting as an object among objects. For example, a Manzoni painting has a literal materiality of few elements, yet it can still present a complex set of references

RF Do you lose some kind of pictorial or imaginative involvement by this change?

MC I think the imaginative involvement came back through the text. The words or phrases that I use have a direct source and meaning, yet there is also a surplus imaginative dimension – a springboard effect to other interpretations – because of their new context in the work. Since 1990 I've made and exhibited groups of paintings and objects – each group under a single title – the work evolving an idea over two or three years. This is more satisfying to me as it sustains my interest, avoiding closure, and false 'resolutions'. The ideas often come from reading. I could choose a poem, fiction, letters or any other text. Through the working process a new object is made.

RF How would you characterise the changes in your attitude towards paint? In earlier work paint was used as a metaphor for the body. Are you moving away from that?

MC Yes, although the visceral substance of paint always puts one in mind of flesh and skin. For instance, paint pouring over an edge seems out of control – the insides out. In general my work continues to refer to the human-scale mostly in terms of volume, weight, and reach. It is one reference point among many and forms a tension with the more cerebral aspect of reading the text. Recently my sculptural objects, and the inclusion of items of furniture, further serve to convey scale to the viewer. They are often objects of utility such as a chair or a table, for example.

RF The positioning of different elements questions how you might negotiate them and how you make relationships between them – some might seem deliberate and some arbitrary

MC I establish the original relationship between the elements in my studio – it's provisional and open to some changes when they're later exhibited and become contingent on a different context and space. Over the years I've made small moves and innovations in terms of what's included – after a ten-year period you realise you've given yourself immense freedoms. The arbitrary so often becomes useful.

RF Can you talk a bit more about language, writing and text?

MC The first time I put words into a painting was a work entitled: *Visibility,* shown in 1992. I sewed the words in white cotton into an exposed seam within a dark satin diptych, on which was painted a matte black image in blackboard paint. I found this text extraordinarily redolent: '*Lemonade, everything was so infinite',* which was the last phrase Kafka wrote on a scrap of paper when he could no

longer speak. I came across it in Helene Cixous's writings. Kafka's original note was in German, Cixous wrote a little book on it in French, and I read it in English translation – I simply wrote its provenance in the three languages. It bore no relationship to the blackboard-paint image – it was simply sewn across the front. I liked this text as an independent element – it didn't need to be pictorial or formally related to anything else there. It possessed a concrete energy, a phrase: material that already existed in the world with a life and history of its own.

RF Isn't importing something with such a history difficult?

MC Maybe. The 'Lemonade' fragment is the most enigmatic that I've included – that was the point within that particular group of paintings. My subsequent themes have dealt with more prosaic aspects of language such as descriptions, declamations and forms of dialogue. Actually I'm interested in the 'histories' and I attempt to transport their tone and voice into the present, which is the work.

RF But don't you think people would need to know more, read Kafka and Cixous extensively, to understand what it really means?

MC Well I'm not so sure but as it happened, I did. The 'Lemonade' is a curious statement, that's my fascination – it floats, and is open to interpretation. It's also simply what it says – a fond memory from Kafka's childhood.

RF And its resonance for Cixous might be different from its resonance for you?

MC She muses on its multiple meanings and extends the poetic language of her own writing by tracing its references to Kafka's life. Cixous has often woven the literature and life of Kafka into her books; she's a vivid example in literary terms of bringing the past alive into the present.

RF Do you think the texts you use are visual?

MC All of Kafka's writing shows a visual imagination. Often filmic, he sets scenes with great economy without telling you what to think. I later used his straightforward descriptions such as looking through a door, the arrangement of a room – setting a scene as a place for actions to occur.

RF Immediately there is a tension between what you're imagining and what you're seeing.

MC Exactly. The mind and the imagination are free to conjecture the text but you also return to the identity of the physical object.

RF It's analogous to the dilemma in the perception of painting – can you see the surface of the painting and the image at the same time?

MC Yes, as in the visual example of a Manet paint mark, which is a squiggle in paint, and, at the same time, a figure against the sky. I think that the art audience is used to this idea.

RF But can it be both at the same time? The juxtaposition between what you're reading and what you're looking at seems to suspend both experiences.

MC To suspend seems useful – a kind of mental vertigo. Can one absolutely instantaneously be aware of everything at the same time? I'm not sure, yet I think that art presents this instantaneousness as the usual condition of itself.

RF Which texts have you worked with recently?

MC Over the last couple of years I've worked with the letters of Rosa Luxembourg. In an earlier series of my paintings the poured paint often drowned parts of the text and obscured its reading. Heavy paint collected at the centre of the canvas, weighing it down and altering the legibility of the text. For the Rosa Luxembourg series I was interested in maintaining the tone of voice characteristic of her letters, which is strident and urgent – I didn't want to delay it in the same way. In order for it to remain visible, I built the raised text deeper to resist erasure by the paint. My other larger-scale white kaolin panels remained bare, and the slightly raised writing on their surfaces becomes legible through angles of light – often lying behind a typographical graphite text.

RF Tell me about the smaller paintings and their relationship to language.

MC These are a series of sound words. I noticed them written in Samuel Beckett's *Waiting for Godot*. We also hear them all the time but it's unusual for your ear to separate them out of the flow of spoken language. I found nine 'sounds' and formed a ladder of these little word paintings on the wall (eh, pah, ah, etc).

RF We were talking about the material and physical aspect of your work and, to me, these are sounds of the body.

MC Exactly. They're beyond sense in a way. I think the viewer has to physically mouth them to themselves, then the understanding is intuitive. I've always been interested in the sensory perceptions at the periphery of visual art specifically sound and weight. Not only the eye – I wish to engage all the senses, as well as the reading of textual language. Currently I'm using Kurt Schwitters' *Ursonata*. He wrote it early when he was an official Dadaist in 1919. It's a sonata of sounds in alphabetic form – he regularly performed it himself. It's somewhere between a song and a poem and he gave instructions as to how parts should be screeched and other parts quieter. It's very visceral, requiring an exaggerated use of the mouth to form the words and sounds – a demanding physical delivery. I included a recording of *Ursonata* in an exhibition in France in 2002 [*Eh*, Maison de la Culture d'Amiens, 2002]. The recording was available on headphones and it accompanied my *Eyeballing* paintings. Loud and abrasive at certain parts, visitors could only listen for a short time.

RF I like the idea of having a counterpoint to the paintings.

MC Yes. Everything I've incorporated has a parallel existence – I don't want elements to overlap; they should conjoin or have an abrupt meeting which the audience encounters and then works out for themselves. The gallery in Amiens, France was a large space over two floors and the curator had asked me if I would like to invite a performance artist to participate at the opening of the exhibition. I decided to include two dead artists: the Kurt Schwitters *Ursonata* recording, and a film called *La Pluie* by Marcel Broodthaers [1969]. It's a performance on film in which Broodthaers continuously writes, it rains heavily, the rain washes away the ink, he keeps on writing.

RF Your references to early Modernism are established; what about your relationship with other practices?

MC I've made a number of works with direct references to early twentieth- century Modernist writers and artists. Other influences have come from artists in the 1960s –70s. Many of them started with painting and worked towards an expanded practice – introducing various other ways of doing and seeing – for example, artists associated with Arte Povera, Situationists, and others.

RF Tell me about the objects you juxtapose with the paintings?

MC	The early ones I called prosthetics, because their purpose could be seen as aids for approaching the paintings. For instance, there are the 'binoculars' formed from kaolined paper cones for reading text, and halter-like attachments with very long arms or legs or neck potentially to wear. I've repeatedly used chairs because they function as a stop, a frame between the viewer and the painting. More recently the relationship between the objects and the paintings has further incorporated the spatial environment.
RF	A chair in front of a painting has a contemplative connotation.
MC	It is an invitation: to sit and look, and think. By sitting one is more inclined to read. In *Can't Wait [letters RL]* [Andrew Mummery Gallery, London, 2005] the chair became a protagonist. I used the Panton chair to suggest a trajectory of Modernist design with its implicit egalitarian ideals for living and social change. The Panton chair was first produced in the 1960s but it's a legacy of Bauhaus thinking, becoming the first single-mould, plastic chair. Ideal for mass production, it's in fact now a feature of a 'designer' life-style. I'm conscious of the decadence that comes after great innovation. Part of its function in this work is to provide a different visual echo to the more relevant social legacy voiced by Rosa Luxembourg. For similar reasons I've placed the 'butterfly' stool in front of a painting which is balancing on two tree logs. The painting itself makes pictorial reference to El Lissitsky's *Red Wedge*. I want people to sit on the stool to be at the same level as the writing in the painting
RF	Can you tell me a bit about *Vera's Room*?
MC	The room itself was started in my studio in 2000. Ideally, when re-created elsewhere, *Vera's Room* is clandestinely placed within an installation of my paintings. For example, when it was shown in Berlin I narrowed the entrance to the final room so that finding and entering *Vera's Room* was a surprise for the viewer. Almost all of the objects in it are white and harshly lit from above to cast shadows on the floor. There are some made objects together with a few articles of furniture and other useful things, such as a bicycle, in the room. Walking around it one finds pockets of detail; other elements are more abstract; shapes that look like domestic objects, but not quite. The objects are made from polystyrene, paper, or cloth that's been hardened in kaolin. One senses that someone occupies this room, possibly the fictional Vera Kasmiach [an anagram of Maria Chevska]. Initially, in 2000, I had some anxiety that in leaving the twentieth century behind, certain histories would be quickly forgotten. The room was partly a homage to people I knew when I was younger, refugees from Eastern Europe whose ingenuity and initiative was

essential to create new lives in a foreign place, some more successfully than others. The making something out of nothing – improvisation as a way of life. Displacement of the individual is still a big issue in the twenty-first century. I find the room rather chilly with everything whiteish and an audible, hard-to-place, sound. I'd recorded the sound in Romania – it was actually the ritualistic banging on a board around the entrances to a church – although in this context it reminds you of heavy rain falling on a roof. The room both distances and suggests intimacy – making you cautious to enter – potentially offering a narrative for *Vera Kasmiach*. 'Making something out of nothing' is analogous to the creative process in an artist's studio, which also is based on material, memories and projections.

TACITA DEAN

Tacita Dean works principally in film installation, although she also makes drawings, found collections, photographs, sound works and prints. Initially, works wove narratives of coincidence and intrigue that blurred fiction and reality. Recent work continues to reflect upon overlooked or ephemeral events and places, often depicting atmospheric phenomena and the material evidence of history and culture.

RF I'd like to ask you about the changes in your work over the years. In the early projects research felt crucial, as if you were discovering your subject through making the work.

TD Perhaps in the earlier projects the extensive research brought out more playful elements. A film like *The Martyrdom of St Agatha* [1994] took a phenomenal amount of research and yet it had a clear final product, a fiction that came out of that research. As well as the film, I did a series of little drawings of St Agatha and the aspects of sainthood. I also made the large scale the photographs that were at the Serpentine Gallery, London [Barclays Young Artist Award, 1993]. I think the research exists in a different way now.

RF Has your work become less fantastic, less playful? *St Agatha* was very funny.

TD It's all been very organic for me. I moved from *St Agatha* to the *Girl Stowaway* installation [1994]. And then from *Girl Stowaway*, which was all about fact, fiction and artifice, I moved seamlessly into the work about Donald Crowhurst [*Disappearance at Sea*, 1996], because somebody lent me a book about him while I was doing *Girl Stowaway*. Obviously that became a very serious work.

RF The playing with fiction, the humour and the fantasy seemed to draw people into your work.

TD Yes and it's still there to some extent – there were very funny moments in *Fernsehturm*, [2001]. But it's true, I have left the playful behind to some extent.

I've just done a series of prints called *The Russian Ending*, [2002]. The Russian ending was the tragic ending to a film that was exchanged with the American happy ending because the Russians like to cry. The images are from found postcards and they're quite funny as well as tragic.

RF So has the work become less narrative?

TD Every single film is narrative, even if it's minimally narrative. An aeroplane taking off or a thunderstorm happening has narrative through time. But I haven't written another story like *St Agatha*, which is a deeply narrative film. When I did *Disappearance at Sea* it signalled a big shift in my work; that film became very sculptural. The principal change is that I've stopped using voiceovers. It doesn't mean I'll stop doing it forever. When I went to Sundance Film Makers Lab in Utah, I took *Disappearance at Sea*, that had been greeted enthusiastically here, and *St Agatha* which had been greeted very unenthusiastically. I showed it to all these screenwriters and actors, and they loved *St Agatha* but they didn't get *Disappearance at Sea*, so I think it's all about context. I don't think the art world likes too much narrative.

RF Do you still have a desire to make a fictional feature film?

TD Well, that's the big question for me. When I came back from Sundance in '97, I really was quite determined to make the film that I took with me.

RF Did you take a script with you?

TD Well no, you see the trouble is I couldn't write a word of the script. I was supposed to take a script with me but all I had was just a synopsis, an idea, just two pages in fact. But I had the most fabulous dialogues with these people and I really thought this is it, I really want to write a film. I want to make a film but I want to write it, that's the problem. I want to write it myself. I can't hand it over to anyone else, because I love writing. It's this thing that sits beside me, the unmade thing. I have two producers now who want to work together on producing the film. I started to think that the way I can write a script is to write it as a sort of novel.

RF Which film makers do you like?

TD Well, I used to be a great fan of Chantal Akerman. She's a prime example for me of someone who shouldn't make video installations, she's such a fabulous film maker. I think her best film, which she made in the seventies when she was

20 something, was *Jeanne Dielman, 23 Quai du Commerce, 1080 Bruxelles*, [1975]. It's a film of a woman and it's just over three hours long. You have to sit through it, it's painful, it's boring. Basically, it's a lower middle-class woman in the outskirts of Brussels, who has this one son and this routine, which is very rigorous. She gets up every morning, you're with her every bloody minute of the day. The only time you feel you don't know what's going on is when the doorbell rings and she goes into this room at the end of the corridor, so you realise she's acting as a prostitute in the afternoons. You watch her peel every potato, you've spent three days with this woman, her life is unremitting. And then one day the guy took too long or whatever and she hasn't got it together, so there's not enough potatoes for her son's supper. At that moment the panic is so profound, you know you're really with her – it's really a fabulous film. Then she made *D'Est*, [1993], that she filmed in the East, in places like Romania, Bulgaria, and has really beautiful long scenes.

RF What went wrong when she tried to make installations?

TD Well, for example *D'Est* is made up of 24 sequences. Each sequence is 20 or 15 minutes long, so she divided each of these sequences onto one of 24 video screens so the whole thing became condensed. Who else do I like? I thought Thomas Vinterberg's *Festen*, [1998] was brilliant. Probably my favourite film is the Alain Resnais film *Providence*. That's such a great film. You see, if I'd made any of those three films, *Jeanne Dielman*, *Providence* or *Festen* I would feel like I could take up gardening or something, retire!

RF Your work seems to have become purer over the years, I think there's a sense of distillation going on. Some of the earlier work contained a wealth of references and possibilities in the blurring between fact and fiction. A work like *Banewl*, [1999], operating in real time, seems much purer somehow.

TD I know what you mean. To some extent that comes from the purity of the event and the place. But I do think my work is simplifying. I've just made this little film that's so pure it's really reduced to a sort of essence. It's just one reel of film, unedited, of the sun setting and at the very last moment you see a green ray. It's called *The Green Ray*, [2001].

RF I started thinking about how the notion of obsolescence runs through a lot of what you've done, from the *Bubble House*, [1999] to the chalk on blackboard drawings.

TD Now people talk about obsolescence, they talk about the whole nature of the projector, but how it happened for me was from a different angle. I can see now the connections between what I'm attracted to. I can see it runs through *Foley Artist*, (1996) to the wave machine in *Delft Hydraulics*, [1996] to *Sound Mirrors*, [1999] to *Bubble House*. Interestingly enough, it's all from around the year I was born, with the exception of *Sound Mirrors* which was round the time my father was born. Someone told me something very interesting about Duchamp. Everyone says that Duchamp's stuff is from his own generation, but all the objects he used are actually from his parents' generation. We just think it's old, so it must be Duchamp's time but it was very specifically from the generation before. The reason I use film is specific to the nature of the process of making it. I just don't understand how people can bear to make video installations. They can be so crudely pixillated, it pains me.

RF Is it to do with the quality of experience?

TD It's not just that, that's just one-tenth of the whole thing.

RF What about the physical engagement of making? Unlike a lot of artists you are often behind the camera.

TD Apart from the *Structure of Ice*, [1997], the only ones I haven't been behind are the anamorphic ones, because the anamorphic camera is too cumbersome an object. But for me the integrity is most prevalent in the editing. You see, I edit alone and I edit on film.

RF So it's like a studio practice?

TD Yes, that's what I relate to most, what it was like when I was making images, drawings and collages.

RF I'm thinking about the difference between the private space of working and the public space of viewing and Michael Newman's comment about how installations relate to the body of the viewer?

TD Yes, this is why I rarely show my films in the cinema. Some works can be seen larger but others can't. I have to be totally controlling about how they're shown because I can see how it fails or succeeds. They are sculptural works, you know. I've had to start doing more and more; making people build, put carpet down and paint the walls grey etc. For *Banewl,* I even have to have a projection box because the sound track is so important.

RF Working with museums must be quite difficult because a lot of the time museums want objects, don't they?

TD I have to say that now the Tate have shown eight 16mm films [*Tacita Dean*, Tate Britain, 2001]. When I did *Foley Artist* in 1996, which was an *Art Now* commission, there was a condition that they could turn it on in the morning and turn it off at night with one single button, so therefore I couldn't show film.

RF Is that why you used video for that? A foley artist is someone who makes the sound effects for film in post production, so it's interesting that you chose to combine visual footage with sound in the work.

TD Yes, originally it was just going to be pure sound. It was a digital installation and then I put the visual element in. When you walk into the *Art Now* space everyone always goes to see the image first, so the monitor was put face to face with the dubbing cue sheets so you couldn't actually see both simultaneously. At a certain point you had to turn around and look at the dubbing cue sheet and at that moment you started to perceive the sound in a different way, because you perceive sound very differently when it's without image.

RF Do you watch people watching your work?

TD I have done. One guy spent hours in *Foley Artist* working it all out. He started to anticipate the sounds, you know, the slam of a door, and where all the speakers were in relation to the whole. It was highly orchestrated, that whole thing.

RF But there must be a huge amount of not knowing when you start filming. I mean, you know what you're going to do, but did you know what that woman was going to wear that day?

TD There was a lot I didn't know. That's what was so beautiful about the act of learning in that piece. Initially it was just going to be a sound piece and the dubbing cue chart was going to be a projected image. I wanted it to look very minimal but be very rich aurally. Pretty late on, I still had no narrative together – the whole thing was going to be a fake soundtrack using the foley artists. It was really chaotic. The order comes in the editing. What was so extraordinary about that piece is, because there was no image relating to the narrative of the sound, it was totally sound led. It took me ages to realise that I could brutally cut sound like I can brutally cut image. It was very good for me to think like that because it had no dialogue and no music and music directs the

atmosphere and dialogue obviously leads the narrative. It was an awful narrative and embarrassed me like hell, but in a way it had to be that bad.

RF If it had been telling a great story it might have deflected from what it was.

TD Exactly. I was working in total darkness with that for a long time. And actually it's the same with a lot of my work. *Banewl* was very frightening. That's my most ambitious project to date. I had four cameras and 21 people involved in that and we'd rented this dairy farm. I really wanted to make a real time film of the eclipse so everyone had these very rigorous timetables that they had to adhere to because there had to be film in one of the four cameras at any one time. And then, completely bloody cloudy! The actual eclipse was two hours and 40 minutes and the film is 63 minutes so it's not real time in fact, it's concertina'd time, but I play on that.

RF It felt like it was slowed down.

TD When I first showed it, everyone said to me it should be half an hour shorter. I was mortified but I knew that it had to be as long as it was. Since then the length has been totally vindicated. But it was risky; I knew that I was pushing boredom. It had to be that long in order to really understand the length of waiting for this absolutely monumental cosmic event. Also, it's a symmetrical event and that waiting the other side is as important. But it's almost unbearable. So many people left the eclipse after totality, they couldn't bear it any more. People leave my film after that as well. The only thing is, if they wait for the cock crow, it's kind of like permission to return. But it does touch boredom. I've had the most extraordinary responses to *Banewl*.

RF I thought it was great to have that in a gallery situation where people often pop their heads in and out. I sat and thought about this kind of time and that I'd like to have it in my life, time to look. It did have an elegiac feel. But could you anticipate that when you were filming it?

TD I was just in despair. No sun. That's what editing is about, though. That's why editing is so crucial and you're right, editing is my practice. Susan Stewart, a writer from Philadelphia, called it an artisanal way of editing – and it's true, I do work like an artisan in a way. I'm more of a craftsperson really.

RF There's the sense that if you wait long enough then something will be revealed.

TD That's interesting, especially with *The Green Ray*. The thing is, when I make a film I go into totally different time and it's so unrelated to what the final product is. For example, with *Bubble House* and *Teignmouth Electron*, they were about half a mile or a mile apart, along the coast. I was with a friend and we'd sit in vigil, waiting for aeroplanes to take off. We had this timetable but the timetable didn't seem to relate to any activity on the runway. Then we'd give up and drive to the Bubble House [an abandoned 1960s futuristic house on Cayman Brac in the Caribbean] and the same thing would happen, then the aeroplane would take off. It became about this toing and froing between these two places and the waiting involved in that.

RF Along with the waiting and notion of revelation is a strong sense that there's an act of faith involved.

TD I use the expression 'act of faith' a lot, because I have to believe that it's going to be all right and sometimes it feels like it's not. With *Fernsehturm* it was overcast weather up until I filmed. I had a camera crew over from England, so it had to be shot then. It was a hell of an anxious shoot, so many things weren't right. One of the cameras had a fault so I lost one-third of the footage. It has this flicker on it, I used tiny bits of it and people think there's something wrong with the projector. Everyone thinks that I'd rented the tower but actually I just booked three tables in a row. People think it's this grand film shoot but actually it's the absolute opposite. I was very interested in these groups from the East who regularly come to *Fernsehturm* [the television tower in Berlin with a revolving restaurant]. So we sat down on the edge of the booked tables and the first group arrived and beautifully they sat in the further seats. The second group were two and a half hours late because they were betting in the Forum Hotel which is next door to the Fernsehturm. It was such a gift, it was so beautiful, having those empty tables because you watch the light change on the tables. I'm very lucky, as well as being unlucky sometimes and in that way I always believe it's an act of faith. With *The Green Ray*, it's almost an act of faith whether you see it or not, it's so small.

RF How long does it last?

TD Probably one frame of a 24 frame film, maybe two frames. It's very short. I've been obsessed with the green ray for many years and I've failed to see it anywhere, even though I've looked. Peter Nichols told me he'd seen the green ray [the phenomenon of a green flash in the sky seen at sunrise and sunset] and so I asked him to write about it. He wrote this rather prosaic piece which I was a bit disappointed with at first. Later, I came to like it because I realised

that, in a way, seeing phenomena is actually quite prosaic. I went to Madagascar because of the eclipse on 21st June, Midsummer's Eve. I went to the west coast, to this place almost impossible to get to, and it was an absolutely perfect eclipse. Unlike Banewl there wasn't a single cloud in the sky, but my light metre stopped working. I borrowed a light metre from people on the beach. That didn't work either, everything went wrong. It was very unsophisticated, there was just my camera and my two and a half minute spools which take 20 minutes to change, so it was the opposite to Banewl in every way. When totality started we were just sort of transfixed and my friend realised he hadn't got a film in his camera, so I said borrow mine, and he reached for my camera and the 16mm camera fell forward, it was a disaster. Then the sunset eclipsed and I saw a green ray. My first green ray, with the eclipsed sun setting. No one else saw it. I think it's related to film editing – if you're used to looking at 24 frames a second, I can see a mark in one frame whereas others can't. I have quite a sharp eye, I think.

Later that night they got confirmation that someone else had seen it, so I wasn't fantasising. I set up vigil and I filmed all the sunsets and I saw it again, but no one else saw it. Then one time we got back so late that the sun was halfway set and I couldn't load the camera in time. As we stood there and there was a green ray and we all saw it for the first time, I wasn't filming it and I was devastated. So, I thought I'd seen it three times but everyone said I'd only seen it once. Then I had a show in Washington and I took this awful Lufthansa flight where I had to watch these terrible films. Everyone was asleep when I noticed the sun was rising and I got up. I had a middle seat so I was leaning over three sleeping people and suddenly, above the cloud line, I saw these two brilliant spots of red and I thought, 'My God, the sun's rising'. Then I saw the most sublime green ray, it was one or two seconds, just twinkling there. I felt physically sick, I had to sit down immediately. It was so beautiful, this thing I'd been pursuing.

RF Did it bother you that you hadn't recorded it; was it enough just to see it?

TD With that one, yes, because it was so unexpected, it wasn't like standing on the beach every night. It has to be a totally crisp horizon and climatically perfect. Then I caught the car ferry from Hamburg to Harwich. I sat outside watching the sun setting as is my habit, and I suddenly realised there was no cloud, absolutely no moisture on the horizon. The sun started to set right into the sea, and in Europe this is almost impossible because land is in the way. I was thinking, this is really extraordinary, how can this be happening? And as I watched it, there was another one. So I saw it five times in five weeks, it was just so strange.

RF	After *Girl Stowaway* you wrote 'chance left me after that'.
TD	I have this strange relationship with chance and I relate it to finding four-leaf clovers as well. In *Girl Stowaway* I felt that coincidence had been so explicit with that piece, it felt like I'd welcomed it. I did think that I wasn't courting it any more or it wasn't happening to me any more.
RF	The green ray story proves otherwise?
TD	Perhaps, along with the narrative, coincidence and chance are slightly less prevalent but they're still there.
RF	Germaine Greer says you don't dominate your material. She sees this as feminine. There is a sense that you're saying, 'there's this phenomenon, I'm going to respond to it, I'm not going to fashion it, I'm not going to make it into something else'.
TD	I don't know if it's feminine, well maybe it is, actually. It's not a very macho thing to do, is it? I demur from my participation and whether that's a pejorative thing, I don't know. I only appear in my videos. I've made three video pieces, one of them was the *Foley Artist* where there's this transient moment when I'm standing behind the mixing desk and *How to Put a Boat in a Bottle*, [1995] where you can hear me, and then you see my hand for one nanosecond. I'm there more explicitly in *From Columbus Ohio to the Partially Buried Woodshed*, [1999]. All three pieces have a very strong real time feel to them and also a very social diaristic quality. It's interesting that I would never appear in one of my films yet I allow myself to appear in a video. I think video for me is better when it's more real time and that's why using video in installation jars with me. Video in visual art came from recording performances really, and its roots were very much like that. The best video work has that quality, like Gillian Wearing's or Mark Wallinger's work. I just make films so they exist in their own time and space and whether that's a good thing or a bad thing, I don't know. My films are working with a totally different quality of time. It's so difficult to know how conscious my position is.

EMMA KAY

Emma Kay is known for text works that take the form of wall-based prints and animated projections. Much of her work has centred on her recalling seminal texts, such as the Bible or Shakespeare, from her distant memory. Kay explores issues of textual authority and how memory personalises facts and information.

RF You were at Goldsmiths College [London University] in the early eighties – what was it like and what kind of work did you make?

EK I spent three years making cast papier maché sculptures but I was drawn to making live art, which was a big part of the culture of the course at that time. There were performance nights in the bar that included poetry readings in the style of *Cabaret Voltaire*. Quite a few students were making site specific performances. I was discovering for the first time the performative work of artists such as Robert Morris, Carolee Schneeman, Bruce Nauman, Chris Burden, Vita Acconci and Marina Abramovic and Ulay, as well Eva Hesse and Carl Andre. I read a lot about the work of Yvonne Rainer and others at the The Judson Dance Theater in New York and about John Cage at the Black Mountain College in the 1960s. Mary Kelly and Michael Craig-Martin were teaching on the course at the time.

RF So what was it about performance that you responded to?

EK I think I was drawn to live art because I had a performance background, having studied music from an early age. In many ways I felt more comfortable with it than I did making objects. Some students at Goldsmiths at that time were very taken with the idea of the anti-object, which is why there was so much time-based and site specific art. In the early eighties the rapid ascent of graduates to commercial success, something which is now often taken for granted, was a new thing. The contradictions between this investigation of the politics of art as commodity and the gradual embracing of art as commodity in subsequent years was what made Goldsmiths such an exciting place.

The course was notorious for being theoretically driven. Sarat Maharaj's critical theory course explored semiotics and post-structuralist and postmodern theory. The theory seminars that I attended, although only half-comprehended, fed my interest in making work without a physical object. However, it wasn't until after I graduated that I digested the experience of the course and began to make time-based works in earnest. I also got involved in music again.

RF What kind of performances did you make?

EK I worked collaboratively with other artists and musicians. Some of the ideas in these collaborative works still inform my practice. The performances that we made were theatrical but not acting (a much debated distinction at the time), involving the performers in repetitive actions based on everyday movement. We recorded sound tracks. The works were designed to be performed continuously in a gallery space with viewers coming and going at will. My recent animations, *The Future From Memory* [2001] and *The Story of Art* [2003], are shown in much the same way. During the early eighties, the heyday of gallery-based or site specific British live art, led by people like Stuart Brisley and Alistair MacLennan, was drawing to a close. The hybrid 'physical theatre', exemplified by *Theatre of Mistakes*, was taking its place. Marina Abramovic and Ulay made the work *Rest Energy* [1980], which I particularly liked, about that time.

RF So what happened when you left college?

EK I began to study classical music again and sang professionally for two years in opera and for recordings. But I came to realise that it was the rigorous discipline needed for classical singing rather than the singing itself that really interested me. Singing is like dancing in that it must be carried out daily. Specific muscles must be exercised and a perfect outcome strived for. In this sense the works I make using my memory are a direct consequence of my experience of live art and subsequently of singing. Once I'd stopped singing I began to want to work alone again. I'd been writing scripts when making performances, and writing became a way of working.

RF Can you talk a bit about your process?

EK I often borrow the title of Yvonne Rainer's dance work *The Mind is a Muscle* [1968] to describe my working process. I thought about the subject of each memory work for a long time before I started writing because I had to be

confident that I'd chosen a subject universal enough for everyone to have some degree of access to it. The first memory work was *The Bible From Memory* [1997], the second, *Shakespeare From Memory* [1998].

A critical factor in my choice of subject was whether there was a good enough reason for presenting the final text as a visual object and whether I thought I could find the right visual form for it. Once I'd decided on the subject I would write in indiscriminate order and have blank pages for adding text and then I'd edit and re-order text. I rarely used any tools to help myself but I did make a timeline for *Worldview* [1999] and *The Future from Memory*.

RF And do you set yourself a time limit in writing these works?

EK No, I just waited until I thought I'd finished; I always knew when I'd got to the point where I couldn't think of any more. One of my rules was that once I reached that point, I didn't hang around to see if anything else came back to me, because it's not really about that. That could fill up a lifetime. I was really trying to represent an idea of the contents of memory, and of course it's a fallible project. I couldn't expand much on the contents of the Bible today, but what's important is that the work represents a task completed.

RF You weren't tempted to go and read it?

EK No, I've never been tempted to check anything except Shakespeare. I did look at an atlas to see where I'd gone wrong with *The World From Memory* [a series of four maps of the world]. I quickly realised that we depend on maps as essential aids to memory precisely because they depict information that we can't possibly hold in our heads.

RF Why do you use yourself as a subject? You could have done a social experiment with different people and their world views. Why an inventory of your own knowledge?

EK I wasn't really interested in sociological research as a subject for my work. I thought of what I was doing as more like making a painting – intense endeavour resulting in a single object. Also, I was interested in the mental imagery engendered in the process of recollection, and this is an intensely personal thing. I'd become more interested in what I didn't know than what I did. I started noticing how people take a pride in what they don't know. Mistakes and failures seemed to have equal significance to viewers of my work and in fact were what prompted their engagement with my work. Each person

was bringing their world view to bear on mine, so in that sense I was including others anyway.

I did however use one of the methods of sociology – cognitive mapping. There's a famous sociological study of how cognitive maps drawn by individuals living in Manhattan were clear indicators of economic status. I was interested in the autobiographical nature of these drawings. Once I'd tried to draw the area in which I lived, I realised that drawing a cognitive map is also a universal experience. An entirely mental but highly visual process is entailed in the making of such an everyday drawing and it's something that nearly everyone has had cause to do. I decided to take this to an extreme, trying harder than would ever be necessary, and taking a long time to do a drawing that is customarily done in moments.

RF Some people see your work as solipsistic whereas others see it as a generous act of sharing.

EK I think that people see it as both.

RF Can you keep yourself out of your writing and do you want to?

EK There are two ways in which I could be in my writing – in terms of literary style, and in terms of the subject matter. I've always tried to remove my own voice; never allowing metaphor or literary style. I found this difficult at the beginning. When writing, some kind of style emerges almost unconsciously. I worked hard to purge it from the texts, which always went through the hands of at least one proof-reader. It was important that I wrote these texts as anti-literary endeavour and I would never describe myself as a writer.

In terms of subject matter, obviously the texts are autobiographical and locate me in time and place but beyond that I don't think my work is any more revealing than work in any other medium.

RF Your reviews centre on the mistakes in your texts, but I'm in awe of how much you know. You mentioned Mary Kelly as an influence and I was thinking about the way she deals with knowledge as a masculine power. Even though Kelly is working with the undervalued subject of motherhood in *Post-Partum Document* [1973–79], the language she uses lends the work authority. Although you are exposing some vulnerability in not knowing everything, in many ways you show you know quite a lot and that gives the work an authority.

EK I don't think it's showing what I know that gives the work authority but the language I use and the way I present it. Imagine what a different effect these texts would have if they were hand written and the language was more poetic. I first saw *Post-Partum Document* as an undergraduate and I didn't really understand it then, but the way it was made and presented really appealed to me, the text being made into a series of discrete objects. I only came to properly appreciate this work much later when I understood how Kelly's rigorous processing and presentation of the personal effected me. Thinking along the same lines, I like the way that Carl Andre's floor works occupy space. I think he described some of his floor works as being footprints for huge buildings. That's the kind of authority I wanted for my work.

RF Perhaps there's a feminist impulse in the personalised account replacing official master narratives or 'his stories' ? Someone suggested to me that in a few years the irony of Peter Davis's paintings might be lost and they'll be used to teach art history on Foundation courses. I thought that might apply to some of your work, particularly if it's in a museum.

EK I hope I never see a future where the work of an artist whose subject was the balance of ignorance and knowledge was taken as fact! But I'm not trying to replace official history. It has been suggested to me however that there's a feminist impulse in revealing what I don't know, based on the supposition that a man would be far less keen to reveal areas of ignorance. I don't really think its possible to generalise in this way; if my work has a subversive impulse it's more in the sense that it focuses on the perceived value of knowledge and an acknowledgment of the role of ignorance. When I made the earlier works I was thinking about the internet and the idea that knowledge is at our fingertips, although clearly it doesn't make any difference to our understanding. I did inadvertently make a work where this balance of knowledge and ignorance was upset, *The Law of the Land* [2002] for which I wrote the laws of Britain. Many viewers took this to be composed from actual extracts from legal reference books. In this case the visual form and presentation of my work had absolute authority over my fallible text.

RF Have you showed it in America?

EK No, just here and in Europe. I made *The Law of the Land* when America went into Iraq and there was a lot of talk about the war being illegal. I was shocked that this could happen and I wondered what I knew about how I was governed and how laws regulated my life. I was thinking about how ethics, faith and law are in constant collision.

RF You are public about your rules, although you don't actually state them in the work.

EK If asked, I state that I don't look anything up because it's an important part of my work. There's no integrity or meaning to what I do unless I abide by my own rules. I don't state these rules in my work because in looking at my work, it becomes obvious what I've done.

RF Does that kind of authenticity place the work in a particular context, say a relationship to conceptual feats of the sixties? I'm thinking of someone like the German artist Hanne Darboven, who makes systematic 'writing' based works that may take years to complete.

EK Yes it does, but mostly in terms of the performative aspect. When I attempt total recall without looking anything up, I experience the process as a physical discipline, working to the point of conceptual exhaustion.

RF Does that mean your retrieval of memory has improved?

EK Not at all, but the process has become more streamlined. I don't need to think about how to apply my rules or about writing style.

RF So can you tell me a bit more about the visual aspect of it? With the object lists you get a mental image from the reading.

EK Yes, the series of works that I call object lists, (for example *The Bible 2717 objects in order of appearance* [2000]), are intended to function in that way. I first showed these works in postgraduate seminars as ideas for sculptures. My idea was to turn a book into a heap of objects but I became convinced that the lists were works in their own right. The texts were triggers for mental images, independent of the narrative from which I'd extracted them. This led me to explore the visual aspect of memory, the mental image, as a means of recall. It was important that I found the optimum visual forms for my texts so that they could have a dual existence as text and as an object that doesn't require reading. The title and appearance of each work alone should convey much of the meaning. This was the biggest challenge for me.

RF But what about the projections?

EK I wanted *The Future from Memory* to be a time-based work. It's still important that the work can be appreciated without reading it, but this time I wanted to try to

make the reading compulsive but elusive, which is how I thought of the future. The obvious visual reference is to the *Star Wars* title sequence. I designed the animation so that the viewer must try quite hard to keep up with the text. To stop reading for a second or two means waiting to pick up the thread again. I like to operate on the threshold of the viewers' attention span, and that's why the appearance of my work is as important as the contents of the text. *The Story of Art* takes this to an extreme, starting at a speed that few would put up with for long. Since the animation is ten hours in duration, however, a viewer might catch it at any point during the incremental increases in speed as the centuries pass. I wanted to make a work where the risk of losing viewers during the slow part was counteracted by their knowledge of what I'd done. I also wanted to see if I could make a work that viewers would return to. At 130,000 words, and a breathless speed at the end, it was so long that it couldn't be read in its entirety in any case.

RF Is it important how your audience engages with the work?

EK Yes, because that engagement is the subject of my work. *The Story of Art* [Tate Gallery, 2003] was commissioned as a response to the institution. Apparently people spend something like three seconds looking at a work of art and four and a half seconds on its caption. It's hard to overcome the urge for information about a work and its maker and simply look. I hope my work acknowledges this relationship between looking and knowledge.

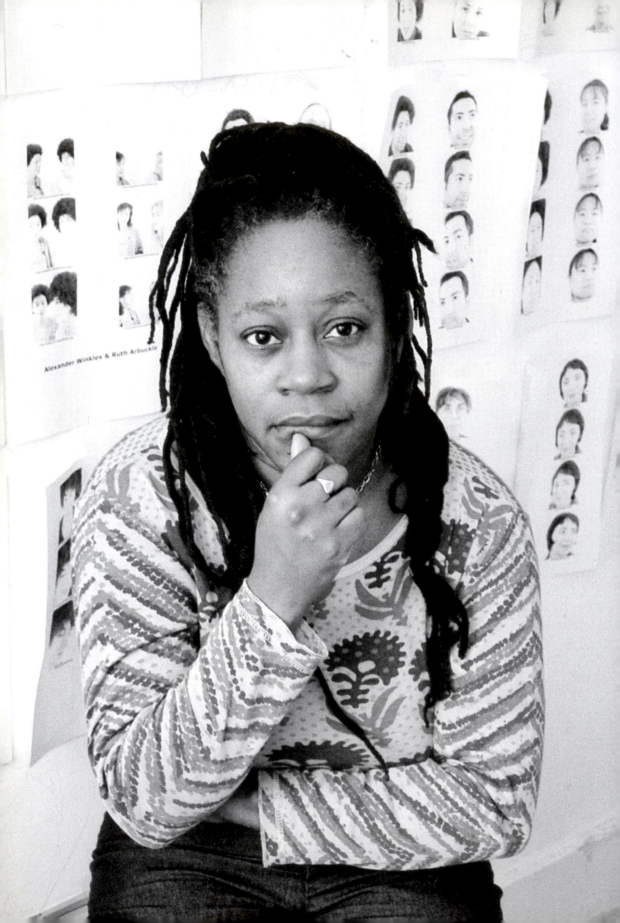

Alexander Winkles & Ruth Arbuckle

SONIA BOYCE

Sonia Boyce works across a range of media, including photography, installation and text. Early large-scale figurative drawings reflected upon growing up within Afro-Caribbean/English culture. Boyce continues to make work that stems from experience, dealing with the ways in which identity is formed and recent work includes events staged with vocalists.

RF You've always struck me as an artist who doesn't necessarily have a game plan.

SB I suppose so. I'm known for those early drawings, which were done for three years, and I knew, at the very moment it was in progress, when I was doing the last one. One of the things I've realised is that I'm not good at doing signature, or worse still, mannered work. Once I've come to a conclusion, I need to move on.

RF Those drawings [eg *Missionary Position II*, 1985, Tate Collection] were phenomenally successful.

SB They were made at the beginning of the eighties, when young artists were catapulted onto a certain kind of public platform. Those drawings were shown a lot but I hadn't caught up with the reception of the work. I'm not disclaiming those works; they were very particular, urgent questions that I needed to address at that time.

RF Were there things about them that, with hindsight, you're critical of?

SB What I feel in conflict with now is the idea of having a pre-set programme before I start. At that time there were expectations that one should go forth with a clear agenda and plan and manage the work in relation to that intention. I think that expectation came from the conceptual art of the seventies, where one sets out a declaration of intent and then carries it out. It's as if the proposition is more important than how it's made, as if you know what you're going to do before you do it. I've not got anything against Victor Burgin but I think he's a strong exponent of this approach. There's a

'manifesto' that sits beside the work and tells you how to see it. But often I've read his manifesto and thought, 'Oh, I see something completely different here'. I think the same is going on in my work. When I'm able to step back, I see that besides the things that I thought the work was about, there's other things seeping in. I made a big shift in the nineties where I was able to let go of this sense of keeping within set boundaries, to do something that I couldn't account for.

RF But it's also to do with what or who you represent, isn't it? It's difficult to be a positive role model because there might be aspects of the work that are in conflict with what one rationally or politically believes. So do you edit it out?

SB I needed to grapple with this other uncensored stuff. Now I don't need to adhere to a declaration of intent; a right and a wrong. Instead I say, 'let's just see what this is and how it unfolds'.

RF Do you think you have to have a certain confidence in yourself as an artist to do that?

SB I'm not sure. The shift that occurred in the work happened when I was making the hair pieces. I didn't have the same kind of public exposure for these as I'd received for the drawings. Things got much quieter and I was just getting on with it, without it immediately being a matter of public discourse.

RF That was quite good?

SB Yes, I think that's what enabled me to move more in that direction. If one thinks about the Black Art Movement, of which I was one of the central people, by the nineties the heated debates had disintegrated, like the heated debates of feminist practice of the seventies and early eighties. It was almost like the debates were the guardians of right and wrong. Through their dissipation I felt it was up to me to make my own judgements, rather than as a collective debate. That sounds like I'm saying individualism should operate above collective activity but that's not really what I mean. I just thought I should stop trying so hard to manage, and see what came along. Rather than declaring it, try to find out what it is.

RF I wanted to talk to you about all the different things you do and the relationship between them and your work. Did your work at the African and Asian Visual Artists' Archive relate to your practice?

SB When I was working for AAVAA, I was co-director with David A. Bailey (my partner). We were there to take archival material slides; reviews; private view cards; books and videos and help make sense of it for researchers. It was a perfect job, because I've been an activist since I was a teenager and this was activism in the field that I work in. What was interesting for me as a practitioner was to look at contemporary practice in relation to programming the archive's own research. Working at AAVAA mirrored my concerns about how the historical is ever present but can often be overlooked. This went alongside the material transitions that were taking place in my work with photographic media, with hair, with texts, with the wallpaper pieces and, increasingly, working with people.

RF If you're not bounded by medium or ideas, what is it that initiates the work?

SB Often circumstance. For instance, I was asked to organise an exhibition at Gasworks Gallery in London; I decided to work with the artist Yeu-Lai Mo and the writer Marcus Verhagen. In the meetings with the exhibition organisers there was a lot of pressure to see how we could address the outreach educational programme. Because I'd invited Yeu-Lai into this scenario, I was reluctant for her to have that 'community liaison' obligation, so I took it on myself. I decided to do a choral piece where I invited three different performances to take place in the building. So it was the circumstances that started to shape what I went on to do.

RF If you have a sense of the audience, does it affect what kind of statement you make?

SB I'm not sure I make statements any more and I think that's also been a big shift. I think the work is much more questioning than it's been before. The earlier works, up until the nineties, were much more about addressing an audience. Since then the work has had more of a question mark about what audience/participation constitutes.

RF A question of getting older?

SB Yes, but also because there are now fewer certainties politically and socially and there are less certainties for me in terms of what the thing that I've just made is.

RF Can you talk about a piece of work that you feel that about?

SB *We Meet Through You* [2004] is a piece that is two photographs and two CDs of two people singing. I went to two different places to record two people singing

and then they're put together through a mixer. You hear one person in one ear and you hear another person in the other ear and they play simultaneously and I'm not sure what sense I want the audience to make of it. I know that the reason for doing it was that it was intriguing me. I was thinking, 'what would happen if I did this?'. I wanted the person who comes to the piece to be the conduit for these two voices. Why, I'm not sure yet. I'm sure as time passes I'll understand it better. In this sense the audience is integral to the piece, but I'm not providing any clear message.

RF The audience experiences a kind of suspension, things held in a balance.

SB Politically, I don't know what I'm suggesting, but I know that for a long time the audience has been key to the work. In the piece I'm questioning and acknowledging their role. For me, the relationship between people is as much a part of the work as putting pencil to paper.

RF Do you have some guiding principles when you're collaborating?

SB Sometimes I feel responsible and sometimes I feel burdened by the responsibility. I know I have ultimate control over what gets put out there as an artwork. There are all sorts of ethical questions involved and, probably because of a history of a certain kind of political activism, I'm caught around this question of representation, responsibility and ethics, often to the point where I want to run in the opposite direction …

RF …..and pick up a pencil?

SB Well, that still doesn't alleviate that question because even text or a drawing is representation and so it doesn't necessarily become a safe space. So I'm not sure it's a resolvable one. I've worked with people that I didn't know for an hour and I've not seen them since. I mean we just meet, they get paid, they do whatever it is, and I make a work and I never see them again. I'm quite intrigued by that kind of brief encounter. I keep thinking about Erica Jong's *Fear of Flying* – there's a sense of a kind of friction, a kind of energy between strangers. She talks about the 'zipless fuck', though I might add that I'm not having sex with any of these people!

RF There's a dominant attitude, perhaps originating from gallery education, about the ethics of working with communities and sustaining any intervention.

SB Yes, there is a kind of morality that comes with that argument that suggests that…

RF ….you're not going to be a tourist ?

SB But if one thinks about the experience of modern life, there's so much
 transitory contact. You might have a conversation with someone at a bus stop
 and then never see them again. That's not an uncommon experience, in fact it
 is how we live with each other. So I'm not wracked with guilt for having these
 very brief encounters with people that I don't know. I've talked about being a
 parasite and I recognise that I take from people. There's been a lot of
 discussion about relational aesthetics. At a conference in Bristol called *The
 Wrong Place*, a number of artists said that they weren't political artists. I said,
 'Actually I am a political artist, even though I couldn't give you my manifesto,
 because I recognise that by virtue of what I am, circumstances around me have
 framed me politically'. This happens whether I want to be political or not –
 and I do. Part of my personality is to be political. That doesn't mean that the
 work turns automatically into polemic but I recognise that circumstances often
 unearth questions of value. For example, I did a project at The Cornerhouse in
 Manchester called *The Audition*. We advertised in the art centre's magazine to
 photograph people, on condition that they wear an afro wig, and we were
 inundated. I took over nine hundred photographs in one day. At one point
 during the day I was photographing this white woman, middle aged, beautiful
 funky hair cut, but she was really uncomfortable. I realised then that the advert
 didn't say I was black. If it had, I don't think as many people would have come
 because they would have automatically read it as political. What was really
 interesting was that it was during the process of the project that its political
 dimensions became clearer.

RF Tell me more about how the work with hair changed your way of working.

SB At a symposium about artists and social engagement I did a talk entitled *Help,
 I don't know what I'm doing*, that related to this question of post-intentionality. For
 me, doing the hair pieces became that moment. I started making them because
 I'd had my hair braided and I started to doodle with these braids that had
 come out of my hair. I started plaiting them and then I started to sew them.
 In my studio I was working on big collages/drawings/photographs, and I was
 really struggling – they were the intentional works. At home I was sewing
 together these really odd hair things, and after a while I had, in the corner of
 the kitchen floor, piles of these ugly looking hair things. I slowly realised that
 I was more interested in doing the hair things than I was in what I was doing
 in the studio and finally I decided to take them to the studio. I found them ugly
 and they scared me. I didn't know why they held my attention and why I was
 making them. I asked a colleague to talk to me about them and it was really
 useful to talk with someone else. That conversation allowed me to impose

intention on them. I started to think about them as curiosities that one might find in a museum and to play with the ways in which I might display them. They became an installation called *Do You Want to Touch?* [181 Gallery, London 1993]. I then realised the potential of these things, these fragments were stand-ins for the black body. This fragment of hair was also a fetishized representation of the black body. One of the things that came out when talking to people when the work was on show was a common experience of black people, of having their hair touched by friends but also by complete strangers and the nature of the black body in a public space being public property.

RF Yes, that happens when you're pregnant as well – people come up and touch your tummy.

SB It's such an affront, suddenly you've become this public property. When you talk about it people get really upset, as if you've chastised them. You're supposed to remain silent about the dynamics of your own subjectivity. That's what I mean about post-intentionality, that in doing something the dynamics of it come out through the process.

RF Tell me about your recent show at The Agency in London [2005]?

SB There were about seven works and they were each quite different. In fact, one visitor asked whether it was a group show! But for me it was one thing – all of the works were about sound in some way. There were photographs, sound pieces, a DVD, a wallpaper piece of text using the lyrics to a song. In moving between the works, the question of sound resonated around the room. For the last five years now I've been trying to make a history of black British female singers – I've gathered about 90 names now. There's also a growing collection of CDs, records, drawings, films and other related material and I've been working with DJ Miss Bailey who played on the opening night of the show. These works were originally intended as hermetically sealed pieces but then a dialogue criss-crossed around the room, which is probably a very apt way of talking about what I've been doing; seemingly unfocused jumps but, of course, really connected.

SONIA BOYCE

Crumpled tracing of Poly Styrene **from the** *Devotional* **series, 2001**

Image courtesy of the artist

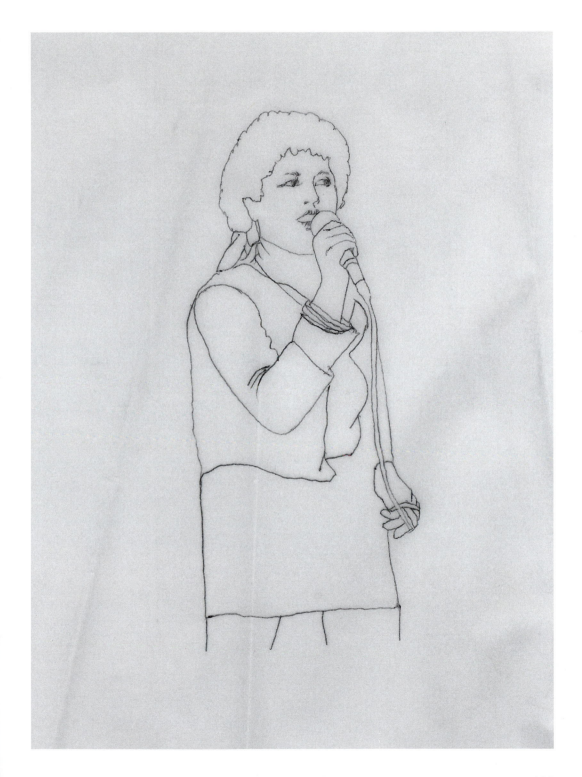

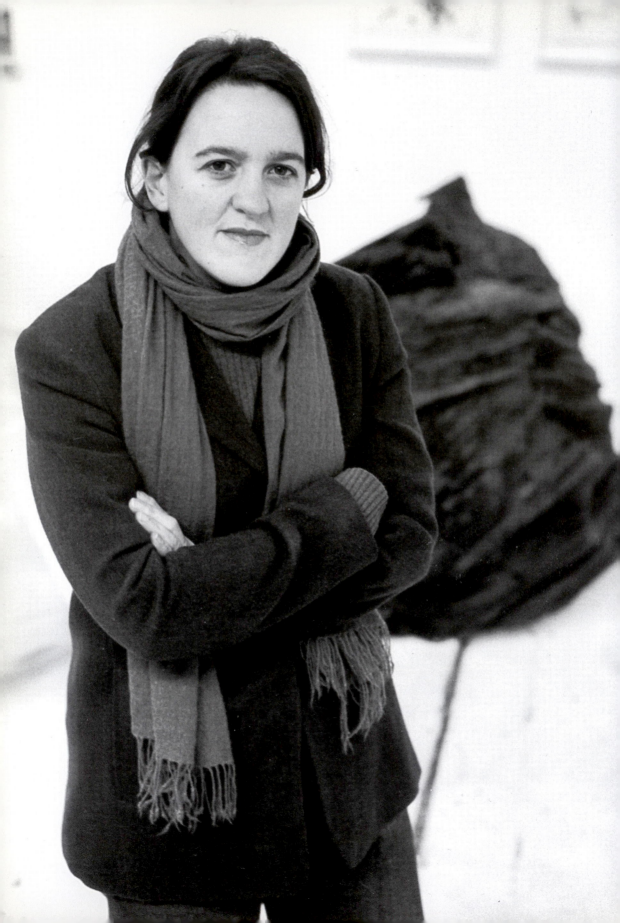

TANIA KOVATS

Tania Kovats works in a range of media. Early pieces used neon in architectural installations and she has gone on to exhibit both in galleries and in land based projects. Her work often explores issues around how landscape is made, for example her exhibition *Schist* [2001], included a machine that made sculptural models of rock strata.

RF You did your Masters degree at the Royal College of Art in London – what was it like in the late 1980s?

TK I found the RCA incredibly misogynistic. I was given a tutorial by someone who said, 'Why are you bothering? You are just going to get married and have a kid' – it made me fairly robust. A few of us spent time trying to assess what our expectations of education were. This was when the thing at Goldsmiths was kicking off – *Freeze* – and it was important to think about what was possible. You weren't expected to sit around and wait until somebody took you seriously, you could make it happen before you left college.

RF So tutors weren't particularly helpful, but your peers were important?

TK Yes, that was where the education happened. I wouldn't make a group of it but because we were going through the same experience, and because of our frustrations, we did have a dialogue.

RF Was that Gavin Turk's year?

TK Yes. Jake Chapman, Liz Wright, Alex Hartley were in Sculpture. Then Tracey Emin, Dinos Chapman and Anne Marie Creamer were in Painting. I should say that it was from the Royal College that I was nominated for – and won – the Barclays Award. It meant I left college financially independent. It made me more confident, leaving college without debts.

RF You're an artist who makes work in different media and situations. I was wondering what you felt your different bodies of work have in common? Andrew Cross has talked about 'the value of absence rather than the presence of something immaterial' as a distinction in your work.

TK At the Royal College I turned up in a school of sculpture and was expected to make objects, hit things, cast things, in a macho way. I started working with light as a material as a reaction to that. I wanted to make work with nothing, rather than manipulate materials.

RF Did you ever make objects?

TK Yes. At Newcastle for my BA I worked with clay and photography. I was interested in Marina Warner's book [*Alone of All Her Sex: The Myth and the Cult of the Virgin Mary*], to do with the maternal body. I made a map of the Virgin's body. I used pieces of her body that are fetishized to make topographical features – for example, her halo was a harbour, her breasts volcanoes that erupted milk, the unbroken hymen was quite a complex mountain range, that you couldn't get into. It was all very literal. It's quite bizarre in relation to my more recent 'map' work, which is far less sexualised. I was thinking of the body as a territory that could be chartered.

RF Your work has been seen as an investigation into the place where the physical and spiritual meet, but I feel the Virgin works operate differently from the others because her image is so overtly culturally placed.

TK For me the Virgin is cultural; an archetype, a political body, propaganda. She stands for women's identity and ideas, how women see themselves and their sexuality and how men see women. She is also, and this is a personal view, a site. She is not just an object but a utopian place. She is a rock, a place, a refuge, on a psychic level. That's my relationship to her because of my personal history. There's one level of discourse I have about her that's to do with the things I listed, which is very important and motivated a lot of my interest in her. But away from all of that I do see her as a place, which has led to a search for other places, not necessarily real.

RF So how do you then negotiate the imagery of her from a kitsch statuette to a beautiful carved mediaeval statue?

TK But she is not the object.

RF So how do you negotiate the object?

TK I think for me the most successful work to do with the Virgin Mary is the
 Fatima piece where she's like a ghost – she's not really there, like a projection.
 Similarly, *Grotto* [1994] was really the last piece of work I did where she's not
 there but her place is. Grottoes traditionally are the doorway to another world,
 the point of crossing over. She's absent from the work but there's the very real
 presence of the ugly-beautiful grotto. It was also a crossover for me, as it
 allowed me to look at landscape. The light pieces are also a type of landscape
 – the landscape of a white-out snowstorm or peering out of a plane window
 into cloud, so there's a relationship between that and the white cube, the
 gallery space. I was looking at the landscape of art as well as the imaginary
 landscape.

RF Were you brought up Catholic?

TK No, but I went to a convent school.

RF Are some of the works that use the Virgin Mary flippant?

TK No, they have got me into so much trouble that they could never be flippant.
 Virgin in a Condom was about serious issues – it's the piece of work nearest to
 propaganda that I've ever made. Within my overall body of work it stands out
 a bit, it's an important piece for me. It's a multiple, so there are quite a few of
 them. I've shown them in Catholic countries and not had any problem but
 when they go to places where Catholics are a minority, where Catholics are
 uncomfortable or disenfranchised, they can be read as a threat. Guards have
 been attacked, curators get in trouble or the work gets destroyed or stolen, and
 there has even been a massive prayer vigil outside a museum. The press file in
 the British Council is very big. The Arts Council owns one that they decided
 not to exhibit to the public, which is quite a big deal politically; the idea that
 they are buying work that they consider they're unable to show. It's
 complicated, very unpleasant. I don't enjoy controversy particularly, I'll defend
 the work but it isn't what motivates me. Unless you've set out to cause it, it can
 be quite a shock. More recently the status of condoms has changed, they are
 now seen as protection, which prompts a different reading.

RF When you were talking about *Rocky Love Seat*, [2000] an outdoor work for
 Belsay Hall in Northumberland, you made the distinction between work you
 can enter physically and work you can enter imaginatively.

TK I've made public works like the plinth for the Ikon [Gallery, Birmingham] that you stood on and *Contour*, in Somerset, where you walked along that piece. I think *Rocky Love Seat* worked quite well in that exhibition because there was an expectation of work to be sat on; all the exhibits were meant to be interactive. It's not the way I'm used to working and I still have to work out my relationship to this dimension of the work.

RF Because it's a different kind of engagement with the audience?

TK Yes. There's a pleasure watching kids climb through it, conquering it. But the landscapes I work with are un-peopled so it's odd to have that kind of interaction.

RF One of the aspects of entering a work imaginatively is that this is done via the act of looking and often your work seems to reflect on this act.

TK One of the things about being out walking is that you can see the landscape unframed and unbound and I think that's a very difficult thing to process. One of the ways of dealing with that is to fragment it, to cut it, to give it a limit – to reference that difference.

RF Between landscape and its representations?

TK Yes, but an interest in the more geological landscape is against notions of looking because the geological landscape isn't readily visible, it's under the surface. I'm also interested in the process of landscape, how its made. That's a way of using landscape that moves away from the visual, but that doesn't mean that the visual isn't important in what I make.

RF Works such as *Rocky Love Seat* or *Sunk,* [1999] also refer to the modernist plinth or the white cube you mentioned earlier.

TK Yes, I became frustrated working with the architecture of the white cube directly because it conforms to such a strict set of rules, so the white cube became part of the work via the plinth. I needed a frame for the language of the landscape – it needed to be contained and given a boundary. It signifies a simplistic gendered activity – the male white cube and the female rock face – an obvious relationship or interdependency. The cliffs and the rock forms are often the thing eroding the solidity, whether they're burrowing into dark interior spaces or making a cave all the way through it, they attack the solidity. They also push the cube over and subject the plinth to the same geological

forces that they're formed by. But the rock formation couldn't exist without the container.

RF I see a dialogue between eighteenth- and twentieth-century notions of the sublime. The luminosity or 'whitening out' you've described is a twentieth-century metaphor for spirituality but you also reference Burke's sublime, the vast, awe-inspiring landscape.

TK They are not easy bits of landscape. I'm thinking of the horror of the sublime as well. There's also a sense of the body locked within them too.

RF Works like *Blue Bird II*, [2000] or *Tilted*, [2003] create 'model' landscapes of cliff formations or other geological features. Do you take the images from postcards?

TK Yes and old books – things like *The Wonderful World of Nature*, those 'technicolour' photographs that try to explain the wonders of the world. Postcards are very useful, they turn complex landscapes into readable things. Very few of my landscapes are 'real' places.

RF Charles Derwent has called your work 'obviously natural but just as clearly artificial' – he was writing about *Contour*, [1999].

TK I made *Contour* for a show called *Secret Gardens*. My garden was actually a valley, it was quite a formal piece. I wanted the crop cut to the same height, regimented like a block of material, following the contour of the valley. It made a very big edge – like making a green plinth. I had to think about when to plant things, harvest things, so I was helped by a farmer. I was pregnant at the time so I was negotiating the various delights and horrors of that state! I think about it as a pregnancy piece.

RF It may seem obvious that you would do this piece after the landscape plinths, yet it seems a contradictory impulse, to deal with the real stuff of landscape.

TK There's a preoccupation with other places, places that I'm not in.

RF Utopias?

TK Yes, but in this piece I had to deal with the real agricultural landscape. In this country what we think of as 'landscape' is managed by farmers who determine what it looks like. I wouldn't put a plinth work outside because it's about

landscape being inside, imported to the cultural arena, the gallery. But when I go outside, I use the language of outside and in this instance it was to do with farming.

RF You've talked about the 'economy of landscape' but it isn't something you want to expose?

TK I know how the economy of landscape affects it but I'm not an environmentalist, or particularly political. I think my work occupies an imaginative realm.

RF Even when it exists like *Contour*?

TK I was able to take great pleasure working with the farmer and looking at the reality of his problems. He made jokes like 'oh well, we've all been told to diversify!' The art was a good bit of diversification; a sculptor plants a crop of oats that's economically unviable, in farming terms it was a waste of time. It's good to engage others in the work and I think there's something to be said for the work having a kind of blankness or dumbness at times that makes it a suitable vehicle for argument. Utopia is a place where people work out political systems. You have a blank territory on which you invent.

RF Keith Patrick wrote that your show with Barbara Hepworth [New Art Centre, 1999] brought us 'full circle to the landscapes that once informed Hepworth's sculpture'. However, Dave Barrett said 'the [work] refers to...this inability to grasp any scale that might force meaningless upon us'. Are you interested in the desires the landscapes engender rather than the landscape itself?

TK For me, being in landscape is more about the feeling of being in motion, the movement from one place to another. A walk can be an emptying out, and then the processing of that experience starts to fill it up again. I'm very fond of Hepworth's quote, 'I am the landscape', it's so euphoric, uncomplicated and bold. But for me it isn't a particular landscape that I return to or have a personal relationship with. It's about moving through different places. People often tell me they know where a piece is based on – they bring their own particular landscapes to the work.

RF So, why coastal landscape? Is it to do with your interest in the edges of things?

TK It's at the edges that you get to see what the landmass is made up of, you get to see under the layer of vegetation or architecture. Coastal landscape is also important because you can see the horizon, the sea and sky horizon.

RF Do you have a favourite horizon?

TK Yes, I probably do – either a sparkling sea on a windy day or a quiet mist hanging over the sea so it dissolves the horizon line, but neither of these is a place, it's the idea of an horizon. I keep coming back to this.

RF You've said 'the art space is a catalyst as well as a container' and you've worked with quite a rich array of spaces and in many different capacities: artist, curator, advisor. You seem to thrive on the notion of collaboration.

TK I go through phases. I came to a point where I didn't want to do any more collaborations for a while, I was feeling very diluted by it. For the Asprey Jacques 2001 show I worked with other people a lot, geologists, cartographers, but it was driven by me rather than having to cooperate. *Lost*, the exhibition I curated at the Ikon in 2000 was a very personal exercise, an intuitive bit of curating. There were connections between works that I'd predicted but it was magical to see them talking to each other. Sometimes I saw it as a clan gathering, a bringing together of things that had enormous resonance for me. It was a great privilege to be able to bring those objects together. Flicking the switch of a Felix Gonzales Torres was one of the most euphoric art experiences I've ever had. I looked at the things that really mattered to me and took stock of how I make work. I also did quite a lot of writing in the catalogue and I was surprised that it affected people.

RF It was interesting you wrote about your pregnancy, as this still seems to be taboo.

TK I know. I think Mary Kelly's *Post-Partum Document*, [1973–79] is a rare event. But pregnancy and having a child has been a formative experience. I would even say that the experience of trying to push a baby out poses a massive sculptural problem. How do you get a big thing through a small hole? Perhaps you could see that the works address that problem. They are *chthonic*, a Greek word meaning 'of the earth', the weight of the earth, not pretty vegetation growing on top. That question – how is this made? – is a question I ask of objects all the time, and I started asking that of landscape, 'how is that mountain made?' Geology and geomorphology are the disciplines that investigate those questions and I think my sculptures are looking at that question of how is something physically and culturally constructed.

RF My last question is about the art market. I feel a lot of what you do implicitly challenges the notion of private ownership.

TK

It's not that there's no renumeration involved. It's just that my time gets bought through fees. That's an odd economy for me, the idea that someone will pay to have my opinion. I don't dismiss the idea of work being bought or sold, but I try to fund my work in lots of different ways, like research grants. There's a commodification process and it's unrelenting; anything can be turned into a commodity. It's our situation. I'd be very happy for this process to be slightly problematic. When you make a piece of work you want to communicate with someone and the idea that someone would want to live with an object is a very generous act. I've loved making my work but the moment in the studio when it comes to wrapping, it's not mine any more; they are public things. The exchange is already in process.

TANIA KOVATS

Mountain, **2001,**
Steel, timber, foam, glass wax and lead shot
$230 \times 168 \times 70$cm

Image courtesy of the artist

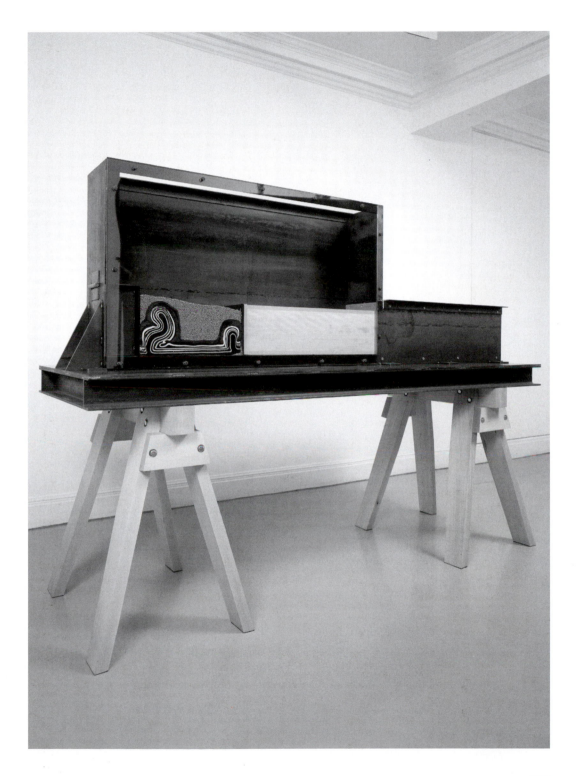

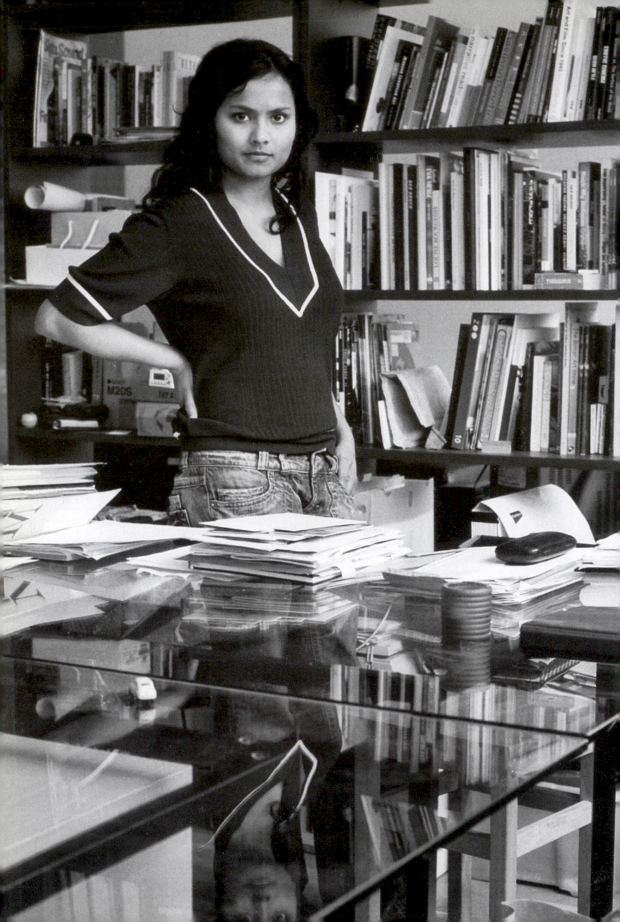

RUNA ISLAM

Runa Islam works in lens-based media and is principally known for her film works. These visually stunning projections unfold complicated and disjointed narratives. Her works call attention to their construction, and their physical installation often enforces the disrupted nature of their consumption.

RF You started out doing a degree in Art History and Philosophy, when did you know you wanted to be an artist?

RI The degree was something I didn't feel completely dedicated to. It was essentially the essay writing and its reference to already qualified canons of thinking that made me restless and in want of a possibility to create something with a personal language. But I hadn't considered being an artist at that time. Actually, I wanted to be a photographer, and that's what I pursued, in an amateur, hobbyist vein. It was only when I was exposed to artists and writers during a kind of summer internship on an art journal called *Lovely Jobly*, that I met artists and writers who were creating a 'living' art history, that I was inspired to change my direction. Working with the artist and curator Peter Lewis, who was one of the editors, gave me an insight into how my ideas could develop further. I continued to work with a camera and also produced an extensive amount of sketchbooks that were a combination of drawings, writings and collages. It was a formative period of finding methodologies that helped me understand that the instrument of the camera, or a found object, could become a critical tool. Everything I made at that time had a home-made quality, but a fresh and experimental approach. I began using a video camera and super-8 camera in 1994 and in 1996 I was accepted to do a residency at the Rijksacademie in Amsterdam. Looking back, I think the change from my living room and everyday locale to the platform that the Rijksacademie provided was an incredible shift. But already by the time I entered in 1997, I had begun to consider myself as an artist.

RF Do you feel that you matured there as an artist?

RI It certainly helped me to focus my practice. The residency lasted for two years and gave me the chance to experiment with many different mediums and materials. There were only 60 artists and a lot of resources. There was a kind of hothouse environment that enabled it to be a prime place for 'maturing'. I remember impulsively and endlessly recording as much as I could of people, places, journeys and improvised set-ups in my studio. The one piece I always look back at with a sense of admiration is the highly complex installation called *Martin*, [1997] that orchestrated five synchronised video channels (each encasing 15 separate passages of film and video), a semi-functional darkroom, a fibreglass sculpture and some huge hand-printed black and white photographs. I think that was my most excessive period, trying to materialise everything that came into my mind. I'd say the maturing process began when I was able to have more control over aspects of the process and outcome of my works.

Martin was made only a couple of months before the very essentialist work *Exile* [1998]. A work like *Five Super-8 portraits*, [1997] emerged when I applied the straightforward parameters that the films I wanted to shoot should be a series of short portraits made on black and white super-8 stock. In that defined space I could do whatever I wanted, or let happen whatever was possible. I mediated between trying to record life in real time in an unaffected manner and admitting my involvement. I realised that holding the camera and minimally guiding the people on the other side was a move towards fictional space and staged event. However, the strong nostalgic overtones of the black and white super-8 quality proved to be the reason that I stopped using it. Since then I've only used video and 16mm film – and more recently 35mm.

RF So did you ever think of going to film school? Or have you always seen your work as operating within a fine art context?

RI I think any romantic desire to go to film school was offset by the knowledge that I probably wouldn't be able, or willing, to make the conventional narrative-based films that would be promoted there. When I use film within a fine art context, I don't need to work from the 'storytelling' basis and am free to exercise the medium as an investigative instrument that can just as easily be concerned with the material, as well as other aspects of the form.

RF Your earlier work meditates on the act of looking and I wondered how that became a subject for you?

RI

There are three 'early' works that can be considered under a theme of 'looking'. *Stare Out / (Blink), Turn (Gaze of Orpheus)* and *Tuin* [all 1998]. They were made one after the other, as if in conversation with one another. However, I didn't make the pieces with any explicit intention to fulfil a theme. The works developed in a natural way, searching and investigating how to represent the qualities implicit to the medium. Qualities such as film's ability to capture and materialise the temporality of a real world, a temporality which in essence is immaterial. In *Stare Out / (Blink)*, a girl's face gazing directly at the camera is presented as the filmic negative. This is inter-cut with clear passages of 16mm film. It's during the clear passages, when the white of the lamp can be seen, that the negative image of the face appears as a positive after-image directly on the viewer's retina like an apparition. This perceptual effect can highlight the direct affinity between the eye and celluloid. It's known as the *phi* effect, which is the phenomenal essence of why we are susceptible to moving images. *Turn (Gaze of Orpheus)* played upon the fatal gaze of Orpheus, where in looking we also are subject to losing the moment and the image. We're left with a memory, an intangible entity. It was only after I made these two works that I was able to identify their concerns. Whilst making them, naming the processes seemed impossible as I wasn't articulated about exactly what I was doing. By the time I made *Tuin*, my interests in the subject and the subject position emerged more clearly (though still not clearly articulated). However, the clearer conception allowed the piece to evolve into a more complexly layered work. The direct act of looking is housed within a framework of 'illusion/reality', 'male/female' and 'viewer/viewed', subject positions. This was displayed on three separate screens to purposely disturb the binary associations, with each of the screens playing a key role in the orchestration of the 'visual' idea.

RF

These are very succinct works. When you started working with texts and narrative, things changed. The idea that reading or interpreting is contingent on time and place seems most explicit in the later work.

RI

You're right. *Stare Out / Blink* and *Turn (Gaze of Orpheus)* are touchstones of clarity, and *Tuin* also. But I think all my works, including these pieces, are invested with intertextual and contingent concerns. My methods are certainly more elaborate in the later works – *Director's Cut (Fool for Love)*, [2001], *Rapid Eye Movement*, [2002] or *Scale (1/16 inch = 1 foot)*, [2003]. These works sustain the dialogical and inter-textual meditation of the subject that emerged in *Martin* and more coherently in *Tuin*. I recall that because of my desire not to build my practice on what could be regarded only as a 'one-liner' or an 'image-bite', I pushed myself to make pieces that couldn't be consumed quickly. That's why these pieces get longer and longer in duration. They both invite the viewer to

endure a boredom that's counterpointed with a dynamic timing or rhythm. *Director's Cut* or *Scale* are set up as double projections, differing in their display, but both refusing to be pinned down to one order of events that close other interpretations. The sense of a sliding scale of meanings and interpretations is at the heart of many of my film works and other manifestations that I regard as my art works. I think there's a constant sort of shifting and moving, like you are going in one direction and also at the same time negating that motion.

RF Your work's subject has been described as 'constantly evad[ing] itself', yet it's not an emptying out; there doesn't seem to be a nihilistic impulse.

RI I'm not trying to be nihilist, but I am using negation to establish something in place of what's questioned. *Twin* quotes a scene from a Fassbinder film that I wanted to break down and readdress in a new perspective. This was a challenge, as the original sequence already portrayed a 360 degree camera movement around its subjects. *Director's Cut (Fool for Love)*, was purposely spread across two screens, decentring the subjects' and viewers' attention. If on one screen you saw the director's face shouting out to the actors on the stage, on the other screen, you'd see the back of his head, obscuring or blurring the actors, saying or shouting out something different. However, by the end of the sentence the words match up to bring the screens into a synchronicity.

RF It seems to me this notion of multiple viewpoints, or no single Renaissance viewpoint, is matched with quite a strong formal sense. As a viewer, the projections are not completely chaotic; you become very aware of an order, and for me, it's part of the aesthetic.

RI I don't want to distinguish the very visual, phenomenological aspects of the work from the formal, or the emotional. It's all part of the process. I like what Bresson said about the deaths and rebirths of the film process. That firstly you kill something by filming it and bring it back to life when you see the rushes, and then by cutting the film you kill it again and resuscitate it in the editing process. This summer I made a work that isn't a film, but that exemplifies my process. The piece is a 'soft' sculptural intervention in a wild, Stone Age moor on an island in Sweden called Öland. I subtly remodelled an area of landscape where wild and hardy juniper bushes grow by engaging gardening clippers and tools and a group of the local people to help cultivate the bushes into perfect oval and circular forms. It wasn't my usual method of editing, but I felt it had a similar approach, that I try to create a new form out of what otherwise passes unnoticed. With the bushes work titled *As Far As the Eye Can See*, as with my film works, I tried to provide a new perspective from which the everyday can be

regarded. That's where I try and place my attention; shifting or editing or framing things to show them in a different way.

RF What place does intuition have in your work?

RI I don't ever use that word, maybe because it seems like a rude word in art. At least in art school. Can you imagine art tutors saying to students, 'Use your intuition', and then going off on a coffee break. I remember once at the Rijksacademie, when I tried to discuss the tension between being confined in the studio and wanting to work outside or travel, Dan Graham said to me, 'You should travel, it's really good for you, you're a Sagittarius'. I thought what a useless, uncommitted thing to say, but afterwards it stayed with me like a mantra. Sometimes you need to follow your instincts or inner rational alongside the critical thinking. Especially when you're trying to distil or capture something that hasn't yet been named or articulated. I have to admit that no matter how much I try to control my working process, there's always that moment when pure improvisation/inspiration takes hold. Maybe that's intuition. I call it a kind of free form-alism.

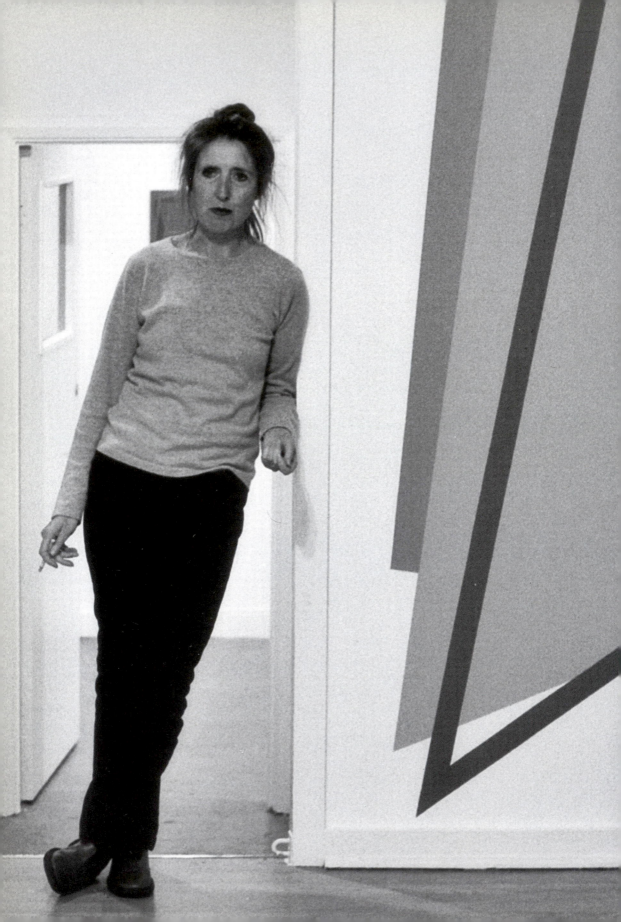

VANESSA JACKSON

Vanessa Jackson makes abstract paintings that employ geometry. Her shapes interleave on the canvas's surface, implying a third dimension impossible to realise structurally. Her choice of colour is unusual, often dissonant, and the paint is applied in a neutral way that avoids mark making. She has also made wall paintings, graphic works and prints.

RF What are the central concerns in your paintings?

VJ I'm exploring a relationship that is to do with an experience of space. I've always been interested in geometry, which I think is at the root of everything. Geometry is a form of 'democracy', it isn't owned by anybody or any culture, and it's an already invented form of understanding space. I used to play with geometry as a child. I came back to it in my second year as an undergraduate fine artist. My interest is influenced by minimalism. I wanted to make some order out of what was a pretty bad period in British painting, where you were urged to 'express yourself' in a physical way which I had no interest in.

RF This was when you were at St. Martins School of Art in London?

VJ Yes, the dominant characteristics of painting were to pick up a broom or make sure the drips were working.

RF And it came out of a misunderstanding of abstract expressionism?

VJ I think it came out of second generation abstract expressionism. I was more interested in the Barnett Newman side of things; the notion that one could 'think' a space. I came to London in 1971, which is the date that feminism started here, thanks to interesting Americans like Susan Hiller and Mary Kelly. Art Feminism came through people who weren't painters, through conceptual ideologies. I made what might be seen as conceptual work – a series of grey bricks that were cast out of the bottoms of plastic turps containers. I laid them out on the floor and photographed them. I then turned them into silk-screens. It was about trying to construct something. I also made a series of hammers

because I liked the notion of the relationship between function and geometry. Geometry can be minimal and clean but it also has connections with architecture, function, the everyday. I abstracted in obvious ways in those days, from the organic. I started with the figure, moving on to six-foot cabbage paintings, and from the organic re-engaged with geometry. Art history was important to me. I was looking at a lot of American painting but I was also looking at analytical Cubism, constructed space. I was trying to be an abstract painter/feminist/Marxist, which was not a happy togetherness. I found great solace in those Russian Constructivists Lyubov Popova, Alexandra Exter, Olga Rozanova and, obviously, Kasimir Malevich. They were abstract whilst also allowing this inter-connectedness with what might now be called craft. They were interested in territories which were to do with stage design or even advertising. Later at the Royal College of Art in London, I was able to visit Sonya Delauney in Paris, to interview her, as another Russian crossing boundaries, with simultaneity.

RF What kept you painting?

VJ I like the discipline of painting. I did try other things – I made a film in my Foundation year and I remember doing a conceptual work with a deck of cards that was appalling! One looked outside always and there were divisions taking place within our group as students. There were people who were doing photographs and text and I was interested but somehow painting remained central. It was something about the discipline, whereby you were (and still are) faced with an absolute absence – you've got to come from nowhere to somewhere. There's something very curious about the fact that in painting, it's just a window. That's an old-fashioned thing to say, but it's just an open space and you're always in the process of making decisions about how to fill it.

RF And the paint doesn't exist until you put it on? It's hidden in a tube ….

VJ Yes. Whether it's earth or chemicals, it isn't anything until you actually make it something. It's a strange process that is really difficult to talk about. It's easy enough to talk about what a painting is at its conclusion and it may not be too difficult to talk about what you want to do with a painting, but to talk about what it is that you do when you're in the process of painting is always interesting. I think that's what keeps painters painting.

RF So how did the rules of your practice come about?

VJ Well, I'm happy with the notion of rules because we all have rules and we spend an inordinate amount of time being in them and then trying to break them. I suppose when I accepted illusion it was my biggest break with what would have been a more formal relationship with abstract painting. The rules are to set up a space that I can dwell in, and I use the word 'dwell' in a Heideggerian way. I provide a structural, real space – 'real' as in Mondrian's use of the term 'abstract real'. Space in a painting can then represent some of those psychological experiences that can be engendered from real space. This is very complicated. I used to be able to move around a painting, almost as if it was my body creating the space. That seems to have shifted quite slowly as my sexual nature has become less important to me than my conceptual nature. It seems to me, and this could sound regretful but it isn't, as I've got older the work has become more conceptual again, more about a relationship with the actual architecture.

RF But architecture implies a body?

VJ Yes, the body is still there. My scale in relation to the paintings is important, my scale within that space. When I talk about architecture, I'm talking about that conceptual relationship of being inside a space. It can be anything from the Pantheon in Rome to the Mies van der Rohe Pavilion in Barcelona. It's not necessarily modern or old, although often when a space is highly ornamented, I find that absolutely extraordinary and I want to be able to make some equivalent. At the same time there's this minimalist in me that responds to purity and stringency. Even in Mies van der Rohe there's a beautiful piece of marble, which people tend not to talk about. And, of course, the glass is open; we're looking out into the world again, so there's a lot of detail that one is aware of. So, I have a minimalist desire as my drawings, etchings and woodcuts would probably tell you. Yet the paintings take on this overloaded relationship to what I would probably call the Baroque, because the Baroque is this meeting place of other cultures.

RF Tell me more about making the painting.

VJ The minimalist in me keeps my hand out of the making. I use a very large palette knife I bought in Soviet Moscow near Red Square. This knife means I've always got a distance. It's important to me that that rule is still there, that I use the brush as little as possible and only when I have to, for fine detail. The space that could be called the background is made with a palette knife to open it up to air. The paint is blurry – put on with a knife and scrubbed off with a rag. It's setting up an 'unobtainable' all-over space.

RF Has that 'background space' happened more recently?

VJ It happened about the end of the eighties. Earlier work was flat all over. I had this imperative sense of the gestalt; everything should have been handled in the same way and there were no margins for something called background or foreground. But I became interested in the experience of space and one's relationship to being inside or looking at, architecture, where you're not sure about how that space ends. You never have the entire completed experience, you're always 'in' an experience. The geometry that takes place on this surface is concrete and constructed. Hopefully it's animated by colour and optical relationships, but it's much more affirmative. The 'background' space is the bit you can't tie down or hold.

RF But it's also quite hard to distinguish visually the geometrical shapes from each other.

VJ Yes, that's the point. It's about that relationship with memory and experience. Whilst you're experiencing something, you're never actually holding it. The only way to hold it is by re-experiencing it, confirming it. Painting for me is the only space I can control, everything else about life is not in control. I want to give the viewer a sense that there's something which you know and understand; an oval, a square, a rectangle, something cutting into something else. Geometry is very plain and simple in many ways, except the more you use it, the more complex it gets. I want the colour to do things that disturb you and make you uncomfortable by kinetically playing on the eye, because that is how experience is. You can never contain it. In painting terms, just when everything's harmonious, I have to disturb it. The first thing that happens in terms of the way the paintings are made, is the underlying open ground, a sort of ethereal space. The next thing is constructing the more formal aspects of planes of interactive geometry and that takes ages because I'm forever changing the colour. The last thing that happens is these disturbance 'glyphs', marks that are both in the ground and can break into the physical space. It means you can't look at the structure as it starts to move optically. It's a simple point of perception, which is both a conceptual notion and the way we perceive the world. No painting can ever avoid that duality.

RF You've written that the paintings have to be made by hand. Why?

VJ I like the mechanics to show. If it was too perfect, I think one would just slip off the surface of it. There's an awkwardness about it, although I do my best by eye, it's only as good as I can get.

RF If you were doing them on the computer it would remove the materiality of it, the sense of labour, the investment in surface.

VJ I have a fascination with wanting to be inside the painting for as long as possible. I love starting paintings and hate finishing them. I like dwelling in them and it elongates the process by doing everything by hand.

RF How does geometry bear experience? Is it possible not to make reference to the appearance of the world?

VJ I want to reclaim the word representation. Like most abstract painters, one finds certain words are problematic. The word representation sounds as if it's from the observational world but I think we represent things in all sorts of ways. When I use the word appearance I'm saying that I'm not painting from a source, I'm dealing with the experience of a source, and that is a form of representation.

RF But how do things you see go into the work?

VJ I make a point of going to look at architecture. I spend a lot of time looking at the links between the ornamental and the baroque of Boromini to the experience of the Alhambra. But the actual practice is me, sitting with notebooks, drawing form into form, interlocking shape into shape, until there's some sense of its rightness. I'm not saying it's not influenced by what I see, but I think what happens in the paintings, is that I'm then able to manipulate those forms and shapes through colour. I try to breed something that's more adjectival and complex.

RF What kinds of decisions are you making whist you're painting?

VJ The decisions whilst I'm painting are primarily about colour because the preconditions of the painting are that the basic structure is set up. That colour is about edging – some things need to be stable, some things need to be shifting, some need to be electric and some need to be calm – all of these curious possibilities that colour has. Sometimes it needs to be plastic and unpleasant and sometimes it needs to be gentle and friendly. So colour is the thing I'm thinking about most of all when I'm painting. I work on large paintings that are to do with my scale, or I make much smaller paintings. The smaller paintings are like little worlds at the wrong end of a telescope. With the little paintings you're close to them when you're making but with the large paintings one's walking to and fro. I think the walking up to, and away

from, the painting is a kind of reflective space where you're not just making formal decisions about what to do next but you're thinking about what that painting is doing to you and what you're doing to it. To use Heidegger again, in *Building, Dwelling, Thinking* there's an analogy with the bridge – it's earthed from both ends. The point of the bridge is to go across and one's in perpetual motion. Above the bridge is something that is perpetually moving, the sky, and below the bridge is probably water, although it might be the M25. I think painting practice is quite like that, it's earthed at both ends, it's earthed in the doing of it and it's earthed in what it is you demand of it, but the space in between is this to and fro thinking. It's a nice analogy.

RF I wondered whether you could talk specifically about the work's relationship to words, fiction, poetry?

VJ I get a huge amount of what I think of as being experience from books and I think it's as real as the experience I have in the world out there. I suppose it's just another form of stimulation. The stimulation that comes from poetry and slow prose (for example Proust or Marguerite Duras, anything good and existential) usually takes time to dwell on, to think about it. Even if it's short poetry, its slowness is important and it's something to do with not being conclusive. People talk constantly about painting being in the state of mourning and an endgame, 'the death of', but I don't think I'm destabilising the thing I'm doing whilst I'm doing it. I believe in the notion of it being a life affirming activity, which is an extremely difficult position to stand in.

RF It has been said that art history privileges sight at the expense of the other senses. However, I'm rather attached to sight as being something that you can use to uncover things and discover things.

VJ Yes, that's why that word perception is important too, because it has that constant relationship between one's own perception and visual perception. We have greater visual imagery around us than ever before. I'm of a generation that was so excited when the Sunday Times colour supplement came out we cut it up and made collages out of it! Today we are absolutely overwhelmed by visual culture and I don't know whether that helps or not. In a way it makes it so complicated to see because we have so many things to look at. I think art history is absolutely implicit within painting, and I think that distinguishes it from other mediums. It can be a dreadful burden as well as a wonderful burden but it is consistently there. Art history is incredible food for thought, because it includes going to places to see things and the context of that country; the smell, heat, cold, whatever it might be. You need to recognise

that those things have come about through their own cultural, historical and political history. I've never been a formalist who could look at a Piero della Francesca without acknowledging the religious content. I'm not just taking the appearance as it were.

TOMOKO TAKAHASHI

Tomoko Takahashi makes large-scale installed works from debris and abandoned materials that are collected, carefully ordered and manipulated, and then placed within an architectural space. She has also worked collaboratively with other artists and audiences on performances and events.

RF What differences did you notice between art school in Japan and London?

TT Oh, it's much freer here! In Japan I was in the oil painting department and I wasn't given the chance to do anything else. Here you can delve around, breaking everything down.

RF What's the relationship between playing and making art to you?

TT On my art foundation course, one of the tutors told me to loosen up and play with things, so I really fastened hard on that. I can really play and I like playing anyway. I used to make games and stuff. That's how I started making my own work, in that sort of light. I do believe in playing because through playing you learn loads of things.

RF Do you watch your daughter play?

TT She's started to play really recently, quite unconsciously – it's quite interesting. My daughter started to say, 'I'm working' when she's engaged with something. If I'm trying to get my daughter to do something else, she says, 'I'm working' but she's playing of course. It seems like she's picked up that working is occupying oneself, so it doesn't matter if it's playing. I'm quite into Patience, I did a project on it with Ella Gibbs [Belt Gallery, London 1999]. We picked Patience because playing it is very similar to working. You have a set of rules; you want to do the best in it although you're just playing by yourself. So that's a kind of play, absorbing but there is a kind of aim for it, there is something you want to achieve, you are trying to do that.

RF Your process of making work involves you going to the gallery space and staying in it. Do you always work like that?

TT Yes. We're at Beaconsfield, a gallery in London, where I'm installing a work in a group show. I used to work here, as a cleaner, a long time ago. I was cleaner, invigilator and painter and decorator, putting things in envelopes and everything. So when they invited me to do *Chronic Epoch* [their tenth anniversary show], I really wanted to do something about me working here, you see, the starting point. I chose to do a work in the disabled toilet because I never cleaned it – it came after I left. A sense of place gives me a really fast start.

RF When I think about your work, I think of you being in a space, absorbed in an activity, quite often by yourself. It's a solitary experience. I wondered if having a child affected that and whether you can have the kind of absorption that you had before?

TT For the Serpentine Gallery show in London [*My play-station*, 2005] I left my daughter for four weeks. I went to see her in the middle for one night but it's interesting because I really do get absorbed in the work. But you always get stuck in some way, and at a crisis point, I thought, 'Fuck, what am I doing? My daughter is waiting, I can't waste my time, I have to do it!'. That was amazing; it does make you concentrate somehow, it makes you more absorbed in the period of time. At home I don't work.

RF Someone described your work as melancholy and I understood that in terms of this self-absorption. Do you see it like that?

TT I don't know, I haven't really thought about it like that before. Usually the work reflects what I was feeling at the time, so sometimes some really sad work comes up but sometimes not; it kind of depends on the work.

RF There is a more obvious aspect that's celebratory, bringing discarded objects back to life and working with other people. You're doing art workshops with kids – a lot of artists wouldn't want to do that.

TT Why not? They're great! Five or six year olds are amazing. They are so free! They are so fascinated about things, they get so absorbed. They're like blank paper but they have things going on in their heads. It's amazing!

RF I want to ask you about the humour in your work because one of the first reactions to looking at your work is, well you might not be laughing out loud, but you're kind of smiling.

TT I was laughing myself – you have to enjoy it! I often do that. I'm working by myself all the time, so I have to make a joke to myself to keep my spirits up. I think that it's a really important thing to keep me going, otherwise I can't do it. It's such a long duration of time, working, just completely by yourself. And that's the playing as well, it's fun to play. I think learning should be fun, working should be fun – the same as playing but in a good cause.

RF When you've worked with Rupert Carey or Ella Gibbs or Simon Faithful or others, what do you get from that?

TT It's great, I really expand myself. The collaborative work is usually events; we're dealing directly with people, it's really different from the solitary installation of sculpture. It's a really good buzz. We can really talk about 'What shall we do? Oh, let's do it!' Lots of different opinions come up.

RF Does that ever go back into the work that you do by yourself?

TT I'm sure it does in some ways. I think everything has an effect.

RF When you look at the major shows you've had, or installations, can you see how things have changed over time?

TT Well the big change was, I believe now, the Serpentine. That was quite different. Lots of people, friends, told me it was more organised, much more sorted. Having a child made me organised in a different way; you have to plan ahead, and I was completely the opposite. It's really a big change and it came through in that show.

RF Your work feels like an activity that maybe quite a lot of people do in private, almost like doodling where you are unconsciously arranging things or folding things and then it's made public. I think one of the reasons why your work appeals, is that people can recognise that need or desire in themselves.

TT Yes, doodling is very right. It's very private when I'm making it because I really don't see people, but the end result is always public. By the private view I leave the space and it's not my home anymore. I don't really go back and see my work either.

RF Do you view it as the thing that's left over from the event of you living there?

TT It's more like I'm living there because I'm making there. Making things is really the aim. A long time ago I did a show in London's Entwistle Gallery [1999]. I lived in the project space, had it as my studio for one month. They asked me to make a set of photographic works. I said I don't have any studio; can I live there and do it? In the end the result was an installation, I was living and fabricating at the same time. I'm making the ideal studio situation and the ideal me. But it was still strangely private; because I left lots of things in the space I used lots of gaffer tape, to stop anyone taking things out; everything was kind of protected. Nobody could touch it. So in some ways it's a fabricated studio, as I don't really leave it as it is lived in. The end result is different from how I was living; it's a work, it's something else.

RF But how does it stay alive? How does it not become like one of those museums where you see a re-creation of how somebody lives?

TT Well, I try to leave what has naturally happened and then I amplify it.

RF And you are also working within the architecture of the space.

TT Yes. Changing the architecture seems like a waste of time.

RF So how do you plan your shows?

TT I have a look at the space, start chatting to people and find out what sort of place it is, what sort of people they are. When I'm in a museum or gallery I look at everything, whatever they have.

RF And look in their cupboards?

TT Exactly! So that's a starting point and then I think about what I want to do at this moment. The Serpentine was the second work I made after I gave birth to my child. Before, I was really doing it every month or every couple of months, an installation, going somewhere, doing something. I didn't really go home that much, sleeping somewhere on somebody's floor all the time. It's completely changed; I got pregnant, I stopped working for eight months, for a year I didn't work. I did a little bit of work just before the Serpentine but I was really out of practice. It's a bit like music where you have to practise the activity. It's like painting, where you have to paint every day, you lose how to handle it. It's quite similar in some ways – I'm still doing a painting in some ways. I was scared for that reason.

RF Maybe it was that break that allowed …

TT The change? Yes, it was a good thing to do, having a break. Public spaces are usually horrible places to work in, but that one was so relaxed; I couldn't believe it. In London, museums are usually so bad. But the Serpentine was so cool. It's an amazing space.

RF There seems an awkward fit between your work and an institution or market, although I know the collector Charles Saatchi has bought your work.

TT It's interesting because sometimes tension makes really good work. I had a terrible time with Saatchi. I had a big row but I think it was good work. I had a real problem with the Tate [Turner Prize, 2000] and I made a bad work, from my point of view anyway. I fail quite often, about fifty per cent of the time.

RF Do you see that as part of the work?

TT Yes, because I don't realise until I've finished it. The one just before the Serpentine, in Germany, was a complete failure.

RF How do you make that judgement?

TT It comes through later on. I usually go to pack up and take pictures. When I sort the pictures out, I keep thinking about it and maybe months later I start to think 'That was bad!' (Laughter) I'm only taking a blind guess you see.

RF When you've done a show that you think is bad, is it hard to do the next one or do you know what you're going to solve in the next one?

TT It's good. In some ways it's very good to have a bad one so you know you shouldn't be doing it that way. You can learn loads from mistakes.

RF Rachel Withers's review of the Serpentine show in the *New Statesman* makes suggestions about how the show worked for the audience and talks about mini-narratives going on within it. I thought that was interesting. But there doesn't seem to be much decent critical feedback about your work because everyone gets so hooked up on what you're making the work out of.

TT That's why I don't really read articles because they don't really say anything. It's always 'Pile of rubbish! Pile of rubbish!'. But maybe I should read Rachel's article.

RF Going back to the art market, how do you operate within that?

TT I don't make so much money because usually I don't sell installations.

RF The Serpentine piece was dismantled?

TT Yes. It's all gone, great! The end is great. I did sell a couple of installations, one to the Tate. I made a mock-up room for it and I set it up perfectly for that purpose. It was a work for the New York Drawing Room and I made it again to sell to the Tate, so they can take the walls off and that's all right. A mistake I made very early was to sell some installations because they're difficult to recreate. It caused lots of problems and I really learned that, so we decided not to sell an installation as it is. But if you know you're going to sell it, you do it that way – you make it and then you sell it. Usually now I operate on a commission, an artist's fee. I come and do things; that's what I get paid for.

RF Your work is simultaneously criticised and praised for making 'beautiful arrangements'. You've talked about the process, the making and the playing, but what about its aesthetic?

TT How it looks, how it's expressing, is very important. But maybe that's different from being aesthetically pleasing – beautiful or ugly. I know I have a real tendency to make it too nice sometimes. I couldn't just make beautiful patterns and then drown in them. That's really quite a dangerous point; I'm quite aware. It also depends on what you mean by beauty. Looking just nice and pleasing doesn't give you anything. You want to *say* something; there are things to be said.

RF Does your work relate to obsessive/compulsive behaviour?

TT It's a bit mad isn't it? But you can lose yourself in it and that's quite important somehow. If you don't get lost in it, something you are not too conscious about doesn't come out. So I think it's really quite an important trigger.

RF So it becomes meditative?

TT Exactly, and then something a bit more important rather than that ego thing comes out. Because lots of true things you want to say are outside of your ego, it's really important to try and get that out.

RF Do you think your work is idealistic?

TT Maybe. I have a tendency to think about right and wrong, which I think is a bad habit.

RF What about the audience? Rachel Withers describes how they're part of the work; you can't step back from it and see it objectively because you're in it.

TT Yes, because audiences, like me, walk into the space, so I always try to see it like them. If you're too much in your self you can't really experience it. So I do think of the audience; me but not me, passing here. I'm conscious of people being surrounded by something.

RF So are you making for them or are you making for yourself?

TT The same. It's the same because the ideal me has to be outside of me somehow.

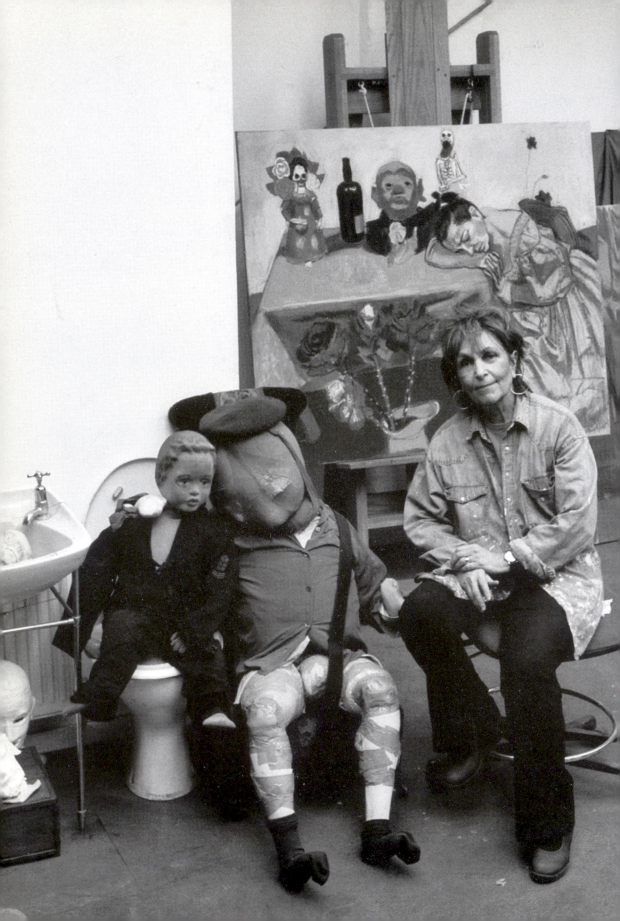

PAULA REGO

Paula Rego makes narrative, figurative paintings, often using novels or other fictions as their source. Earlier work used a cast of anthropomorphised animals to depict intense psychological relationships. This interest continues in her prints, such as the *Nursery Rhymes* series [1991–6] where well-known children's stories take on disturbing connotations.

RF I was thinking about the long history of work you've made…..

PR Fifty years. Fifty years.

RF …and wondered how you know when you're coming up for a change in your work?

PR When you're sick of it. If you get nauseated by what you do! There are times when you're just doing things that have the look of your work and that's not very good. I started off at the Slade doing oil paintings and then went on to collage later on, which gave me the freedom to improvise and to tell a story differently. Then I'd done enough collages; they became a method. The subject matter always has to be more important than the method; the method is a means to an end. When the method takes over, that's really awful.

RF How do you recognise this?

PR You're aware that things were put in place to make a picture, not because it was part of the subject. And you're fed up with it. I was doing things to cut up for the collages and my friend said, 'That's so nice, why are you cutting it up?' I said 'What do you mean?' And he said, 'Why don't you just leave those nice monkeys?' And I did.

RF A lot of artists don't want comment about ongoing work but you seem to be open to it.

PR There are times when other people could have come in before and said it and
 it wouldn't have been right, but this was the right person and the right time
 and you're always grateful that somebody will speak out. If they told me
 something I didn't want to hear I wouldn't have done it. With Vic[tor Willing],
 I did a lot of things that he suggested, quite risky things, because it was him
 telling me and I trusted him.

RF I wanted to ask you about telling stories. Do the stories emerge from the
 images? Or do you already know the stories?

PR The original story of the Red Monkey series came from Vic. When I began
 to draw the Red Monkey, the Dog with One Ear and the Bear they became
 people I knew. Then they act the part of the person and you can moralise or
 take some kind of revenge.

RF But did you know where the story was going when you started?

PR When I did the monkey hitting his wife, I knew exactly what that was. Later
 I put the bear beside them but wasn't sure why. Pictures like the *Operas* were
 totally improvised. I went along with the brush mark hitting the paper. I knew
 that I was depicting the Duke singing 'La Donna e Mobile', where the father
 says, 'You are no longer my daughter' [Verdi's *Rigoletto*] and the work would
 come from that.

RF Is there a difference between working with a story that isn't known and a
 famous one like *Jane Eyre*?

PR The story is known – but not really. I go into the book, muck about with it,
 take sides! In the Portuguese novel, *Father Amare*, I brought in the Angel to take
 revenge earlier.

RF You changed the story?

PR No, I didn't change the story because she has the baby and the baby is killed,
 but I brought in somebody, the guardian angel, that had been there all the
 time. I brought her in to do justice to the woman who gets pregnant. They are
 scenes from the book but they are really quite personal. They are involved with
 my life; there's a great deal of empathy that goes on. They are not illustrations
 of the book; I go in there and change things. The images that end up being
 made are not done reading the book, although sometimes I read the book 20
 times. I did with *Jane Eyre*. I now use models, sitting them down, putting them

in positions, making them relate to each other in certain ways. It's invented you see. My model Lila can act anything, even animals. The models can play all sorts of games; of irony, of truth – games of everything.

RF We tend to think of painting as being a snapshot, a moment, but you elongate that moment within the painting.

PR The painting is a thing on its own, apart from you. I mean you're doing it to find out what the result will be. When I've finished it's telling *me* something. A picture reveals to me what I intended in the first place. What's discovered in the process of doing it is often hidden from me and lives in another area of consciousness, it comes up in the picture and then I can see, 'Oh! I wasn't so sympathetic to her, after all'. I can do anything; I can take revenge, even on nice people. I can even like people that are nasty dictators. I don't like them in life but I can pretend in a picture properly.

RF But your paintings aren't only a way of you finding out what you feel?

PR No, not just that, but that's very important, very important. I tell you, I keep on seeing things in them, even years later. I don't like looking at my pictures but sometimes I open up a book [of my work] and realise, 'Oh God, no, the monkey is vomiting as the wife cuts off his tail – what she's doing is cutting herself away from him'. That's a psychological interpretation based on how faint she is in the picture, she's hardly there, she's like a shadow. That told me something, didn't it?

RF Do you think that's how other people relate to them?

PR With other people you mean? Their relationships with their boyfriends and so on? Yes, I'm sure they do.

RF Going back to the devices you've used to stretch the narrative moment in the painting. If you have the same character at different moments of her life, immediately you're alerted to the fact that these are not just people sitting in a room, it's something that's happened over time. How aware are you of the different ways of constructing the narrative within the painting?

PR Being at the National Gallery, London [Rego was the National Gallery's first associate artist in 1989-90] was quite something. It had a lot of influence on me. Being in constant contact with those extraordinary pictures, seeing how they depict and what layers of magic you sense that they have in them. They

transform you. One likes them more and more. You may start off not paying any attention to high art.

RF Sometimes we take the paintings for granted and can be blind to their strangeness.

PR Of course you are! And you look at the weirdest ones. I used to love Piero de Cosimo's *The Battle of the Lapis and the Centaurs*. I still like it a lot but then, as I got to know the pictures, I could tell that others were even stranger, more mysterious and full of endless, endless marvel.

RF It struck me that you haven't disassociated your work from the word 'illustration'. Often it's used pejoratively in relation to painting, isn't it?

PR Oh God yes! They're such snobs. I like so many people that are called illustrators. For instance, Daumier was a caricaturist and illustrator and he's an artist full of emotional depth, of perception of people, of compassion. You could call Goya an illustrator, then Cruickshank and all those Victorian ones. I don't like the modern illustrators so much. I think that Gustave Dore was wonderful and he illustrated everything under the sun, even Dante. I've always liked him and looked at him. As a kid I had lots of books with that sort of thing in it. Illustration is wonderful; I like people who can draw well. I don't like the quick kind of thing, not even Paul Klee.

RF So observation is at the heart of it?

PR Observation, empathy, compassion, people, being represented in depth. Even in *Alice and Wonderland*, the Tenniel illustrations, there's observation of the animals who are people. They are really wonderful and you can identify with them.

RF So what about Disney?

PR I love early Disney, not the late Disney crap. Pinocchio is scary.

RF My son won't watch it – the whale sequence…

PR You see, you see! It's terrifying. I think that Disney was aware of Surrealism. It was that time in the thirties where everything had the mark of something very dark in it. I think it was the rise of fascism and Surrealism gave a face to fear. It comes across in the early films.

RF Is there a difference between working from a visual source, a film or a master painting say, to working from a literary one?

PR I subvert the master painting, always. I can't just do a straight copy of it without getting my own in there. Not disrespectfully but I change the story so that a man hasn't got the place of honour or a woman at the back comes forward. Usually I don't work from pictures, I only did at the National Gallery. It's mostly from stories, which is much better because they haven't got images attached to them. You can just go in there and make a play of it. I mostly work with people I know. They sit for me.

RF But they're acting?

PR Yes, but I do the casting. Lila can do anything, good and bad. Sometimes it's fun casting people against their own nature! But it's like playing – you dress up.

RF How do you know when you've met someone that would be good in your painting?

PR Oh, it's very few people; only three or four and my grandchildren – they dress up and play and then they sit still. So it's a form of playing; we are in here, we set up the scene and sometimes the playing is cruel.

RF When you say they cast against their nature ….

PR They don't know.

RF But do you think they think about it?

PR Yes, they're not stupid! (laughter)

RF It could be a very interesting insight into a part of you that's submerged.

PR That comes out in the other person? Well, in Lila certainly. She's myself, she's a reflection or something. I've been working with her for a long time and she's marvellous.

RF I want to talk to you about your process. Michael Baxandall describes how Giovanni Battista Tiepolo problem-solved for his huge frescoes with smaller works, by doing pen and wash drawings where he had the freedom of his wrist. The composition has a liveliness and freedom that it wouldn't have if he'd only

worked on a large scale that's difficult to physically move around. When I read this I thought of your drawings for *The Maids*. I wondered whether you used them to work from the imagination, drawing freely, and then something of that goes into the painting?

PR It's exactly so. It begins in the imagination; the drawing is done from the imagination. It's sometimes very difficult; it takes a lot of hard work. You'd think that coming from the imagination it would flow, but it bloody doesn't. Sometimes you have to work so hard at it and take a long time to winkle it out, but it serves as the basis for a picture. The ideas are there.

RF What is it you want from the drawing to transfer into the painting?

PR Finding what's in your head and putting it down, that's the difficult bit. I used to do more drawing from my head. What I have to do now is make actual figures, you know? Make them in papier mache and so on. Then I copy them. I don't do an initial sketch, I just make these characters, with a stuffed pair of tights and papier mache etc. I made that little boy and those rabbits. I sculpt it and then I copy it absolutely faithfully, there's no room for interpretation or projection of any kind. If you start emoting about what you've actually created, you start projecting and feeling, then it's bad, terrible things happen. It's not good; it's imprecise. When I copy it as precisely as I can it comes to life. Only that.

RF I remember when I talked to you before you told me how you sat on the floor to draw, pretending you were not making 'art'. Is it like that when you're making the objects?

PR Yes, exactly. Because they aren't art, they are like playing, you see. I used to do a lot of plasticine things. You create a character and then you copy that – absolute rigorous, observational copying.

RF Is that related to your experience of being at the Slade and William Coldstream's observational influence.

PR Maybe. But they weren't terribly strict with me at the Slade. I was able to work from my imagination all the time I was there.

RF Yes, your work from that time doesn't seem to have that influence but it sounds like you still relate to that discipline of looking.

PR Very likely. There is a chronometer in your head; the vertical and the horizontal, everything is measured that way. Squiggling is not good, I find squiggling very bad – almost immoral!

RF It seems to me you have an increasing interest in the articulacy of gesture.

PR I'm interested in the theatre. Unfortunately, nowadays we don't get much melodrama – the language used to express feelings was much more declamatory in the old theatre. The Theatre of Blood is pretty good, they are terrible hams! I'm very interested in the gestures – of course they've got to be sincere.

RF It really struck me when I was looking at *Dog Women*.

PR The *Dog Women* was something special, it was my reliving of my love for Vic. They really are not illustrations; they were exact emotional equivalents – there's a woman pissing in the bed and stuff like that. They weren't so choreographed, I just said put yourself like this, put yourself like that. They just told the stories. For instance, in *Target* she is holding the dress because she is an accomplice to herself being hit with the arrow. So they weren't so choreographed, they were just ways of telling.

RF Do you look at contemporary dance?

PR No, I don't like dance. I love the theatre, but I don't like dance. There are no words. I like words. I like opera.

RF Do you have a sense of where your characters are? Are they in the studio?

PR Oh no, I know exactly where they are! That man fishing there is in a place in Portugal that I recreated here in the studio. Lots of them are in churches. Lots of the pictures have a religious theme, not because of religion but because of the religious paintings one is brought up with.

RF You've don't seem to be afraid to tackle political issues.

PR The Abortion pictures? There's nothing taboo about most of my pictures, only the abortion ones because it's forbidden in Portugal but I can't see anything else that's taboo.

RF But sexual relations within the family are sometimes hinted at in your work?

PR But that is common, everyday. I'm not making a point of it, I'm just depicting what is, not making a moral issue of it.

RF You said that you didn't like looking at your own work.

PR I'm embarrassed by my work really. I like to see my work in a book best. I don't really like looking, it's embarrassing, going to see my work exhibited and so on. My prints I'm not embarrassed by. I did my nursery rhymes without models straight out of my head. And they're good, inventive. I'm happier with my prints; pictures are something else.

RF Perhaps that's why you keep painting ?

PR Of course, you want to do some things big and in depth. Also, the graphics you don't change but the pictures you change and change, over and over again, as you find new things.

RF You would never use a photograph?

PR Never. A photograph is already selective of certain things. It hasn't got three dimensions. A model is alive and changes her expression. 'Now smile, now shut your eyes, now open your eyes, now move a little bit, now turn your head', all that has to go on all the time, it's constantly moving, which is fantastic, really fantastic.

RF Your light changes all the time.

PR I know, my light changes all the time. And to be able to do it? I surprise myself, that I'm able to actually do it. Look at this hand, this leg, that I manage to actually do it, it seems miraculous really!

ARTISTS' BIOGRAPHY

Rebecca Fortnum (b. 1963) read English at Corpus Christi College, Oxford before gaining an MFA from Newcastle University and taking up a fellowship at the Skowhegan School of Painting and Sculpture, USA. She has been a Visiting Fellow in Painting at Plymouth University and at Winchester School of Art; a visiting artist at The School of the Art Institute of Chicago; a Senior Lecturer at Norwich School of Art and Wimbledon School of Art and an Associate Lecturer at Bath Spa University and Central St Martins School of Art. She is currently a Senior Lecturer at Camberwell College of Art, University of the Arts, London and Research Fellow at the Lancaster Institute for the Contemporary Arts at Lancaster University. She has received several awards including the Pollock-Krasner Foundation; the British Council; the Arts Council of England; the British School in Rome and the Art and Humanities Research Council. She has exhibited widely, including solo shows at the Collective Gallery, Edinburgh; Spacex Gallery, Exeter; The Winchester Gallery; Kapil Jariwala Gallery, London; Angel Row Gallery, Nottingham; The Drawing Gallery, London; and Gallery 33, Berlin. She has exhibited in group shows in New York, Maine, Budapest, Salzburg, Marseilles and Gdansk as well as numerous UK exhibitions. Recent group shows include *Fluent; painting and words* (2002) and *Unframed; the politics and practices of women's contemporary painting* (2004). She was instrumental in founding the artist-run spaces Cubitt Gallery and Gasworks Gallery in London and has worked as curator and an art writer, contributing to various magazines and books.

Jananne Al-Ani was born in Kirkuk, Iraq in 1966 and moved to England in 1980. She studied at the Byam Shaw School of Art and completed her Masters degree in photography at the Royal College of Art. She exhibits internationally with recent group shows at Museum of Modern Art, New York (2006); Kunstmuseum, Thun (2005); Mori Art Museum, Tokyo (2005); Palazzo delle Papess, Siena (2005); Al Beit, Amman (2004); and Fotographie Forum International, Frankfurt (2004). Group shows in the UK include Modern Art, Oxford; The New Art Gallery, Walsall; and Kettle's Yard Gallery, Cambridge as well as the National Portrait Gallery; Victoria and Albert Museum; Whitechapel Art Gallery; and Barbican Art Gallery, all in London. Her film installation *The Visit* was shown at the Norwich Gallery, and as part of the *Art Now* programme at Tate Britain, London (2005). She has also held solo exhibitions at the Smithsonian Institute, Washington DC and the Imperial War Museum, London. She has received awards from the London Arts Board, Arts Council of England and the London Artists Film and Video Development Award, as well as winning the John Kobal Photographic Portrait Award and East International. Her work can be found in many public collections including the Arts Council of England; the Pompidou Centre, Paris; The Smithsonian Institute, Washington DC; and the Victoria and Albert Museum in London. The monograph, *Jananne Al-Ani*, was published in 2005 by Film and Video Umbrella.

Gillian Ayres was born in London in 1930 and studied at Camberwell School of Art. She taught at St Martins School of Art, Bath Academy of Art and Winchester School of Art. She first exhibited with *Young Contemporaries* in 1949 and since then has held solo shows regularly, including Kasmin and Knoedler Galleries in London; the Serpentine Gallery, London (1983); Arnolfini Gallery, Bristol; and the Fruitmarket Gallery, Edinburgh (1990). Recent solo shows include the Tate Gallery, London (1995); the Royal Academy of Arts, London (1997); Gimpel Fils, London (1999, 2001); Alan Cristea Gallery, London ; and Nevill Keating Tollemache Gallery, London (2004). She has also exhibited in many group exhibitions worldwide, including France, Italy, Germany, Denmark, Switzerland, New Zealand, Australia, USA and Japan and, in 2006, *Passion for Paint*, National Gallery, London and tour. She was nominated for the Turner Prize in 1989 and has received many awards including the Arts Council of Great Britain Bursary and Purchase Award, Second Prize, John Moores Biennale, Liverpool (1982), and received the Gold Medal at the Seventh Triennale, in India (1991). Ayres was awarded an OBE in 1986 and was elected a Royal Academician in 1991. She was made an Honorary Doctor of English Literature by London University (1994), a Senior Fellow of the Royal College of Art, London (1996) and received a Sargent Fellowship from The British School at Rome in 1997. Her work is in numerous public collections including Arts Council of Great Britain; Art Gallery of South Australia; British Museum; Gulbenkian Foundation, Lisbon; Museum of Modern Art, New York; Victoria and Albert Museum, London; Yale Centre for British Art, Connecticut; British Council, New Delhi; and the Tate Gallery, London. Gillian Ayres lives and works in Cornwall and London.

Claire Barclay was born 1968 in Paisley, Scotland and completed a BA and MFA at Glasgow School of Art. Solo exhibitions include *Silver gilt*, Stephen Friedman Gallery, London and *Foul Play*, doggerfisher, Edinburgh (both 2005); *Half-Light*, Art Now, Tate Britain (2004); *Ideal Pursuits*, Dundee Contemporary Arts (2003); *Some reddish work done at night*, doggerfisher, Edinburgh (2002); *Homemaking*, Project Space, Moderna Museet, Stockholm; *Take to the Ground*, The Showroom Gallery, London (both 2000); *Dream Catcher*, 200 Gertrude Street, Melbourne (1998); *Out of the Woods*, Centre for Contemporary Art, Glasgow (1997); *Museum Intervention,* site-specific installation, Colonial Room, The Tasmanian Museum and Art Gallery, Hobart; *Claire Barclay, New Works*, Plimsoll Gallery, Centre for the Arts, Hobart (both 1996); *Claire Barclay, New Works*, Transmission Gallery, Glasgow (1994). She has exhibited in many group shows internationally including the British Art Show Baltic; *Zenomap*, Scottish Pavilion, Venice Biennale, 2003; *Early One Morning*, Whitechapel Art Gallery, London; Tate Britain; *Howl*, Canberra Contemporary Art Space. She has held

several awards including an AHRC Fellowship at Glasgow School of Art from 2000-3 and a Scottish Arts Council Creative Scotland Award from 2005-6. She was Artist in Residence, 200 Gertrude Street, Melbourne and at the Millennium Project, Govanhill, as well as being awarded the Scottish Arts Council Australian Residency in 1997. Publications include *Now and Then*, Tate Britain; *Claire Barclay, Ideal Pursuits*, Dundee Contemporary Arts; *Early One Morning*, Whitechapel Art Gallery, London; *Here and Now*, Dundee Contemporary Arts, Dundee; *Take to the Ground*, The Showroom Gallery, London; and *Moderna Museet Projeckt*, Sweden. Claire Barclay lives and works in Glasgow.

Christine Borland was born in Ayrshire, Scotland in 1965. She studied for her degree at Glasgow School of Art and completed a Master of Arts, University of Ulster in Belfast. She is the recipient of many grants and awards including Kunstwerke, Berlin Studio Residency (1996); *Creative Scotland Award* (1999); Scottish Arts Council (1991, -2 and -3); British Council, Scotland (1993); and the Goethe Institute Cultural Scholarship to Berlin (1992). In 1997 she was nominated for the Turner Prize and exhibited at Tate Britain. She has held over 40 solo exhibitions including, *Conservatory*, Anna Schwartz Gallery, Melbourne; *Simulated Patient*, Lisson Gallery, London, (both 2004); *An Hospital*, Mount Stuart, Bute, Scotland; *Christine Borland: Take All the Time You Need*, Dunkers Kulturhus, Helsingborg (all 2003); *A Survey Exhibition with Christine Borland*, Kunstverein, Munich; *To be Set and Sown in the Garden*, Permanent Sculpture Commission, Glasgow University; *Christine Borland*, Contemporary Arts Museum, Houston; *Significant Notes*, Aarhus Kunstforening af 1847, Aarhaus, Denmark (all 2002); Art Gallery of York University, Toronto; *Fallen Spirits*, Anna Schwartz Gallery, Melbourne; *Hoxa Sound, The Constant Moment*, Tomison's Academy, Scotland; *Nephilla-Mania*, The Fabric Workshop, Philadelphia; York University Art Gallery, Toronto; and Lisson Gallery, London (all 2001). She has exhibited in group shows worldwide including, Arnolfini Gallery, Bristol; Museum of Contemporary Art, Sydney; The Jewish Museum, New York; Musée Cantonal des Beaux-Arts de Lausanne; Hayward Gallery, London; Henry Moore Institute, Leeds; Charlottenborg Udstillingsbygning, Copenhagen; Peter & Paul Fortress, St. Petersburg; Kunstverein, Munich; Berkeley Art Museum; Auckland Art Gallery; Kópavogur Art Museum, Iceland; Irish Museum of Modern Art, Dublin; and the ICA, London. Christine Borland lives and works in Scotland.

Sonia Boyce (b. 1962) studied Fine Art at Stourbridge College of Technology and Art. Since graduating in 1983, she has exhibited extensively. Solo exhibitions include: *Conversations*, Black Art Gallery (1986); Air Gallery (1986); Whitechapel Art Gallery (1988); *Something Else*, Vanessa Devereux Gallery (1991); *Do you want to touch?*, 181 Gallery (1993) all London; *Peep*, Brighton Museum (1995); *Performance*, Cornerhouse, Manchester (1998); *Recent Sonia Boyce: La, La, La*, Reed College's Douglas F. Cooley Memorial Art Gallery, Portland (2001); *Mm*, Turner Contemporary, Margate (2004); and The Agency, London (2004). Group shows include: Africa Centre; ICA; Chisenhale Gallery; Hayward Gallery; National Portrait Gallery, all London; and Winnipeg Art Gallery; Wilfredo Lam Cultural Centre, Havana; Studio Museum Harlem, New York; and Yale University Art Gallery, Connecticut. Recent group exhibitions include: *Century City*, Tate Modern (2001); *Self-Evident*, Tate Britain (2002); *Strangers to Ourselves*, Hastings Museum and Art Gallery (2003); and Sharjah International Biennial 7, United Arab Emirates (2005). Her works can be found in the Tate and Victoria and Albert Museum collections. She has been artist-in-residence at Vancouver Art Gallery; Duke University, North Carolina; Brighton Museum; University of Manchester; and Reed College, Portland, and has participated in artists' workshops including Soroa, Cuba; Pachipamwe, Zimbabwe; Li Jiang, China; and with Guillermo Gomez-Pena and La Pocha Nostra, Oaxaca, Mexico. Sonia Boyce has been the recipient of many awards from the Arts Council; Artsadmin; North West Arts; the British Council and in 2004, a two-year NESTA Fellowship. Recent monographs include: *Speaking in Tongues*, published by Kala Press (1997); *Annotations 2 / Sonia Boyce: Performance*, published by inIVA (1998) and *Recent Sonia Boyce: La, La, La*, published by Reed College (2001). She is also co-editor of *Shades of Black: Assembling Black Arts in 1980s Britain*, Duke University Press in IVA (2005). Sonia Boyce lives in London and lectures at University of the Arts, London.

Maria Chevska is Professor of Fine Art at the Ruskin School, University of Oxford, where she has been Head of Painting since 1991. She has received several awards including: Gulbenkian Foundation; British Council; British School at Rome; Centre D'Art Contemporain, Parc St. Leger; and Arts Council, England. She has exhibited widely, both nationally and internationally. Solo shows include: *[Who Is Refused]* , Slought Foundation, Philadelphia, USA (2005); *Reading Room*, MOCA, London (2005); *Can't Wait [Letters RL]*, Andrew Mummery Gallery, London (2004); *Vera's Room*, Kunstpunkt Berlin (2003); *EH*, Maison de la Culture, Amiens, France (touring 2002-3); Galerie Philippe Casini, Paris (2003); Wetterling Gallery, Stockholm (2002); Company, Watertoren, Vlissingen, Holland (2000); Abbot Hall Art Gallery and Museum, Cumbria, UK (1999); *Spoken Image*, Kunstmuseum Heidenheim; and Museum Goch, Germany (1997); *Perpetua*, Angel Row Gallery, Nottingham UK (1994); *Visibility*, Anderson O'Day Gallery, London (1990); Bernard Jacobson Gallery, London (1987); Chapter Arts, Cardiff (1986); and Air Gallery, London (1982). She has exhibited in group shows in England, France, Germany, Italy, Poland, and Romania. Her most recent group shows include: *Lekker*, APT Gallery, London (2005); *Translator's Notes*, CafÈ Gallery, London (2003); *Independence*, South London Gallery (2003); *Peintures*, Rennes, France (2002); *Stoff*, Malerie, Plastik, Installation, Staatliche Galerie, Albstadt and Kunsthaus Kaufbeuren, Germany (2002); *Fluent*, London (2002); Marianne Hollenbach Gallery, Stutgart, Germany (2001); *Chora*, London, and touring UK (1999). In September 2005 a monograph titled *Vera's Room, The Art of Maria Chevska* was published by Black Dog Publishing. It included an essay by art critic Tony Godfrey and a text by French philosopher and writer Helene Cixous, with whom she has collaborated on the Slought Foundation project.

Tacita Dean was born in Canterbury, England in 1965 and completed her BA at Falmouth School of Art, Cornwall in 1988. She then took up a Greek Government scholarship to the School of Fine Art in Athens before her MA studies at The Slade School of Fine Art, London University. She has held over 40 solo exhibitions of her work worldwide including most recently, Schaulager, Basel (2006); Tate St Ives (2005); Museum of Modern Art, Ljubljana; Fondazione Sandretto Re Rebaudengom Torino (2004); De Pont Foundation, Tilburg; Presentation House Gallery, Vancouver; Ludwig Forum, Aachen (2004); Marian Goodman Gallery, New York; and Musee d'Art Modern de la Ville de Paris (2003); MuseuSerralves, Portugal; Kunstverein fur die Rheinlande und Westfalen, Dusseldorf (2002); Museu d'Art Contemporani de Barcelona; Tate Britain; International Biennial, Melbourne; Frith Street Gallery; Marian Goodman, Paris and DAAD Galerie and Niels Borch Jensen, Berlin (2001). Recent group shows include the Hayward Gallery, London; 15th Biennale of Sydney, Australia; Kunst Museum Lucerne, Lucerne; and Neuer Aachener Kunstverein, Aachen, all in 2005. In 1998 Tacita Dean was nominated for the Turner Prize and won the Sixth Benesse Prize at the 51st Venice Biennale. Other awards include the Regione Piemonte Art Prize (2004); Aachnerkunstlerpreis, Aachen (2002); DAAD Scholarship, Berlin (2001-2); as well as Artist in Residence, Wexner Center for the Arts, Ohio (1999); Scriptwriters Lab, Sundance Institute, Utah (1997); and Barclay's Young Artist Award (1994). In 2005 she curated the group exhibition *An Aside* a National Touring Exhibition from the Hayward Gallery. Dean is represented in many international public and private collections including the Museum Winterthur, Zurich; Tate London; Fundacio La Caixa, Barcelona; Arts Council of Great Britain; Musée d'art Moderne de la Ville de Paris; the Hirschhorn Museum, Washington and the Museum of Modern Art, New York. Tacita Dean lives and works in Berlin.

Tracey Emin was born in London in 1963 but brought up in Margate, Kent. Emin completed an MA in painting at the Royal College of Art and her interest in the expressionist works of Munch and Schiele informed the paintings she produced at that time. She subsequently destroyed these works when she suffered what she has described as her 'emotional suicide', following an abortion. Some years later, Emin returned to making art, this time using her personal experience to make highly confessional works. Her first solo exhibition, at White Cube (London) in 1993, was entitled *My Major Retrospective*, and included a display of personal memorabilia and photographs of all her destroyed paintings in a disarmingly frank exploration of her own life. Emin's art is one of disclosure, using her life events in works ranging from storytelling, drawing, filmmaking, installation, painting, neon, photography, appliqued blankets and sculpture. Emin exposes herself, her hopes, humiliations, failures and successes in an incredibly direct manner. Often tragic and frequently humorous, it is as if by telling her story and weaving it into the fiction of her art she somehow transforms it. Emin has exhibited internationally, including solo and group exhibitions in Holland, Germany, Japan, Australia and America. In 1999 she was shortlisted for the Turner Prize at the Tate Gallery (London). She has had solo shows at White Cube in 2001 and 2005; Stedelijk Museum (Amsterdam); Haus der Kunst (Munich) and Modern Art Oxford in 2002; Art Gallery of New South Wales (Australia) 2003 and Galleria Lorcan O'Neill (Rome) in 2004.

Anya Gallaccio was born in 1963 in Scotland and studied at Goldsmiths College, University of London. She first exhibited in the important group exhibition *Freeze* in London in 1988. Since 1992 she has had over 30 solo exhibitions, including most recently, *One Art*, Sculpture Centre, New York (2006); *Shadow on the things you know*, Blum and Poe, Los Angeles; *The look of things*, Palazzo delle Papesse, Siena, (all 2005); *Love is only a feeling*, Lehmann Maupin Gallery, New York (2004); *Sometimes with one I love*, Annet Gelink Gallery, Amsterdam (2003); *beat*, Tate Britain, London (2002); and *Falling from grace*, Kunsthalle, Berne (2000). She has been included in group shows worldwide and her work is in many collections, including the Arts Council of England. She has undertaken many projects and site specific works including work with the English National Opera and the Third Eye Centre, as well as *Intensities and surfaces*, Wapping Pumping Station (1996); *Keep off the grass*, Serpentine Gallery Lawn, London (1997) and *Glaschu*, Tramway at Lanarkshire House, Glasgow (1999). She has been a Sargent Fellow at the British School in Rome (1998) and an Artist in Residence at Artpace at the Foundation for Contemporary Art, San Antonio, Texas. She has received a Paul Hamlyn Award for the Visual Arts; an 1871 fellowship at the Rothermere American Institute, organised by the Ruskin School of Fine Art, Oxford University with the San Francisco Art Institute (2003); and in 2003 was nominated for the Turner Prize, exhibiting at Tate Britain. She has been written about extensively and recent monographs include Ikon Gallery Publications (2003); *beat*, Tate Britain (2002); *Chasing Rainbows*, Tramway, Glasgow and Locus, Newcastle-upon-Tyne (1999). She lives and works in London.

Lucy Gunning (b. 1964) studied for her MFA at Goldsmiths College, London and her BA at Falmouth School of Art in Cornwall. Solo exhibitions include *Esc*, Matt's Gallery, London (2005); *Quarry*, Spike Island, Bristol (2003); The Centre for Drawing at Wimbledon School of Art, London (2002); *Passing/Performance*, Matt's Gallery & GLOSS Vauxhall, London (2002); *Stage I (Show the Way Mischief)*, Westfalischer Kunstverein, Munster (2001); *Intermediate II*, GreeneNaftali Gallery, New York (2001) and Tate Britain, London (2001); Galeria Presenca, Porto, Portugal (2000); *[BACKSPACE]*, Matt's Gallery London (1999); *Malcolm, Lloyd, Angela Norman & Jane*, GreeneNaftali Gallery, New York (1998); Chapter Arts Centre, Cardiff (1998); Presentation House Gallery, Vancouver (1998); Matt's Gallery, London (1997); University of New York Art Gallery, Buffalo (1997); Harris Museum and Art Gallery, Preston (1996); GreeneNaftali Gallery, New York (1996); City Racing, London (1996); The School of the Museum of Fine Arts, Boston (1996). She has exhibited in group shows nationally and internationally, including at The Henry Moore Institute, Leeds; Westfalischer Kunstverein, Munster; Institute of Contemporary Art, London; Kettle's Yard, Cambridge; Camden Arts Centre, London; British School at Rome; and Centre Georges Pompidou, Paris. She has held many

awards and residencies including the Paul Hamlyn Award for Individual Artists, 2004; Spike Island Moving Image Residency, Bristol, 2003; DAAD Munster, 2001; and The British School at Rome, Rome Scholarship, 2001. Her work can be found in the Arts Council of England Collection, as well as the collections of the Contemporary Art Society; Hayward Gallery; Tate Gallery; Cornell University, USA; Museum of Modern Art Toyama, Japan; and the Centre George Pompidou, Paris. She lives and works in London and is a Lecturer in Fine Art at the University of the Arts, London.

Jane Harris (b. 1956) studied for her MA at Goldsmiths College, University of London (1989-91). Recent awards have included the Rootstein Hopkins Sabbatical Award in 2004 and the Arts and Humanities Research Council Small Grants Award in 2005. She received the Arts Foundation Painting Fellowship in 1995; was Artist in Residence at Camden Arts Centre in 1996 and shortlisted for the Jerwood Painting Prize in 1997. She was an award winner at the John Moores Painting Biennial of 1995; the Cheltenham Drawing Prize of 2000; the Jerwood Drawing Prize (2002). She has exhibited extensively and internationally. Solo exhibitions include: Aldrich Museum, Connecticut; Hales Gallery, London (both 2005); Kontainer Gallery, Los Angeles (2004); Southampton City Art Gallery; Jack Shainman Gallery, New York; Marianne Hollenbach Gallery, Stuttgart (all 2001). Group exhibitions include: *Mythomania*, Metropole Gallery Folkestone and LAAC Dunkerque (2005); *Death is Part of the Process?*, Void Gallery, Derry (2005); *Unframed*, Standpoint Gallery, London (2004); *Painting Per Se*, Galeria Milan, Sao Paulo (2004); *Painting as a Foreign Language*, Edificio Cultura Inglesa/Centro Brasileiro Britannico, Sao Paulo (2002); *Out of Line*, Hayward Touring Exhibition (2001-2); *The Best of Season*, Aldrich Museum of Contemporary Art, Connecticut (2001). In 2002 she curated *Once Again* at the John Hansard Gallery, Southampton, an exhibition of 22 international artists on the theme of the 'double' . She is currently a Senior Lecturer and Course Leader within the MFA Fine Art programme at Goldsmiths College.

Runa Islam was born in Bangladesh in 1970 and studied at Manchester Metropolitan and Middlesex universities before taking up a residency at the Rijkacademie in Amsterdam and completing her MPhil studies at the Royal College of Art, London. Recent solo shows include *How Far To Färö*, Museo di Arte e Contemporanea di Trento, Rovereto; *Time Lines*, Inside The White Cube, White Cube, London; *Be The First To See What You See As You See It*, Hammer Projects, UCLA Hammer Museum, Los Angeles; *Out of the Picture*, Camden Arts Centre, London; *Scale (1/16 inch = 1 foot)*, Prefix Institute of Contemporary Art, Toronto; *Visages & Voyages*, Dunkers Kulturhus, Helsingborg (all 2005); *Runa Islam: Scale 1/16 inch = 1 foot*, Shugo Arts, Tokyo (2004); *Director's Cut (Fool for Love)*, Kunsthalle Wien, Karlsplatz Project Space, Vienna; *Runa Islam, Film and Video Works*, Voralberger Kunstverein, Bregenz; and *Rapid Eye Movement*, MIT List Visual Arts Centre, Cambridge, Massachusetts (all 2003). She has exhibited extensively in group shows including Kunstverein Dusseldorf; Gothenberg International Biennale for Contemporary Art; Taipei MOCA; Kinskich Palace, Prague Biennale; Badischer Kunstverein, Karlsruhe; De Appel, Amsterdam; Witte de With, Rotterdam; Whitechapel Art Gallery; and Tate Modern, London. She has had residencies at Iaspis, Stockholm and Spike Island, Bristol. Commissions include Public Art Strategy for the Home Office, Samling Foundation & NESTA and she has received prizes from the Fondazione ReRebaudengo and Rijksakademie Van beeldende Kunsten. Her work is in various public collections including Arts Council Collection, England; Centro de Arte Contemporaneo, Malaga; Musee d'Art Moderne de la Ville de Paris; Museu Serralves, Porto; Museum of the 21st Century, Kanazawa; and the Stedelijk Museum, Amsterdam. Runa Islam is represented by White Cube Gallery and lives and works in London.

Vanessa Jackson was born in 1953 and studied painting at St Martins School of Art and the Royal College of Art, London. She is a postgraduate and research tutor at the Royal College of Art and the Royal Academy Schools. Since her first one-person show at the AIR Gallery, London in 1981, she has exhibited widely in Britain and abroad, including the New Contemporaries and the John Moores Painting Biennial and, more recently, one-person shows at Art Inc, New York (2003) and Keith Talent Gallery, London (2005). She has spent some time in the USA, in New York, and was selected for two Yaddo Fellowship residencies, in Saratoga Springs in 1985 and again in 1991, and received an Arts Endowment Award for work shown in the Drawing Centre, NYC (1986). Recent group exhibitions have included *Warped, Painting and the Feminine*, Angel Row, Nottingham; Inside Space, London and touring 2001; and *Shelf-Life* at Studio 1.1, London in 2003. She has participated in exhibitions from New York to Tokyo, Botswana to Bergen, Norway and has received British Council and British School at Rome awards. From 1988-97 she was Head of Painting at Winchester School of Art and in the past five years has been an External Assessor for the University of East London; Wimbledon School of Art; Chelsea School of Art; Otis College for the Arts, LA; Bergen Arkitekt Skole, Norway; and the Ecole Cantonale d'Art du Valais, Switzerland. She is currently a member of the Edwin Austin Abbey Council, for the British School at Rome, Chair of the Advisory Board for the Brazier's International Artists Workshop and a Director of the City and Guilds of London School of Art. She was made a Fellow of the Royal College in 2004.

Emma Kay was born in London in 1961, received an MA Fine Art from Goldsmiths College in 1997 and lives and works in London. Solo exhibitions and projects include *What does it mean to be a British Citizen?*, a public art commission for the Home Office, London (2006); Galerie Toni Tapies, Barcelona (2005); *London Underground map*, a commission for Frieze Art Fair and London Underground Platform for Art (2004-5); *The Story of Art*, The Power Plant, Toronto (2004); *The Story of Art*, Tate Contemporary Intervention, Tate Modern, London (2003-4); *The Law of the Land*, The Approach, London (2002); UCLA Hammer Museum, Los Angeles; *The Future From Memory*, Chisenhale Gallery, London (both 2001); *Shakespeare From Memory*, The Approach, London (1998). Recent group shows include *Et Maintenant*, CRAC Alsace; *General Ideas: Rethinking Conceptual Art 1987-*

2005, CCA Wattis Institute for Contemporary Arts, San Francisco; *Move Your Past*, Signal, Malmo; *I really should…*, Lisson Gallery, London; *After the Fact*, Tullie House Museum & Gallery, Carlisle; *Unizone*, Riksutstillinge/Riksutställningar, Norway and Sweden, touring (all 2005); *Common Property*, Werkleitz Biennale, Halle; *Le Proche et la Lointain*, CRAC Domaine de Kerguéhennec France (both 2004); *Micro/Macro: British Art 1996-2002*, Muscarnok Kunsthalle, Budapest (2003); *Biennale of Sydney* (2002); *The Fact Show: Conceptual Art Today*, Pittsburgh Center for the Arts; *ARS 01*, Kiasma, Museum of Contemporary Art, Helsinki; *All Systems Go*, Contemporary Arts Museum, Houston (all 2001); *British Art Show 2000*, touring UK; *Biennale*, Istanbul; *Abracadabra*, Tate Gallery, London (both 1999); *New Contemporaries 1998*, Liverpool, London, Newcastle; and *A-Z*, The Approach, London (1997). Emma Kay is a member of Cubitt, an artist-run organisation in London.

Tania Kovats was born in Brighton in 1966. She completed her BA Fine Art at Northumbria University and an MA Sculpture at the Royal College of Art in 1990. In 1991 she won the Barclays Young Artist of the Year at The Serpentine Gallery, London. Her recent solo exhibition, *offshore*, at Newlyn Art Gallery and at the Oriel Mostyn Gallery, Llandudno, brought together a body of sculptures and drawings primarily concerned with coastal landscapes. Other solo shows such as *Slip* at the Yorkshire Sculpture Park, and *Schist* at Asprey Jacques Gallery, London, have looked at the geological make-up of landscape. Group shows considering landscape include: *At Sea* at the Tate Liverpool (2001); *Unseen Landscapes* , The Lowry, Salford (2001); *Landscape*, an international touring British Council exhibition (2002); and *Wild Landscapes* at Compton Verney (2005). Her work has been shown at Kuntstraum, Innsbruck, Austria; Galerie Dorothee De Pauw, Brussels; Kettle's Yard, Cambridge; Camden Arts Centre, London; Victoria and Albert Museum, London; MOCA, Sydney; Westfalischer Kunstverein, Munster; with solo shows in Italy, France, and the Netherlands. In 2000 she curated *LOST* for the IKON Gallery, Birmingham after her collaborative work with the architects on the IKON's new building. She won an RSA Art for Architecture Award and is acknowledged as having demonstrated a pioneering approach to the possibilities of collaboration. In 2002 she relocated to Los Angeles for 18 months. On returning she was appointed The Henry Moore Drawing Fellow. This led to the publication of The Drawing Book at the start of 2006. She is currently the Visiting Fellow at Ruskin School of Fine Art and Drawing and the School of Archaeology, Oxford in connection to her appointment as the artist on The White Horse Project. Kovats currently lives and works in London.

Maria Lalic was born in South Yorkshire in 1952. She studied painting at the Central School of Art and Design, London and, as a postgraduate, at Chelsea School of Art, before becoming the Fellow in Painting at Bath Academy of Art (1977-8). She has taught at Goldsmiths College, University of London, the Slade School of Fine Art and other colleges, and since 1998 has been Professor of Painting at Bath Spa University. She has exhibited widely: three solo exhibitions in London at Todd Gallery, three in Munich at Galerie Renate Bender and two in Auckland and Wellington with Jensen Gallery as well as numerous group exhibitions in Britain, Austria, Eire, Germany, Holland, Hungary, Norway, Sweden and in New Zealand and the United States. Her work is included in publications relating to these, most recently *Seeing Red* (Fehr and Wurmfeld); *Blue* (Jenkinson, Gage and Tooby); *Small truths; Repetition and the Obsessional in Contemporary Art* (Foster, Sheridan and de Ville); *Die Farbe hat mich* (Fehr and Stempel); *Maria Lalic; The Lead Fall Paintings* (Jensen and Smith) and *Tate Women Artists* (Foster). In 1997 she was shortlisted for the Jerwood Painting Prize. She has received awards from the Arts Council, British Council and the Arts and Humanities Research Board. Her work is in many private collections internationally, including those of Deutsche Bank and the Department of Trade and Industry, and in public collections including Tate; Victoria and Albert Museum; the Arts Council of England; the Karl Ernst Osthaus Museum, Hagen; and the Museum fur Konkrete Kunst, Ingolstadt.

Hayley Newman (b. 1969) received a BA at Middlesex University before gaining a Higher Postgraduate Diploma in Fine Art at the Slade School of Art, London. In 1995 she took up a DAAD scholarship in the class of Marina Abramovic at the Hochschule fr Bildende Kunste, Hamburg, after which she was awarded the Stanley Burton Practice-based Research Scholarship at the University of Leeds, completing her PhD in 2001. She is currently Senior Research Fellow and Graduate Tutor in Fine Art at Chelsea College of Art and Design, University of the Arts, London and Research Tutor at the Royal College of Art. In 2004-5, she was the recipient of the Helen Chadwick Arts Council of England Fellowship at the British School at Rome and the Ruskin School of Drawing and Fine Art, Oxford. She has performed and exhibited widely and has had solo shows at Matt's Gallery, London, The Ikon Gallery, Birmingham and the Centre d'Art Contemporain, Geneva (2001-03). Recent performances include *Their feet should not touch anything solid*, Camden Arts Centre, London; *ffffashion*, South London Gallery, London; *Karaoke Record Cutting*, Barbican Art Gallery, London; *Make-up/wake-up*, Rialto, Rome; and *Volcano Lady*, British School at Rome (all 2005). Recent group exhibitions include *Chronic Epoch*, Beaconsfield Gallery, London, *Her Noise*, South London Gallery, London; *Documentary Creations*, Kunstmuseum, Lucerne; *Resonance*, Montevideo, Amsterdam (all 2005); *Camera/Action*, Museum of Contemporary Photography, Chicago (2004); and *Live Culture*, Tate Modern, London (2003). Her current interest in *Rubbernecking* describes the act of slowing down, craning the neck and straining to look, and involves a series of trips to places reported in the daily news. She lives and works in London and is represented by Matt's Gallery.

Paula Rego was born in Lisbon, Portugal in 1935 and studied at the Slade School of Fine Art, London University, where she also taught. In 1987 she was nominated for the Turner Prize and she has received honorary doctorates from University of East Anglia, Rhode Island School of Design and Oxford University amongst others. In 1990 she was appointed the first National Gallery Associate Artist in London. She has exhibited nationally and internationally. Recent solo exhibitions include Serralves

Museum, Oporto; Tate Britain, London; Charlottenborg, Copenhagen (all 2004); *Paula Rego - Pendle Witches*, Hebden Bridge Arts Festival, Yorkshire; (*Jane Eyre and Other Stories*, Marlborough Fine Art; *Paula Rego - Jane Eyre*, Galeria 111, Brito, Portugal and Marlborough Gallery, New York (2002); *Celestina's House*, Abbot Hall Art Gallery and Yale Center for British Art, New Haven (2001). Other solo shows include *The Sins of Father Amaro*, Dulwich Picture Gallery (1998); *Paula Rego Retrospective Exhibition*, Tate Gallery Liverpool (1997); *Tales from the National Gallery*, a travelling exhibition to the National Gallery, London and The Calouste Gulbenkian Foundation, Lisbon, amongst others (1991-2). A retrospective exhibition at the Serpentine Gallery, London was also held in 1988 which toured to Lisbon and Oporto. Recent group shows have includedKistefos Museum, Norway, Fundación Caixa Catalunya, Barcelona; The Science Museum, London; and the Hayward Gallery, London. She has been the subject of various monographs including *Paula Rego*, Phaidon Press (2006); *Compreender Paula Rego - 25 Perspectivas*, Publico Serralves (2005); *Paula Rego: The Complete Graphic Work*, Thames & Hudson, London (2003); *Paula Rego*, Tate Publishing (2002). Her work in public collections includes British Museum, National Gallery, National Portrait Gallery, Arts Council, Saatchi Gallery and Tate Gallery in London, Gulbenkian Foundation, Lisbon and the Metropolitan Museum of Art in New York.

Jemima Stehli (b. 1961) lives and works in London. She studied at Goldsmiths College, London where she completed her BA and MA in Fine Art. She first became known with photoworks shown at the artist-run space City Racing in 1998. This was followed in 2000 by her first major solo show at the Chisenhale Gallery in London. She is currently working on a solo show of new and commissioned work for the Centro Cultural de Belem, Lisbon, Portugal. Other recent solo shows include *Jemima Stehli*, Centro de Artes Visuais, Coimbra, Portugal; *Put there*, Galerie BerndKluser, Munich, Germany (both 2004); *mm Studio*, Contemporary Art Gallery, Vancouver, BC, Canada; *The Upsetting Table*, Jeffrey Charles Gallery, London; and the Lisson Gallery, London (all 2003). Group shows include *Film Performance* , Moma, Oxford (2006); *Corpomodamente*, Trieste, Italy; *Black on White*, Elga Wimmer PCC, New York (both 2005); *Camera/Action*, Museum of Contemporary Photography, Columbia College, Chicago (2004); as well as shows in Prague, Marseilles, Mombai, Calcutta and Bregenze. Between 1998-2000 she was an artist in residence at Delfina Studios in London. Jemima Stehli's work has been written about extensively and is included in *Art and Photography* edited by David Campany, Phaidon Press; *The Photograph as Contemporary Art*, edited by Charlotte Cotton, Thames and Hudson; *Curve: The Female Nude Now*, Universal Publishing, New York; and *Art Crazy Nation*, by Matthew Collings, 21 Publishing, New York. Two recent monographs are available on her work *Jemima Stehli*, Centro de Artes Visuais, Coimbra and *Jemima Stehli*, ARTicle Press. Jemima Stehli is represented by the Lisson Gallery in London and Artra in Milan.

Tomoko Takahashi was born in Tokyo in 1966 and has lived and worked in London since the early 1990s, studying for her BA at Goldsmiths College and MA at The Slade School of Fine Art, both part of London University. She has shown nationally and internationally in commercial, public and artist-led spaces. Her first important work was made at Shave 95, the international artists' workshop at Shave Farm in Somerset, UK. In 2000, with Jon Pollard, she was commissioned by the Chisenhale Gallery to make an installation and web-based work, *word perfect*. She has also collaborated with the artist Ella Gibbs on *The Day of Patience* at Belt, London and *48 Hours* at Tablet, London (1999) and with Rupert Carey in *Tickertape Parade Without Parade* at Milch, London (2000) and the Mori Art Museum, Tokyo (2003). Most recently her solo exhibitions include *Wet Paint (for Rupert Carey)* at Galleria Charlotte Lund in Stockholm (2001); *Deep Sea Diving* at the Kunsthalle Berne in Switzerland (2003); *Auditorium Piece* at UCLA Hammer Museum in Los Angeles (2002); and *my play-station* at the Serpentine Gallery in London (2005). Recent group shows include *Park light* at Clissold Park (2000); *Realm of Senses*, Turku Art Museum, Finland (2000); *Sprawl*, The Contemporary Arts Center, Cincinatti (2002); *Charlie's place*, Annely Juda, London (2003); and *Chronic Epoch*, Beaconsfield, London 2005). Other group shows include East International, PS1, New York; Saatchi Gallery, London; the New Museum of Contemporary Art, New York; the Atlanta Contemporary Art Center, Georgia; and Kunsthalle zu Kiel, Germany. In 2000 she was shortlisted for the Turner Prize and exhibited at Tate Britain, London. Takahashi lives and works in London and is represented by Hales Gallery in UK; Gallerie Charlotte Lund in Stockholm; Galleries Pedro Cera in Lisbon; and Grant Selwyn Fine Art in Los Angeles.